131931 ✓

AUG 67 ✓

DATE DUE

ite

131931 ✓

769.924
Breeskin, Adelyn Dohme,
 Anne Goldthwaite : a
catalogue raisonne of the

10.00

Horseshoe Bend Regional Library

DADEVILLE, ALABAMA

THIS BOOK PROVIDED BY
ALABAMA PUBLIC LIBRARY SERVICE

In Memory of Lucy Goldthwaite

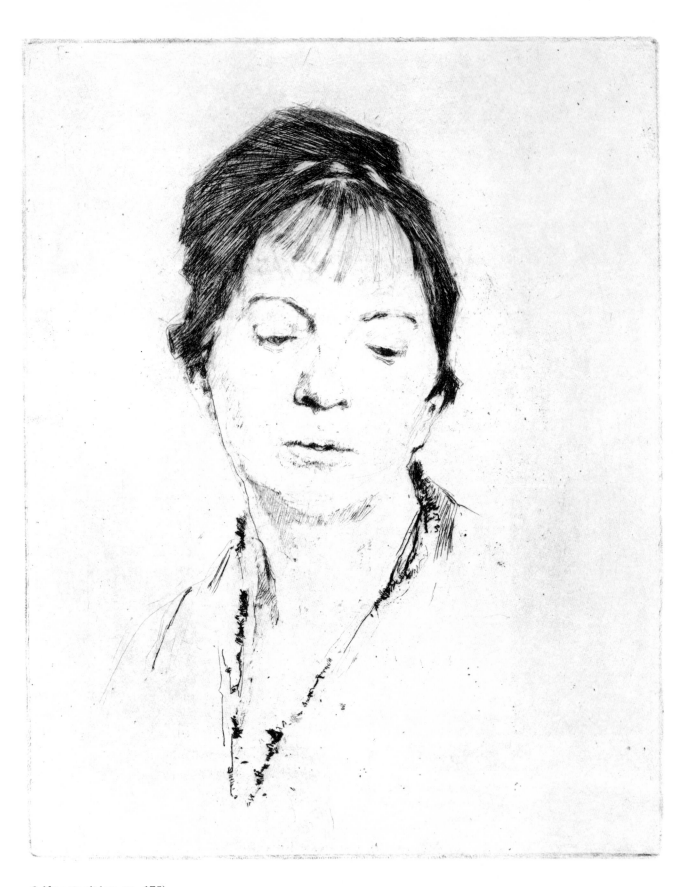

Self-portrait (cat. no. 178)

Anne Goldthwaite

A Catalogue Raisonné of the Graphic Work
by
Adelyn Dohme Breeskin

131931 ✓

Montgomery Museum of Fine Arts
Montgomery, Alabama
1982

This catalogue has been published in conjunction
with an exhibition of Anne Goldthwaite's prints held
at the Montgomery Museum of Fine Arts from June 30
to September 8, 1982.

Copyright © 1982 Montgomery Museum of Fine Arts.
All rights reserved. No portion of this book may be
reproduced without the written permission of the
Montgomery Museum of Fine Arts, 440 South
McDonough Street, Montgomery, Alabama 36104.
Telephone (205) 834-3490.

Library of Congress Cataloging in Publication Data

Breeskin, Adelyn Dohme, 1896-
 Anne Goldthwaite: a catalogue raisonné of the
graphic work.

 Bibliography: p. 135.
 1. Goldthwaite, Anne, 1869-1944—Catalogs.
I. Montgomery Museum of Fine Arts. II. Title.
NE539.G63A4 1982 769.92′4 82-6425
ISBN 0-89280-019-4 AACR2

Cover illustration
Bébé von Knapitsch (cat. no. 86)

Contents

Acknowledgements

In 1977 the Montgomery Museum of Fine Arts recognized the contribution of Anne Goldthwaite by mounting an exhibition of her paintings and graphics. It became apparent that she was being neglected by many art historians although she had earlier been known as a talented artist and chronicler of life in the southern United States. The Montgomery Museum has now organized a retrospective devoted solely to the artist's work in the print medium to celebrate the publication of this catalogue raisonné of Anne Goldthwaite's prints.

Neither the exhibition nor this publication would have occurred without the commitment of Adelyn Dohme Breeskin, a longtime friend of the artist and a dedicated supporter of her work. Unknown to the Montgomery Museum, Mrs. Breeskin worked for many years on the catalogue raisonné; it was our pleasure to discover the results of her labors and to prepare her manuscript for publication. In the edited memoirs and biographical sketch following Margaret Lynne Ausfeld's introduction, Mrs. Breeskin relates the artist's sensitive observations of life in the South, in New York and abroad in the late nineteenth and early twentieth century. Personal records such as the one printed here are becoming more important with each year as living documents of the past. Together, the exhibition and this publication afford considerable insight regarding Anne Goldthwaite's position as an artist, a Southerner, and a woman.

As a special gesture to mark the publication of the catalogue raisonné, Mrs. Breeskin has generously donated to the Montgomery Museum a comprehensive collection of Anne Goldthwaite's graphic work. This large group of prints joins an existing collection of Goldthwaite work, most of which was donated over a period of many years by the artist's family: her sister Lucille Goldthwaite, her niece Lucy Goldthwaite, and her nephew Richard Goldthwaite.

The publication of a book as thorough as a catalogue raisonné requires an extraordinary amount of time-consuming work. The Montgomery Museum wishes to thank the institutions that helped us to survey their collections of Goldthwaite prints. David Kiehl, Assistant Curator of the Department of Prints and Photographs at the Metropolitan Museum, provided special assistance in documenting that museum's large collection of Anne Goldthwaite's graphic work. The staff of the Montgomery Museum has been especially dedicated to this project, particularly

Margaret Lynne Ausfeld, Assistant Curator. She served as coordinator for the entire project, transforming the manuscript from handwritten notes to finished form and expertly assembling the retrospective exhibition of Anne Goldthwaite prints. Secretary Susan Cain typed the complicated manuscript with patience and care. Volunteer Margaret Baucom and Preparator Patrick Kirkland helped to ready the prints for cataloguing and display. I would also like to thank Mitchell Kahan, Curator of Painting and Sculpture, for initially proposing the exhibition and publication.

It has been a great pleasure for the Museum staff to work with Mrs. Breeskin on this project, and I offer my special appreciation for her generous donation of the prints and her dedication to Anne Goldthwaite's work.

Philip A. Klopfenstein
Director

Introduction

Although best known as a painter, to her contemporaries Anne Goldthwaite was equally renowned as a printmaker. Her work in the graphic media includes more than 320 prints executed between 1895 and 1942. The life which is briefly and charmingly recreated in the memoirs accompanying this catalogue finds its true expression in Anne Goldthwaite's remarkable oeuvre. This visual chronicle is stamped with the brevity of statement and unerring sense of design that characterized all of her works, and with the wit and sensitivity so evident in her written account.

In general, the subjects of her graphic work are those of her paintings—the milieu of a Paris art student at the beginning of the 20th century or the New York scene she called home for so many years. From bucolic landscapes to urban landmarks, exotic dancers to ecclesiastics, the images are endlessly varied and keenly realized. Early etchings such as *Still Life with Chianti Bottle* (cat. 4) and *The Potter* (cat. 7) are the products of her Paris training in a traditional atelier. Meticulously constructed and highly polished, they represent the required studies of composition and anatomy which served as a foundation for her later style. While her memoirs relate that singular afternoon when she first "took tea" with Gertrude Stein, Anne Goldthwaite's prints tell us that other afternoons were spent strolling the parks of Paris or studying formidable architectural landmarks such as *St. Sulpice* (cat. 28) and the *Madelaine* (cat. 29). She was equally inspired by the timeless silence of a churchyard (cat. 44) and the prospect from a sunny country hillside (cat. 85). She writes that she "found little satisfaction" in sitting at restaurants and, judging from her prints, the nourishment more to her taste was the dance and music which pervaded Paris at that time. She gives us scenes from Diaghilev's *Ballet Russe* (cat. 65) and portraits of its dancers (cat. 61 and 64). The pianist Harold Bauer was a favorite of Anne's, and later in her career musicians continued to be frequent subjects.

It was Anne's intention to return to Paris after a summer visit to the United States in 1913. When World War I intervened, she chose to live in New York, where she had first come to study art at the turn of the century. Her student days over, she became a professional. "We do not play here as in Paris," she wrote, "but work hard and sternly—in spite of which old New York may, perhaps, be best of all." People—friends, family, neighbors and strangers—were the central focus of

her New York life. She writes of Woodrow Wilson and Katherine Dreier, preserving her visual impressions as well (cat. 108 and 140). But it was not celebrated personalities that captured her imagination on a daily basis. On the contrary, it was young Victoria with her lace hat and piquant nose (cat. 148), or the dashing Captain Edward Lowry (cat. 173) or the Bowery urchin who is known to us only as Mike (cat. 193). There is the characteristic face of a large city— great churches (cat. 206), towering skyscrapers, and her own rowhouse window (cat. 256). She attended baseball games (cat. 225) as well as museums, and everywhere discovered something to spark her artistic interest.

If there is one facet of Anne Goldthwaite's personality that is consistently noted by her biographers, it is her youthful outlook. Her spirit of adventure and love for the sunny aspects of life inspired frequent visits to the South of her childhood. Consistently, her views of Southern life and landscape are adjudged her finest work and, in light of what she has written of her earliest childhood memories, this seems only appropriate. The Southern scenes are vibrant and alive with the sights that early impressed themselves upon her visual memory. She depicts a time when "it was a disgrace to be rich," but one still found "the glitter of silver and glass, oil paintings in beautiful Italian frames," and the genteel, unhurried way of life along hot, dusty small-town streets. Markets, shaded by ancient oaks or chinaberry trees, are preserved in Anne's art as monuments to a gentle, peaceful security that characterized the South of her memory.

Anne describes her earliest experiences with etching when she writes of her encounters with Mr. Kimball and "young Voight." The detailed and self-consciously picturesque compositions of her student days gave way to a fluid, notational style related to that of Matisse. (She apparently was personally acquainted with Matisse. In an article on her etchings written for *The Montgomery Advertiser* in 1931, Kelly Fitzpatrick asserts that Matisse saw an exhibition of Anne's work in 1930 and "gave it his personal acclaim." Anne's niece, Lucy Goldthwaite, recalled arriving at her aunt's studio and passing Matisse, who was exiting.)

This style, which was intended to preserve in the etched work the spontaneity of drawing, found early expression in her etchings of dancers. One sees it particularly in the *Moment Musical* series of 1911 and in other dance subjects. Later works in this style—*Carnival* (cat. 188) and *Boguehomme* (cat. 185) for example—are successful in capturing an experience, briefly suspended and quickly translated through the eye and hand in one surge of creativity. In the late 1920's she began to work in the medium of lithography and utilized it for the next twenty years with a variety of subject matter. These prints generally preserve the effects of chalk or conté crayon drawings.

After the artist's death in 1944, Mrs. Adelyn Breeskin, then at the Baltimore Museum, received a collection of prints to catalogue and the request that any duplicate prints be donated to interested museums throughout the United States. For this reason, a number of museums, widely distributed geographically, maintain collections of prints by Anne Goldthwaite.

In 1915 Anne told an interviewer from the New York *Evening Sun* that, "there's one thing about being an artist that is really very nice . . . every time you open your eyes you see possibilities for a picture." The size and variety of her print

oeuvre prove that she meant what she said and took every opportunity to express her reactions to what she saw through her art. Consequently, little bits of Alabama, Paris and New York—notes jotted down on a hillside, in a concert hall or at East Tenth Street—enliven the walls of museums and exhibition galleries across the country.

Margaret Lynne Ausfeld
Assistant Curator
Montgomery Museum of Fine Arts

12

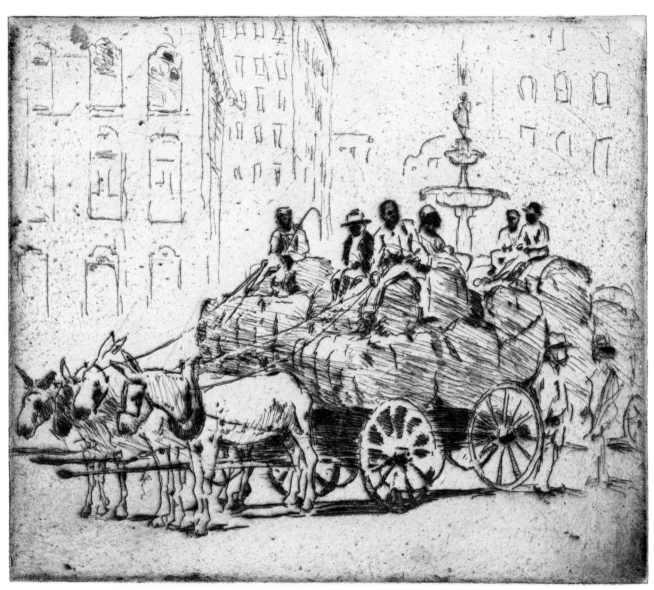

Cotton Wagons in Court Square (cat. no. 187)

Anne Goldthwaite
1869-1944

IN 1935, Anne Goldthwaite was persuaded to write her memoirs. She started out quite valiantly, but before long there were gaps, and finally she wrote that she was a painter and not a writer and therefore gave up the project entirely. Nevertheless, what has been found so far in her handwriting gives so much of her own personality that it is well worth introducing as a major record of her life. Interspersed will be necessary details such as the various exhibitions of her prints and an account of her memorial exhibition, etc., but as much as possible will be in her own words:

THE EARLY YEARS of my life were the golden age. They were filled with love and warmth and ease and approbation. I remember only happy things— sitting on a grassy lawn eating syllabub at John Elmore's birthday party; my father in a white suit trying to catch butterflies for me in our flower garden, the quickly melting snow on our back porch and the slippery steps I pretended to fall down to attract Mammy's wandering attention.

My Mammy was of tremendous importance to me and I to her. She was inordinately proud of my good looks and my bad temper, especially the latter. In a group of nurses with their charges, I have heard her boast of my misdeeds.

Years later, on my eighth birthday, Mammy gave me a golden ring, like a wedding ring, and a filligree breastpin to remember her by when I was grown. She lies buried in a negro graveyard in Texas, and there is a stone at her head with her name carved deep so that we children might always find her. We are now far from her grave. I have lost all of her presents, and I am conscious of guilt; but if I can write her name—Nancy Sykes—into this book I shall have atoned.

In those days my father and mother lived in a little house of their own, but my grandparents' home was headquarters. There we went every day and always to dinner on Sundays. Four granddaughters sat at a small table in the big back hall with our nurses behind our chairs. We could look into the dining room with its glitter of silver and glass and fine linen, but as I finished my rice and gravy and threw myself back with abandon, I rejoiced that we were safe from the restraint of those tedious folk in the other room. There were grandsons too, but to me they seemed negligible, and I do not know where or how they dined.

My grandfather had a beautiful house, and I learned later that he was a great man. Though I never doubted this greatness, there was something unsatisfactory about these Goldthwaites. My mother's people were Armisteads of Virginia and that was as it should be, but my grandfather Goldthwaite was from New England, having for an ancestor one Ezekiel Cheever, the first schoolteacher in Boston. This seemed a little dubious.

A certain Colonel Thomas Goldthwaite was his grandfather. Colonel Goldthwaite was an officer in the British army and was in command of the Harbor at the time of the Boston Tea Party, doubtless at home in bed when tea was served. More to his credit, his portrait was painted by Feke, and his sister's by Copley. The portrait of Elizabeth Goldthwaite Baker now hangs in the Brooklyn Museum, one of its prized possessions. In this year of 1939, Feke and Copley are at the peak of fashion, and I somehow feel that I acquire merit from the artistic foresight of Colonel Thomas.

My grandfather was the youngest of his family. His father managed to have him appointed to West Point, but from there he was soon expelled for a hazing escapade. His indignant brothers put him on an old grey horse that stumbled and sent him down to Alabama where lived Henry, the eldest brother of all.

In Montgomery, legend still tells of his youthful adventures—his pursuit of our much-admired outlaw, Kin Mooney, into Cypress Swamp with an inconvenient cannon; how he swam the rushing current of the flooded Alabama River to dance with the witty Musadora Morgan at her brother Henry's wedding. They tell too that he disappeared for a whole year with a traveling circus and could forever after astound the world of children with his juggler's tricks. But on high holidays at the Capitol, I have listened while governors and senators praised Henry and George Goldthwaite who had written and revised the liberal code of Alabama and had for years administered her laws.

They were both justices of the Supreme Court. While Henry died young, George lived to be Chief Justice. He never lost his love of fun and adventure. As he sat on the judge's bench, he amused himself by caricaturing all who came before him. After a session of court, attendants would sweep up these quick pencil sketches which littered his desk and the floor. I wish they had saved some of them.

Though opposed to secession, George Goldthwaite found it his lot to equip the Alabama soldiers for the Civil War and to send his own four sons to fight for the Confederacy. He was the first southern senator sent back to Washington at the end of the scalawag/carpetbag rule.

In the South after the Civil War, it was a disgrace to be rich, so my grandfather could not have had much money, but he and Grandmother had enough while he was senator to make the grand tour of Europe. They were presented to Queen Victoria and had an audience with the Pope as was then the custom. They brought back many large oil paintings in beautiful Italian frames. These pictures were copies of old masters—Titian, Raphael, etc. They were in their places on the walls for me to see when I first came into the world. There must have been many such paintings in the Eastern states leaving their imprint on American art, as the originals had done on the art of Europe.

The South was, and is now, a strange mixture of luxury and poverty. Though the rich lands of the Black Belt were still adequate to feed and warm its people, there was little money. In homes such as I knew, one found beautiful silver and broken china, worn carpets and great cracked mirrors, the best of cooks and much leisure, beautiful old books, but no money for new ones.

Reconstruction was over but all men were without hope of a better future. My father, being young and adventurous, decided to seek his fortune in Texas. This was not such a radical move, as his family had always used Texas as a kind of playground. Grandfather owned plantations there and often went out to see about them. A younger George Goldthwaite was a judge in Houston and there were cousins in Galveston reputed to be making fortunes. Indeed, there is somewhere in that big state a tiny town named Goldthwaite for some stray member of the family. One day, a year after my father had left us to find a home in Dallas, we followed him—my mother, my brother, my Mammy and I.

This I am told, for though so great an event in my life, I remember nothing about it.

TEXAS—1880. My real consecutive memory begins in Texas. I remember tarantulas and centipedes (or half of them) and prairie dogs and civit cats and prairies studded so thickly with brilliant flowers that the Unicorn Tapestries would seem denuded in comparison. There were donkeys, mustangs and bantam chickens, and there were lariats, quirts and bowie knives. I do not know whether all this came to me with such a surprising freshness because I was so new to the world, or because I was a little Alabamian in the, to me, new State of Texas.

My brother and I had an idea that panthers roamed the yards at night. We found on the soft flower beds what served as foot tracks whenever we looked for them. And to prove that we really lived in a dangerous country, I remember well that the family of a little friend of mine had to close the shutters every night at dark because of a cowboy feud carrying a threat to kill her father. So Texas held its terrors as well as delights. Longhorned cattle were often driven through the streets. If we were then outside our fences, our Mammy would be watching and would call us.

The presence of my father and mother pervaded those days. My mother belonged to a family noted for its wit, and perhaps she was the wittiest of all. I didn't appreciate what she said, but could see that in any crowd everybody listened to and laughed with her. My father, I imagine, did not have this gift of bringing laughter, but though he was rather quiet, he was always the leader. I am told this was as true in Civil War days, as captain of his battery, as when he was our childhood's play-boy. Whenever he was there life was a romantic adventure. In those days we used to play with a family of children whose mother was the joy of our group. She was the daughter or granddaughter of Sam Houston, and Texas seemed to belong to her. She was lovely to me, as many women have been, taking me to themselves as if I were another daughter. She once wrote an acrostic on my name. I wish I could remember it, but it is one of my lost treasures. And another is the pearl and gold pin that she sent me after we went back to Alabama. To this day I feel the keenest remorse that I never wrote to thank her for that present, but the difficulty of getting ink, paper and stamps together was insurmountable.

DALLAS—1884(?). My education was begun at a little "Ladies' School." There was a small white house of two rooms, built in the corner of a great big lot covered deep and thick with Bermuda grass. My father had passed this school daily as he walked to his office, and it was his choice as a place of learning for his eldest daughter. All the pupils were little girls and he had never seen one of them do anything of which he disapproved. The schoolmistress was tall and stately. She kept the school chiefly as a means of educating her own two daughters.

On the day school opened in this most important year, my father was out of town and I waited to be entered until his return. My father was a man of the world and I was sure his conduct would always be elegant, distinguished and seemly. Though young, I recognized all these qualities, but I was not old enough to understand my mother's ways, and I held them as somewhat suspect. People, strangers even, were apt to smile, or even laugh, when she was around in a way that left me a little uneasy and I had no idea of having a cloud cast over my entrance into this new sphere by my mother's levity. I did not know that as she laughed she was always studying to make a little picture of me. "Anything for looks," she would say as I writhed and made faces under her brush and comb. As a proof of her genius, Mrs. Coughanour has told me that as I came into her schoolroom that morning with my handsome father, no lovelier vision had ever been there before. I have seen many little girls who I know resembled me closely, but who, lacking the magic fingers of my mother, were not much to look at—little pointed faces, grey eyes and straight dark hair. To make me shine was my mother's art.

Mrs. Coughanour's school was run on the sugarplum system. Though this was way back in the early 1880's, Mrs. Coughanour held the very advanced theory that if all the little girls knew only love and were given everything they wanted, they would all be good. If I remember aright, it worked out somewhat as she expected.

It was some time before I had occasion to distinguish myself in mathematics, but for years I treasured the book of fairy tales I won by reciting the multiplication tables. For days it had been held before me as a delicious tidbit that I was going to be given an examination in arithmetic. When the day came and I was safely seated in Mrs. Coughanour's lap, the conditions were laid down. To win the prize—there were no other contestants—I was to say the ten tables up to ten times and must not make more than six mistakes in each table. I won, but I cannot remember with what margin!

After Mrs. Coughanour gave up her school I went to the Convent of the Ursuline Nuns, where I said "Hail, Marys" most of the day and played in French at recess, learning a few phrases. The first that penetrated my conciousness was, "Prenez garde, mes enfants."

Far from believing in co-education, my father would say, "If any man will let his daughter go to school with my son, I will be very happy, but my daughters shall not play rough-and-tumble with other people's sons." It was, I think, a question of manners, and he filled out with tales, books and games any information I did not get at these far from strenuous schools.

We often played in Turtle Creek, taken there Sunday afternoons by our young parents. I suppose it was near our home, but it seemed a long and dusty walk. Turtle Creek was a miniature canyon—just a trickling stream at the bottom of a deep, steep-walled gully with rocky sides.

All pleasure was doubled when my father was there. He was a lawyer and went downtown to his office every morning. In the summertime before he left, we would walk together over his vineyard and orchard. Just before putting on his hat and leaving home for downtown, he would take his large pruning knife from his pocket and lay it in front of the clock on the mantelpiece. I think he did it as a certain ostentation as he looked towards my brother and said, "It is better to be killed than to kill a man." This was in the days when it was an everyday affair to have a fight in the routine manner. I first heard that "discretion is the

better part of valor'' when Colonel Obenchair was laughing at the heavyweight my slim father had selected as an opponent. Having been a captain of artillery in the Civil War, and though he had won great applause as a soldier, he was at heart a pacifist.

When the day was over we watched for his coming home and went down the road to meet him. My father was not always indulgent, but sometimes very severe. Once, when he had decided my brother needed a whipping, he sent me for the switch. Having but one idea, that I must execute the commission as well as in me lay, I chose a very good switch, tough, long and keen. I remember his look when I handed him the superb weapon. I said it was a pity that he did not feel privileged to let me have a taste of it myself.

When on a dare I walked through the hot ashes of burnt leaves and burned my legs badly up to my knees, he was more disgusted with my stupidity than sympathetic.

He and my mother must have been a little bored by games with children, for they were very severe about our bedtime. My father would read long into the night and around the sofa next morning we would find books by Théophile Gautier and other French books.

Young lady cousins would come out from Alabama to see us and stay a year at a time, and that would mean fun for us all. And every Sunday afternoon people would drive out to see us.

It wasn't all fun like that. The new milkman passed one day and my mother was unaccountably caught up in a conversation with him. When she turned from him towards the house there were tears in her eyes, and in a kind of explanation she said he was Will Elmore. How surprised she was to see him driving a milk cart instead of his own phaeton.

Another day I remember coming home and finding my mother, with tears on her cheeks, talking to a negro man who, they told me, was my father's old body servant who had been with him till the end of the Civil War. That was after my father's death. Borky often came back to see her, and my mother had for him a deep affection. Though so witty and amusing, my mother was capable of the deepest emotion. Wit and depth of nature go together.

My father had a vineyard and orchard in the big lot that ran back of our house all the way to Cedar Springs Road. He planted there every vine that he had heard or read of that could be found by his nurseryman. Also, every one whose name fitted those of the children in the neighborhood—the Herman and the Anna, the Walker and the Lucia. I wonder if a few were not rebaptised right there in the vineyard! In the orchard were apricots, almond trees, nectarines and fig trees, as well as such staid things as peach, pear and apple trees. When, in the summer, all these trees and vines were bearing—and with the great care my father gave them, most of them really did bear—my mother would pile the fruit high on the table, around the tall epergnes, brought from Alabama, making a picture of this as she did of her daughter. All Dallas (which was not much of a crowd, after all) would drive out to see us. I remember chiefly young men who laughed. Dallas was full of adventurous young people. Everybody came from somewhere else. There was always at the gate a cluster of light-wheeled buggies and long-limbed trotting horses. There would be drinks and talk that was as thrilling to us children as a game of keeno of our own with Papa as banker.

Though we had our own strange, mysterious fears and sorrows belonging to childhood, these were happy days that could not last forever.

18

When we were left alone, out there in Texas, the family sent for us to come back to Alabama, and did all they could to make us happy—not for a little while only, but always, even down to this day, those that are left of them. But children without their parents feel they have no right to be in the world.

That journey back to Alabama was a trip to another planet. Our cousin, Joe Gayle, a young man of twenty-four, came for us. Our mother had left us to him as wards, thinking our uncles might die before we were grown, but that he, so young, would see us through. It was night when he took us away from our Texas home and, looking back as we drove off, I caught a glimpse of our sitting room brightly lighted and in the center of the light Papa's big armchair, vermilion shot with a gold design, a rather gay picture to carry away with us.

When we came to the Mississippi, it was night again. In fact, I do not remember that it was ever day. Always night, with bright pictures picked out of the darkness by the lights of the train, and later of the boats.

There was a great flood and the waters of the Mississippi had spread over the country for miles beyond both its banks. We could not reach New Orleans at all and had to take a river boat, fighting our way against the big river for miles to find a landing on its eastern bank. We did not know where we were—nor cared; only we were on a boat and could see the heavy water swirling about us when it caught the light. We were not afraid. As Cousin Joe was at ease, so were we without fear too.

At first there were many boats and much confusion about us. Then we pulled out and were up the river, alone in the dark. We stopped at many little piers and our searchlights picked out pictures of white houses, landings with summer houses about to float away, cabins swimming down the stream.

I believe we journeyed all night, and I cannot remember how we got off the boat and made our way to Alabama.

It must have seemed strange and burdensome when our young guardian found himself with those four children to look after, even though we had enough money to pay our way after a fashion. Though a debonair young man, he was good and patient with us and took care of our little money the best he could. I felt that he belonged to me more than anybody left in the world. How it happened I never understood, that this lighthearted boy should sink into melancholia. He was finally sent to a sanitarium, and we never saw him again.

Cousin Joe and his father and brother belonged to a firm of cotton factors and cotton warehouse owners. They were highly intelligent and honorable men. When it was finally seen that Cousin Joe could not take care of us, they sent for me and told me that we ought now to be considered the wards of the Probate Court of Dallas County (Texas), but that the charges the Court would bring against the estate for administering it would be so large that most of our small fortune might disappear. Therefore, though it would be illegal, they had decided to continue to look after our affairs as Joe had done and say nothing of his disability. They said that when we were grown we could probably collect from them every dollar they would have disbursed for us, but that they had no idea we would ever try to recover anything, that that was all, and that I might go home. I probably said nothing in reply, but my heart almost burst with gratitude that they should be so concerned with the interests of such small mites. They continued to collect our income and pay our bills till my youngest sister was twenty-one.

To make it easy for Marks & Gayle, it was arranged that my bills were to be paid once a year, even my washing, no matter how many white dresses I wore a week. "Aunt Sophie," who lived on the Old Arrington Plantation, was paid for them all—a flat sum—on the first of January. I had no cash except when Aunt Molly, at strategic points, would give me a five dollar bill. This was not at all embarassing as none of my companions, no matter how well off, had money in their purses. We carried no handbags and left our small purses home in the top bureau drawer. As I look back, we all lived in comfortable or luxurious homes. But we did not go to the drugstore for a soda. We sent a little darky boy (there was one attached to every household) to the grocery store for ginger ale or a Washington with a "Tell them to charge it." We needed no carfare for everybody had a horse and phaeton or dog cart. In New York now even the children of families on relief have more cash than we had. When I try to help by having a little girl pose an hour for me, the half dollar she gets is spent on trash before she gets home with it. This lack of small change should have had some effect on my views on finance, but I have never quite decided what that effect was.

I was one more added to Aunt Molly's family of six sons, three daughters and a brother-in-law—and her husband, of course. Uncle Tom Arrington was judge of the City Court, and with his salary and plantations and Aunt Molly's own income, we lived in plenty in a large and loose but dignified style.

MONTGOMERY—END OF THE CENTURY. After the death of our parents I was always troubled about money. I heard so much of hard times and depression in Texas, where we had our real estate, that I could not believe our income would hold out. When financial conditions were talked of, I listened closely, but did not know, with that deep ignorance of childhood, how to ask questions whose answers might shed light on our financial condition. I felt weighed down with responsibility for my brother and sisters, with no way to discharge that responsibility. Probably it was not apparent, but I always carried a load of melancholy that I could feel tangibly pressing on my heart, especially if I went off to have a good time on some cotton plantation. The night was so sad it was almost unendurable. I would have liked to find some way to earn my living, but no such idea was spoken of and there seemed nothing to do but grow up and be a "young lady." And of course I might get married.

When I was eighteen I came out with a reception and dance, just as my older cousin Olivia had done. Aunt Molly saw that I had everything like Olivia. There was nothing to do but to get invited to as many parties as possible and work hard to attract what beaux we could. No doubt the end was to be matrimony, and though I often thought of it as a solution to my problems, I saw after a winter or two that to make both ends meet—the man I liked and the man who liked me—was not very easy. I was brought up to believe that matrimony was the desired end of a woman's life and a woman's career. My Aunt Molly's favorite quotation (quoted ceaselessly) was, "Gather ye rosebuds while ye may," adding, "It is not I, but the dear old bishop who says, 'It is better to marry badly than not at all'." But one summer, being home on a vacation from my New York studies, I asked Aunt Molly, while she worked among her rosebushes, why she had not of late urged me to gather rosebuds. "You are twenty-three years old, and a girl doesn't have many chances after that age." As Aunt Molly was so wise in the ways of the world, I took to art as a serious career and abandoned matrimony.

Anne wandered the town freely, going wherever life looked different and bizarre. She would show up at the blacksmith shop in Boguehomme or down on Monroe Street where throngs of negro cotton-hands fried their catfish in buckets at the noon hour. When she began to sketch these things Aunt Molly decided, ''The child has talent,'' and promised to send her to New York and Paris for training.

At about this time Uncle Henry Goldthwaite came down for a visit. To me Uncle Henry seemed rich, and for a bachelor in those days he certainly had enough money. He went to England to buy his clothes every summer and seemed to do what was done by other men about town. Sometimes he felt extremely poor as he was a cotton broker with a seat on the Cotton Exchange, and that implies a precarious life. Perhaps he paid this visit to us in a prosperous moment, for he asked me to go back to New York with him and study art. I thought it a poor idea and told him my talents would seem very thin in New York but, unconvinced, he promised to pay my expenses for 8 or 10 years. He had known many artists and thought my training would take that long, and after that he would see that I painted the President of the United States. Perhaps he might have, as he always seemed to have some political influence. For example, he went to Washington and apparently saved my godfather from being garroted by the Guatemalan Government for having murdered one of their subjects. I have always been proud of the charm and popularity of this godfather—a Randolph of Virginia, though living in Alabama. He was my father's first partner and later was probation judge of Montgomery. Apparently, in an absent-minded moment, he used some $30,000 of the County's money and felt it best to leave. There was always a feeling in the background that he had been badly treated, and when he got into trouble for so small a thing as shooting a Guatemalan, the

Alabama public rose as one man and demanded that Guatemala send him home. When he got there the little matter of the $30,000 was never alluded to, and he could have lived in peace and almost in honor. However, he took a dislike to a certain nephew of his, sending him a warning he would shoot him on sight. His nephew most reluctantly shot first.

So I journeyed back to New York with Uncle Henry who took me to a house arranged especially for students and left me in the charge of two older girls whom he thought sufficiently aged to serve as chaperones—about which he was very careful. That shows how long ago that was. On the way to New York he had tried to protect me with good advice and extended promises and was very kind.

I studied hard and seemed to get on as well as anybody else. My first instructor was Henry McBride who told me to go to the Metropolitan and study the paintings by Henner.

At the first of May we were told suddenly that the house in which we lived was being closed—it evidently didn't pay. Not knowing where to live, I went home. Before leaving, several of us made a plan for renting an apartment and keeping house together the next winter.

The flat was found and furnished by the older half-grown ones and the young and irresponsible were asked not to come until things were going ahead a little. For that reason, I do not know which was the great legal mind who compiled our constitution, but it was a perfect document which took care of every detail of our lives.

We spent $100 for furniture, each paying an equal share. If one of us left the group, she lost all claim to the investment. If the conduct of one was such that she was not wanted, she was thought to have lost. We had a cook, Maggie, who was maid in our former home and was young like the rest of us. If we were at home, we had three meals a day. If we must be away, we were allowed 10 cts. toward lunch downtown.

We girls were very practical with an eye always out for business, and we were very eager to tell each other where one was apt to find some small job. I was sent one day in 1894 to a Mr. Kimball who lived in a beautiful little red brick house on West Eleventh Street, one of a group of houses called Bride's Row. Mr. Kimball was starting in his basement a business that he called the Cheltenham Press. He was very kind when I applied for work, but there seemed to be nothing for me to do. Had I been an etcher, however, he assured me, there would have been unlimited opportunity for me.

I had been in New York scarcely a year and barely knew what an etcher was, but Mr. Kimball was enterprising and decided to make an etcher of me then and there. He had a large flat book on etching by Lalanne. This he would read to me while I, with etching ground, roller and needle, would try to follow Lalanne's instructions. The book was an English translation, and I might have read it myself to better advantage, but for some mysterious reason this did not seem permissible.

The real advantage of my connection with Mr. Kimball was that he supplied the plates and the services of his printer, John Ridley. Slowly it came to me that John Ridley was a printer of engraved plates, visiting cards, invitations, etc., and that I might do better at Kunmel & Voight's, real printers of etchings.

There was an obstacle, however. Young Voight who did the printing was afraid of women, so I must be kept in the office and never speak to him. I could learn nothing from him nor give any instructions as I had hoped.

I was very canny and never asked to see the printing rooms, and to reward my good behavior, middle-aged Mr. Kunmel and old Mr. Voight would give me, one at a time, trial proofs of plates by Swain Gifford, William Pratt, Zorn and Whistler. These were unsigned, and I was sworn never to show them.

One day young Voight came into the room where I waited. He was looking for something that must have been extremely important. He came in sidewise with his face averted, but I didn't budge and seemed absorbed in things outside the window. It took only that one glimpse to break the ice and on my next visit I was shown into the printing room.

Young Voight added freely to my unsigned collection. He told me not to believe it when told that such and such an etcher did his own printing, that the truth was that the etcher had stood around and waited for Voight to do the inking and had waved a gauge perhaps after his wiping.

I had a press given me by my sister Lucy who had a librarian's salary. I could have printed well if somebody had only turned the heavy wheel. But I decided later I had best pull my prints as they did at Kunmel & Voight's.

While still struggling to be an etcher, the news came to me that there existed such things as etching classes. I heard of one notable class at the Academy. I went at once to the Academy on One Hundred and Ninth Street and was admitted after some difficulty and after submitting several drawings from life. Frank Mielatz was the careful and brilliant instructor. He criticized my work seriously and made no difference between me and the young men in his class, except that when we went into the park to draw from nature, he and I walked together ahead, and the men and boys straggled behind.

Then came a great event! Mr. Mielatz asked four of the students to bring him their portfolios the next Saturday—Zimmerman (Zim), Eddie Shole, Arronson and me.

The New York Water Color Society was to hold an exhibition where for the first time in many years etchings were to be included. Mr. Mielatz told us there was probably no chance that we could get in, the jury was so severe and we were not good, but he would take our work down, though it was rather hard on him to submit such things.

Before long the three men knew they were in, as they each received an invitation to the stag dinner. But what about me? I couldn't go to the stag dinner. Should there not have been some notice sent me if my prints had been accepted?

The stag dinner was on a Friday night, and at seven o'clock Saturday morning (perhaps on his way home from the party), Arronson rang our bell to tell me that my four prints hung with the others! I shall remember him always for that thoughtfulness.

That was perhaps the greatest or most unexpected event of my life. What I had been thinking I do not know, but I'm sure I had never really expected to hang with serious artists in that Fine Arts Building. After that nothing seemed impossible to me. However, nothing ever gave me the same pleasure. With comparative indifference I have seen my canvases in the Paris Salons, in Venice, at the Academy, and bought by the Metropolitan and the Museum of Modern Art.

This summer, the year of the New York World's Fair, I am hung in the "Three Hundred Years of American Life" exhibition. My *Waiting on Tenth Street,* a painting of a tired old horse and buggy in the rain waiting for a fare, hung as the last moment of the three hundred years. When I saw my little canvas so beautifully

placed, I felt something of the surprised pleasure of my first appearance in the Art World.

One day I went for an important journey to Princeton by bicycle and by train. A friend who was abroad for the summer had asked me to go down to see her three old aunts who would be lonely without her. I went for the day, but they were so glad to see me, they begged me to spend the summer in Nellie's place.

When I consented to stay a while, one of the ladies ran over to their near neighbor's to say there need be no more anxiety about them, as a young girl from Alabama had come to stay with them. These neighbors were the Woodrow Wilsons who, thinking that I in my turn might be lonely, invited me over on many evenings to eat fried chicken and other good southern dishes.

After supper, Mrs. Wilson, her three daughters, and I would sit on the veranda and listen to Professor Wilson—this was the summer before his election to the Presidency of Princeton—scarcely speaking a word ourselves. Such talk as we heard! I have listened to wonderful conversation but to none more brilliant than his. He would speak of art and literature, of the art of eloquence and the pleasure of winning a difficult audience.

He told me of one of my mother's forebears, Speaker Robinson of Virginia's First House of Burgesses, whom he called the "most elegant figure in American history." It was Speaker Robinson who said to Washington, back from the French and Indian War, "You may sit down, Mr. Washington. Your modesty is only exceeded by your valor." I had known of him, as we still have somewhere in the family his silver casters and some tablespoons. I think my spoons of that period marked *R* and very much worn, were his.

These after-supper talks at the Wilsons are very vivid in my mind. I remember well Mrs. Wilson's charm, her red hair, her arched eyebrows which she deplored because she considered them too conventionally pretty. I remember too her boundless pride in her husband, and her radiance as she sat quietly, watching him, listening eagerly as he spoke. Professor Wilson was ugly, but with an interesting sort of ugliness. His manner was warm and kindly, and without the least condescension, he adjusted his conversation to the experience and understanding of a young visitor from Alabama!

The next winter Mrs. Wilson and Mrs. Howe came up from Princeton to New York to have me paint a small portrait of the former. This was my first portrait commission, and I was overcome with anxiety lest they waste their carfare, and their time. That portrait must have been a poor thing, but it was the best I could do. If Mrs. Wilson was not pleased with it, I never knew.

Paris—1906. After six years in New York at the National Academy of Design, I came to Paris after a little trip through Germany and went straight to Mrs. Whitelaw Reid's Club for American girls in the rue de Chevreuse. It was a charming place, supposedly the hotel of the Duchesse de Chevreuse, a friend of Anne of Austria, and I have no reason to believe it is not true. It was a very old house, built around a wide courtyard. On one side was an opening to an underground passage leading, it was said, to the Palais de Luxembourg. At any rate it started off in that direction before losing itself in darkness.

The Club was full of interesting young women. There I met Frances Thomason, very handsome and an *arrivée*. Artists are very good to young students, and she took me under her wing to show me the ways of Paris. One

afternoon she took me to the Luxembourg Gardens to sketch. I was painting on an insignificant thumbnail panel when she called me over to meet a large, dark woman with whom she was talking, and who looked something like an immense dark-brown egg. She wore, wrapped tightly around her, a brown garment like a kimono, a large, flat black hat and stood on feet covered with wide sandals. "Miss Stein wants us to go home with her for tea," Miss Thomason said. Looking at her dreary clothes which suggested abject poverty to me, I wondered whether we should accept the invitation, whether she could afford to divide her tea with us.

It was not far to the rue Fleurus, and as we walked past the concierge's cage, Miss Stein ordered tea to be served for three. Across a little pebbled court we went into a beautiful large studio filled with antique Italian furniture. The walls were covered with the most remarkable pictures I had ever seen. I knew that they must be pictures because they were framed and hanging on the wall. Before we sat down Miss Stein and Miss Thomason asked me what I thought of them. I knew they were stringing me and answered that in that light I could not judge them very well. They then made me mount the long refectory table that ran down the middle of the studio, and I walked up and down, trying to decide what to say. I need not describe the paintings as we have all seen them many times since then. There was a head that I know now was by Picasso, looking like a design made of the backbones of fish; The *Joie de Vivre* by Matisse; a small gray canvas by Cezanné; and a yellow nude on a peach-colored background, the feet hanging down as in an Ascension. It is the only painting I remember seeing that day whose creator I do not now know. It may have been the only mistake made by Leo and Gertrude Stein. This was my introduction to what we now call Modern Art, made some six days after my arrival in Paris. During the next two or three years, it was with surprise that I met American students who had never heard the names of Matisse, Picasso, etc., and had never heard of *l'Art Moderne* or, if they had, thought it completely negligible.

As tea was quickly brought in by the concierge, Miss Stein and Miss Thomason let me come down from the table without committing myself too far, probably not interested anyway in my callow opinion. We had a most ample tea and the most delightful conversation. Miss Stein spoke of her writing and how she listened for her words to come in the darkness of the night. She and Tommy had a stiff argument about the value of the paintings at the Louvre (a favorite theme in those days), and always about painting she would say, "I know nothing about it. I only quote my brothers, Mike and Leo." I remember especially how clear and profound I thought her opinions. She was witty, too, and I classed her with Woodrow Wilson and a few others I can think of as brilliant talkers.

I have been back to Gertrude Stein's studio many times since, but never have I found her in the mood of that afternoon. I wonder if Matisse and Picasso would exist as the artists we now know, had it not been for the Steins. Applause and money were necessary to develop from obscurity their brilliant qualities. Not only did the Steins praise and buy their pictures, but it was through them that the Cones of Baltimore, distant cousins, bought generously from the French modernists.

PARIS—1910. My life in Paris centered around what was known collectively as the American Girls' Club, at 4 rue de Chevreuse. I was content that it should be so, though many of my friends thought that they were not "living" unless they

ate at the Chat Noir on the rue Odessa, or at least Boudet's Le Duc's. But the food at the Club was much better, and I found little satisfaction in attempting to sit with young men at restaurants. My life was serious enough for me to take it as I found it and not play that I was living in Bohemia. After what seemed to me a good dinner at the Club, a group of us usually went to a café—L'Avenues to hear Shumaker play his violin, or to the Closerie des Lilas or even to the Bal Berlin. We almost never went to the Dome. To sit sometimes on the *terrasse* in summer was as far as we went in that direction. There was a tacit agreement between the American men and the American women—that they might have one place to themselves beyond the view of their own countrywomen. We would hear of German, Russian, Italian or even English women strolling in and out of the Dome, but no American woman entered.

I had two friends, Miss Mars and Miss Squires, who were habituées of L'Avenues. I will not describe them since Gertrude Stein has written their portraits in "Miss Furr and Miss Skene," and I refer you to that. As I understand it, she did not go into this part, so it may not be amiss for me to say that when I first met them we were all new to Paris, having lived there only a month or so. They were nice Middle Western girls in tight, plain gray tailor-made suits, with a certain primness. This was in September. By May you would never have thought they came from Springfield, Indiana. Miss Mars had acquired flaming orange hair and both were powdered and rouged with black around the eyes until you could scarcely tell whether you looked at a face or a mask. The ensemble turned out to be very handsome, and their conversation, in public that is, became bloodcurdling. I went often with them to the café where they preempted seats in the best corner, never drank but one *café crême* for eight sous and gave two sous *pourboire*. They paid their debts and in private led exemplary lives. I hope they will never read this last statement, as they would think I was offering them an insult—breaking down the legend they had laboriously built up!

Since I first saw Marguerite Zorach, she too has undergone a transformation. In our early Paris days she was Marguerite Thompson, and she also wore her tight little New England tailored suit over her slim form. But she moved in a circle that wrote and published a magazine called *Rhythm.* Her gray suit became a bit more flowing each day and her blouse a little brighter blue, and by the time I met her back in New York, married to Bill Zorach and the mother of Tessim and Dahlov, you could have sworn she was a true Mother of Israel. But, in whatever style they were dressing, I have never known three finer and more attractive women.

Though our lives were somewhat exemplary, we knew all that went on around us. I was fairly intimate with several models, but it was not from them that we learned. The Club, now Reid Hall, has changed very much for the worse since then. Thank God for its beauty and liberty, as it was in my day. Jean Moffatt was the Directress, for it was not a club at all, but a glorified *pension* for American women art students. We paid little board but lived in the midst of luxury and romance. The tiled floors and mansard windows added a zest to the warmth of the living rooms, and there were good bathrooms with plenty of boiling water. Miss Moffatt ordered everything in the grand manner. Her morals were of the strictist, but she disguised the fact with so much splendor of living that everybody desired an entree to the Club and if their lives were irregular, they tried to conceal their waywardness that they might be invited to Thanksgiving dinner. All Miss Moffatt's gowns came from the best French designers, and the

chairs of crimson satin were hired for one of those Thanksgiving dinners at a cost of $60 for the evening.

As Anne's Paris years passed she participated in the mild Victorian bohemianism of Montparnasse, but also saw Diaghilev's Russian Ballet, saw Nijinsky dance as well as Isadora Duncan, heard Harold Bauer's concerts and made many good friends. Among them was David Rosen who had a class made up mostly of American women whom he conducted during more than one summer to Ile-aux-Moines in the Oise country on sketching trips. Among Anne's etchings and drypoints done while in France between 1907 and 1913 were a number done while attending his summer classes.

Another good friend was Elizabeth Duncan, Isadora's sister, through whom she met the many dancers whom she sketched in all of twenty-three different etchings and drypoints. With David Rosen's help she became one of the organizers of the Académie Moderne. A small group of young artists agreed to meet regularly asking Charles Guérin to serve as critic of their efforts. They held an exhibition each spring, and then the best of the work would be shown at the Autumn Salon. Guérin's friends and colleagues—Pierre Laprade, Albert Marquet and Othon-Friesz—came from time to time to air their views. And so the years passed—seven altogether before the threat of World War I drove Anne home in 1913. Her reactions to the change in atmosphere for an artist are of interest. She has written:

> I found that the great difference between the life of an art student here and in Paris is that in New York nobody is conscious of the fact that such individuals exist, nobody thinks of them as a class; each student is seen as a strange person who happened to go astray in a labyrinth called art. In Paris, on the other hand, they are a class whose existence is acknowledged as important and scarcely abnormal.

Therefore upon returning to New York important adjustments were necessary.

POP HART. I think in general artists must live by their own efforts. Few painters can live by the sale of their pictures. There are spectacular exceptions to this rule and each student expects to be the exception. In New York in 1914 there were about 10,000 art students and two or three hundred painters of sufficient reputation to be included in current exhibitions. Of these, 2 percent sold enough paintings to keep alive. However, not all artists are poor. A very few have private fortunes, big or little, and many more make a living by some other work, perhaps closely connected with art—mostly by teaching. And some have the art of living on so little that even the sale of a few paintings will cover their needs. But to live so is a work in itself. The painter is not as free as the poet. Villon could take to the road, but a painter has responsibilities he cannot shirk. He is no longer free when he has painted his first canvas. He must take care of that painting. He loves it and must protect it. He needs a studio and money for rent! Pop Hart was eloquent on the subject of a solution to these problems. I must have known Pop Hart for years, but now it seems that I knew him first in New Orleans as he passed through there

on his way to Mexico. For some years he spent his winters in Mexico, protesting that he found it easier and cheaper than struggling with the cold and discomfort of this region of New York. He found it (or had an idea that it was) good publicity to say that he had an Indian wife, and every year, not being too versatile, he would get a story into some New York newspaper describing his life in Mexico with this native wife, who later seemed nonexistent.

Tiring of these trips to Mexico, where he had done beautiful work, he thought he had worked out a way of life for an artist when he moved to Coytsville, New Jersey. I think he bought his house there. From the looks of it, almost anybody could have afforded it. One day my sister and I went out to see him. He received us royally—met us at Fort Lee, paid our carfare to Coytsville, and took us to his two-room shanty. There were many canvases and water colors and drawings around the studio baseboard, but we had not been asked out to see these and paid them no attention. The burning question was how one could live on what one made and have a little time left over to make a little more money to begin to live again. Pop wanted to show us the scene of his future and his disappointment. He believed that in his own house, living alone, he could simplify life and have time for "his work." (All artists speak of "my work" with solemnity). He had planned to have a loaf of bread on a nail in the wall and when hungry to whack off a slice. An egg would give variety and an apple from a neighbor's tree would supply the important fresh fruit vitamin content. But things hadn't worked out that way. He had to build a fire to cook the egg, and even so, he felt insufficiently nourished. He felt impelled to find and cook a good deal more than he had planned, and as winter approached he had to consider keeping himself warm. From morning to night he was drawing water and lugging wood, with no time for "his work." He wanted us to see with our own eyes that should he abandon the simple life and come to live on West Eleventh Street, Manhattan, he had been forced to do so. He took us to a fine dinner at a roadside restaurant and confessed that he had to go there often.

Pop did move to Eleventh Street and (whether coincidentally or not) his fortunes improved. Mrs. Sterner gave him an exhibition at her West 57th Street Gallery. He came to see me one day while I was having a much less successful exhibition of prints across the street. . . . He was a little dazed by what he had just seen at his own show—thirteen red stars, one on each of his thirteen paintings. He could scarcely believe it—all were sold.

After that, I think Pop had no more financial troubles. [The Downtown Gallery managed his affairs after Anne had recommended him to Edith Halpert.] No more necessity for a loaf of bread nailed to the kitchen wall! Trips to Paris where he could sit on the *terrasse* in front of the Dome. But that was towards the end of his life and, though riches for him, I do not suppose his income would have spelled money for any but a lone painter.

Unlike Pop Hart, Anne lived well in New York after her return from Paris and after her adjustment to these differences. After 1921, she had her salary from The Art Students League. There were some few times when she had to resort to what are called "potboilers"—doing etchings to order of different New York churches or some book plates for a friend or even drypoints of pet dogs or polo or golf games. But just as Pop Hart had Edith Halpert of the Downtown Gallery to manage the sale of his work, for at least five

28

years she did the same for Anne between 1929 and 1934. However, one of her first New York print exhibitions after her return from Paris was at the Brummer Gallery in 1921. As early as 1915, she painted a portrait of Joseph Brummer, which was bought by Miss Etta Cone for the Cone Collection later.

She received many commissions for portraits. Among them was one of Kate Wehle who was the wife of Harry Wehle, the distinguished curator of paintings at the Metropolitan Museum in New York. He was an enthusiastic admirer of her abilities as is recognized by his comments published in the memorial exhibition catalogue at M. Knoedler's shortly after Anne's death. In that same catalogue, Holger Cahill wrote an equally appreciative review. As one of the organizers and directors of the W.P.A., he could compare her work with that of thousands of others profiting by work under his direction.

It was Holger Cahill who saw that she was given the opportunity to paint two murals under the Section of Fine Arts of the Federal Works Agency of which he was in charge. Both were painted in post offices in Alabama—one at Atmore, which she entitled *The Letter Box,* and the other at Tuskegee, called *Tuskegee Landscape.* Both were installed during 1937-38 and were very fine examples of her native style.

During her last years she enjoyed working with her friend, David Rosen, with whom she had been on sketching trips to Brittany while abroad before 1913. David Rosen had become a most distinguished conservator of paintings in a number of our foremost art museums. Anne did some inpainting on European old master paintings under his guidance. I visited them at the Philadelphia Museum of Art and was deeply impressed by Anne's remarkable color sense that made it possible for her to match colors absolutely. She enjoyed the work and found it both interesting and rewarding. She always enjoyed visiting art museums and in 1920 and 1921 she completed a group of etchings and drypoints of early Renaissance sculpture at The Metropolitan Museum.

PARIS—1913. Boulton and Francis Jones were great figures about this time. They were certainly charming gentlemen, as were so many of their contemporaries who were Academicians. I had studied with Francis at the National Academy. I thought he showed me especial courtesy, making a little fun of my mistakes as a friend might do and talking about indifferent things on the side. When I thought of coming back from France I counted on him as at least an adviser. I had been exhibiting in all the salons and felt that I was not so altogether out of the running. I couldn't expect such treatment as had welcomed Leon Kroll (who had a scholarship from the Academy). He was given, quite rightly, the Academy Room for his show, his pictures were welcomed, and he was made an Associate almost immediately. Such, I knew, was not for me, though I by no means looked up to him. But I was presumptuous enough to go to see Mr. Jones on his day at the school of the Academy. I told him I was back and asked him what I should do next. I thought he might say, "Be sure to send to the next exhibition" and he would look out for my canvas, as was the custom in Paris. (How often I had been pushed ahead in Paris.) That, and more, is expected from one's *"chère maître"* in Paris.

Study for WPA mural *The Letter Box,* Atmore Post Office, Atmore, Alabama

Study for WPA mural *Tuskegee Landscape,* Tuskegee Post Office, Tuskegee, Alabama

Mr. Jones seemed glad to see me, asking about my work, but as to advice about exhibiting, told me there was a women's society to which my work would be very well suited. I took his advice and when invited, almost immediately, I became a member of the National Society of Women Painters and Sculptors. I will always remember their hospitality and the prize that they awarded me.

However, I sent to the Academy as well and must admit that I was never refused. But they hung me so high, and I believed my pictures looked so badly reflecting the blue-grey of the skylight, that I sent only during two or three years. No doubt I was wrong to discontinue and should have persisted until they had grown familiar and so kinder to me. I might now be an Academician, which would be something if I had it. Not having it, I think nothing of it.

Anne came back from Paris during the summer of 1913. She meant to go back to France after a few months of seeing her family and friends in and around Montgomery, but she got so many commissions to paint portraits that she stayed on for some months. Then, after seeing people and dealers in New York, the War started which kept her stranded in New York.

The first winter I was back in New York Mrs. Harold Bauer brought Katherine Dreier to see me. With her habitual generosity and interest in all forms of art, Katherine invited me to come to her place at Redding, Connecticut and to paint her portrait. I had already been to Saranac Lake to paint a portrait of her sister Dorothea Dreier. Katherine was one of the easiest people to paint a portrait for I have ever known. I had scarcely begun her portrait before she thought it finished and very satisfactory. It looked something like Marie de Medici, and that she thought amusing. She urged me to stay longer and paint the country around Redding which I was glad to do. I turned one end of the barn into a studio where I worked part of the time. One or two of Mrs. Dreier's guests were always strolling out to watch me work. I remember vividly a very heated discussion with one guest, a Mr. Merkle.

I had not been back from Paris long, and whenever I had shown my work I had been called a modernist. This was a great surprise to me, for I knew I was painting, not according to any school, but according to the way I saw my subject. Perhaps I *was* modern, but if it were true, I was so innately and not by conscious effort. Mr. Merkle, assuming that I was a member of Katherine's Société Anonyme, jumped into a deprecation of the modernist's idea that subject-content is of no importance. He insisted that no matter how beautifully I painted the barn door, through which at that moment a good north light was streaming down on my canvas, I could never make it hold any interest for him. On the other hand, he declared if I chose a mother and child for subject, I would claim his interest right off. I protested that I had no intention of trying to make a barn door interesting, that this was not in the least what I wanted to do. Later he wrote me a letter of apology, saying that he had seen more of my work and that he realized he had made a mistake in cataloguing me with the modernists. It was an amusing incident and one that was repeated often in those years when the French modernists were astonishing and setting art critics and art lovers on their ears. Though I was constantly being pigeonholed and attacked, I never really got over being surprised each time it occurred.

Anne had returned in time to see the 1913 Armory exhibition. She had heard about it well beforehand in Paris and arranged to send two landscape paintings to it since her sister Lucille had visited her and offered to carry them back with her and deliver them in time, which she did.

She spent almost every summer after her return from Paris in Montgomery with her family. She felt completely at home there and loved the sunshine and the heat. In her walks around the town and the surrounding country she found a deserted brick kiln. From it she took clay and with it made a number of very characterful small negro heads measuring about 6 or 8 inches in height as well as some small seated figures. After they were fired, she glazed them so that they resembled brown bronze sculpture and were quite durable. Each was an individual portrait and was given a name. They seemed to have helped her in the constructing of her painted portraits.

In 1915 she won national recognition by winning the McMillan landscape prize given by the National Association of Women Painters and Sculptors and during that same year a bronze metal for an etching at the Pan-Pacific Exposition in San Francisco. In the fall of 1921 she started teaching morning and afternoon painting classes at the Art Students League, including Saturday classes for students from six years old to sixty. Also, beginning in 1921, she held exhibitions of her prints—one at the Brummer Gallery in New York. Mr. Brummer had the foremost gallery selling Medieval and Renaissance objects of the highest quality to art museums throughout our country. To have set aside space for Anne's prints was surely a generous gesture. He even wrote a short introduction to the catalogue of her work in oils, watercolors and prints held at his gallery as follows:

In her prints we see the quiet badinage of a gay-spirited philosopher whose gentle wisdom could only stem from wise generations back of her. . . . Hers is the lightness of touch of the well-bred Old South, with the disenchanted wisdom of Paris added.

Few American painters have produced as much graphic art spread out over as many years as Anne Goldthwaite. Prints took much of her time between portrait commissions and charming figure compositions as well as landscapes. She was for some time the chairman of The American Printmakers and showed in many of their annual exhibitions as well as at Korner & Wood Co. in Cleveland, and at the Downtown Gallery between 1929 and 1936, and at a number of our art museums, such as the Corcoran Gallery in Washington and at the Syracuse Museum. After her death in 1944, a Memorial Exhibition of her works in all media was held at M. Knoedler and Co., in New York. In the catalogue of that exhibition, Holger Cahill wrote an essay in which he commented that during her mature years she was recognized as one of the two or three leading women painters in this country and as the leading painter of the South. He also stressed that she is best known for her compositions of women

and children and for landscape and genre paintings of her native state. He also
wrote:

> No one could record better than she the blazing summer sunlight on the rich
> vegetation of the black belt, Negroes playing or working in the fields, the look of
> a market square filled with mule teams and cotton wagons.

In all of her work she achieved that rare quality called style. It proved
to be a very individual style, evoking the very spirit of the South vividly and
eloquently. I know of no other artist of her time, or since then, who has so
sensitively portrayed the hot, sunny fields, the glittering bayous and the life
of the black people as truly, with as clear a vision and with as much vigor of
touch and spontaneity of handling as she has given us. I agree so thoroughly
with Harry Wehle, who was for many years the curator of paintings at The
Metropolitan Museum of Art and a close friend of Anne, that I would like in
closing to give you the main part of his Foreword to the Catalogue of the
Memorial Exhibition which has long been out of print:

> When Anne Goldthwaite spoke, and she was particularly fond of conversation,
> her acquaintances could count on her utterances being pithy. Her ideas were well
> balanced and mellow, and at the same time hospitable to what was new. The
> language she used was simplified to a degree which sometimes surprised people
> meeting her for the first time. But her simplicity of speech can have been no acci-
> dent. It must have been arrived at by a process of long-continued self-discipline,
> unconscious probably, in which an arrived point of view about things in general
> achieved a civilized sort of wit and pungency conveyed in forms of abbreviated
> understatement.
>
> Since she was a well integrated personality her painting was the counterpart
> of her conversation. From almost everything she drew or painted there emanates
> a breath of wit, not mere whimsy but a wiser sort of gaiety which looks with
> more than tolerance into the hearts of her sitters, whether they be judges, minis-
> ters, little girls, trees, flowers or Alabama mules or Negroes. She knew them all
> and delighted in them, and much of her delicate humor in depicting them is
> actually a function of her pungent, insouciant, elisive [sic] way of painting. Far
> Eastern painters such as Korin found a similar delight in the use of expressive
> shorthand, the prerequisites being effective draughtsmanship and deft painting.
>
> Anne Goldthwaite's subtle, understated color is an outcome apparently of
> sheer good manners. I once had the pleasure of witnessing her effective repainting,
> on request, of a pupil's brightly competent but literal landscape painting. The
> composition and drawing remained almost unaltered but rapid strokes changed
> every color to something choicer, more apposite, better chosen for making the
> picture count as a living organism. She painted with gusto, rapidity, and knowl-
> edge. When she put colors together on her palette she seldom bothered to examine
> the resultant mixture, she knew how it must look and her brush flew to the canvas
> like a loaded bee to the hive. Her requirements for professional paraphernalia
> and facilities were of the barest, and one of her loveliest landscapes was painted
> in a small motorboat crazily rocked by the waves. . . . She used to say that Walter
> Shirlaw taught her more than anyone else, but the years in Paris which followed
> must in fact have meant more to her. At any rate when she returned to New York at
> about the time of World War I, her style was informal but thoroughly informed.

For twenty-three years she shared her knowledge and wisdom with pupils at the Art Students League, and was active on the managing committees of numerous professional organizations. Each year, however, she returned to Alabama, preferring always the blistering months of midsummer when the South presents its most characteristic aspect for the painter. But her subjects were in fact anywhere, everywhere. Nothing could distract her from her interest in paint and her style like herself remained young to the end.

Adelyn D. Breeskin
Senior Curatorial Advisor
20th Century Painting & Sculpture
National Museum of American Art
Smithsonian Institution

March 11, 1982

Abbreviations of Public Collections

In each entry, abbreviations for institutions which follow the list of exhibitions indicate collections in which the print is represented. Specific states of the print, however, are not indicated for each collection.

Baltimore — The Baltimore Museum of Art
Baltimore, Maryland

Boston — Museum of Fine Arts
Boston, Massachusetts

Brooklyn — The Brooklyn Museum
Brooklyn, New York

Chapel Hill — The Ackland Art Museum
The University of North Carolina at Chapel Hill
Chapel Hill, North Carolina

Cleveland — The Cleveland Museum of Art
Cleveland, Ohio

Honolulu — Honolulu Academy of Arts
Honolulu, Hawaii

Library of Congress — The Library of Congress
Washington, D.C.

Los Angeles — Los Angeles County Museum of Art
Los Angeles, California

Metropolitan Museum of Art — The Metropolitan Museum of Art
New York, New York

Museum of Modern Art — The Museum of Modern Art
New York, New York

National Museum of American Art — National Museum of American Art
Washington, D.C.

Newark — The Newark Museum
Newark, New Jersey

Philadelphia — Philadelphia Museum of Art
Philadelphia, Pennsylvania

St. Louis — The St. Louis Art Museum
St. Louis, Missouri

Seattle — Seattle Art Museum
Seattle, Washington

Springfield — Museum of Fine Arts
Springfield, Massachusetts

Wadsworth Atheneum — Wadsworth Atheneum
Hartford, Connecticut

Worcester — Worcester Art Museum
Worcester, Massachusetts

Yale — Yale University Art Gallery
New Haven, Connecticut

Catalogue Raisonné

Height precedes width for all citations of dimensions.

When a print has been commonly known by a title other than that given by the artist, the alternative title is listed in parenthesis below the artist's title.

The listing of institutions following the exhibitions within each catalogue entry represent those that maintain a copy of that print in their collections.
No attempt has been made to identify the state of the print within the individual collections.
The Montgomery Museum of Fine Arts maintains in its collection at least one impression of each print in the catalogue raisonné except catalogue number 245.

Prints which are illustrated in the catalogue are reproduced immediately preceding their catalogue entry.

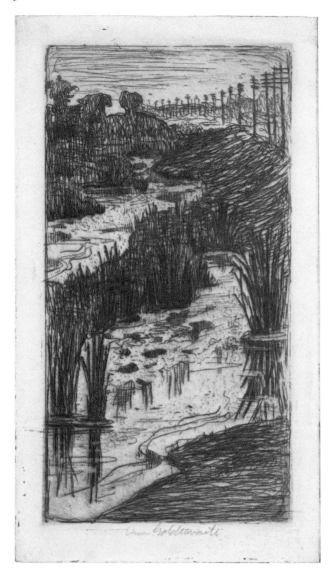

2 Bulrushes (No. 2) c. 1895
Etching
6 ¼ x 3 ½ in. (15.8 x 8.8 cm.)

Only known state: The same rocky stream with the bank at right projecting in three pointed segments. No telegraph poles in background, just trees.

Montgomery Museum of Fine Arts, Montgomery, Alabama, 1982

The artist's sister notes that this scene is a bayou in Alabama.

3 Bookplate of Frederic Harriman Sanford
c. 1895
Etching and engraving
3 ⅜ x 2 ¼ in. (8.6 x 5.7 cm.)

Only known state: Decorative foliage surrounds a helmet above a bull's head. Entwined in foliage a scroll on which is sketched: "Auditur/non/Trahitur." Below is engraved: "Ex Libris/Frederic/Harriman/Sanford."

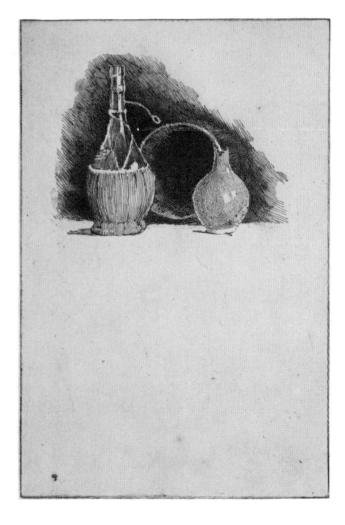

1 Bulrushes (No. 1) c. 1895
Etching
6 ⅛ x 3 ½ in. (15.7 x 8.8 cm.)

Only known state: As illustrated.

Montgomery Museum of Fine Arts, Montgomery, Alabama, 1977 (cat. 9); Montgomery Museum of Fine Arts, Montgomery, Alabama, 1982

According to the artist's sister, this is supposed to be Anne's earliest work. Lucille wrote on the back of one imp., "I believe this is Anne's earliest etching—Lucille." The print is screened to 5 ½ x 2 ⅞; some imps. are in sepia. Attached to one imp. of this print is an engraved bookplate. Under decorative leaves and other insignia is printed: "Ex Libris/ Frederic/Harriman/Sanford."

4 Still Life with Chianti Bottle c. 1901
Etching
8⅞ x 5⅞ in. (22.6 x 15 cm.)

Only known state: As illustrated.

Note in artist's writing: "very early." Done at the Art Academy.

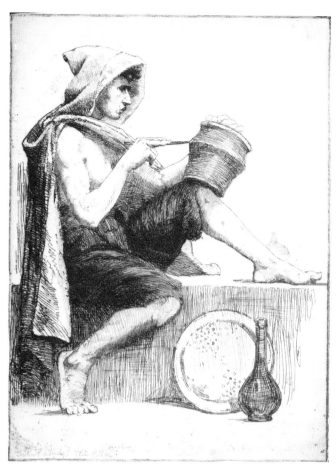

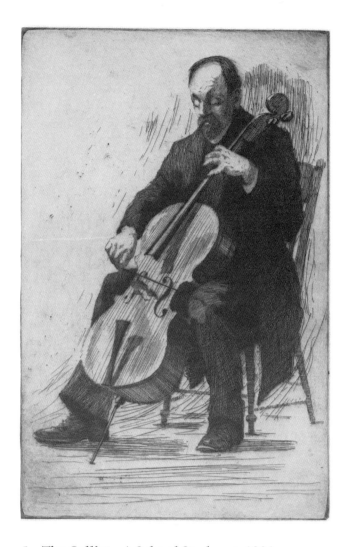

7 The Potter—School Study c. 1902
Etching
11⅞ x 8⅞ in. (30.3 x 22.7 cm.)

First state: With less shading on leg and feet, touched up with conté pencil.

Second state: As illustrated. With dark flecks on lower foot and other corrections.

5 The Cellist—A School Study c. 1901
Etching
8⅞ x 5¾ in. (22.6 x 14.6 cm.)

Only known state: As illustrated.

Philadelphia

On one imp.: "At the Academy" and again: "Earliest work in New York about 1906," but it should be c. 1901.

6 The Shoemaker c. 1902
Etching
8⅞ x 5¾ in. (22.5 x 14.6 cm.)

Only known state: He sits on a stool facing slightly to right and looks down as he hammers.

School work at the Academy, c. 1902.

8 American Indian Model in Class c. 1903
Etching
11⅞ x 8⅞ in. (30.3 x 22.7 cm.)

Only known state: As illustrated.

Montgomery Museum of Fine Arts, Montgomery,
Alabama, 1977 (cat. 1); Montgomery Museum of Fine
Arts, Montgomery, Alabama, 1982

On back: "Early work, about 1903."

9 Portrait of Miss Jennie Kirkman c. 1903
Etching
4⅝ x 2⅞ in. (11.7 x 7.5 cm.)

Only known state: She is seen in profile to right,
wearing a small bonnet on top of her high, curled
pompadour.

*Done on a trip to Paris with Lucille around 1903. One
print only, marked on back: "My first portrait
etching/A.G." Also: "Miss Jennie Kirkman/Paris &
Nashville."*

10 Man in a Turban c. 1904
Etching
5⅞ x 4⅜ in. (15.1 x 11.2 cm.)

Only known state: Head and shoulders of a man
wearing a turban with a thick tassel over his ear,
looking to the left.

Montgomery Museum of Fine Arts, Montgomery,
Alabama, 1982

On back: "Early, before 1906."

11 The Scissors Grinder c. 1905
Etching
8¹⁵⁄₁₆ x 5¾ in. (22.7 x 14.6 cm.)
Handmade—Sweden

First state: With design complete.

Second state: As illustrated. Peppered with dots in
foreground and background.

Portland Art Association, Portland, Oregon, 1916;
Joseph Brummer Galleries, New York, New York,
1921

Library of Congress

*On back of one print: "Early work before 1906." On
another under her signature: "1905."*

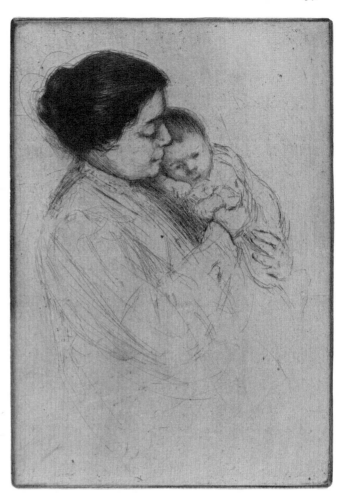

12 Poplars, Morningside Park (No. 1) c. 1905
Etching
8¾ x 5⅞ in. (22.2 x 15.1 cm.)
C. H. Whitman

Only known state: As illustrated. With bare trees and bushes and horses in far distance.

Portland Art Association, Portland, Oregon, 1916; Joseph Brummer Galleries, New York, New York, 1921; Montgomery Museum of Fine Arts, Montgomery, Alabama, 1982

Says: "early work." Some imps. have ink on plate in lower foreground.

13 Poplars, Morningside Park (No. 2) c. 1905
Etching
9 x 6 in. (22.8 x 15.2 cm.)

Only known state: Four bare young trees. A row of houses much closer than in other version. People walking along path between houses and trees.

Yale, Philadelphia

14 Minnie Watts and Baby c. 1905
Etching and drypoint
8 x 5½ in. (20.3 x 13.9 cm.)

Only known state: As illustrated.

Portland Art Association, Portland, Oregon, 1916; Joseph Brummer Galleries, New York, New York, 1921; Korner and Wood Company, Cleveland, Ohio, 1942; Montgomery Museum of Fine Arts, Montgomery, Alabama, 1982

Library of Congress

The artist wrote: "Very early" on one imp. On another: "about 1905" - "one of Anne's first - Minnie Watts who objected to having it called 'Mother and Child.' " Some imps. in sepia.

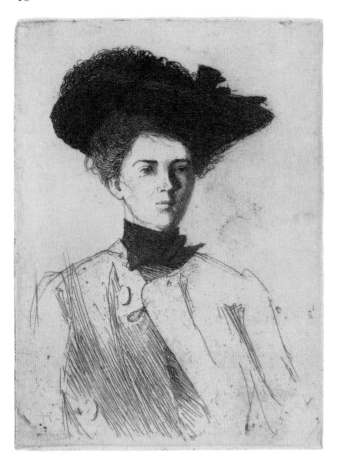

15 Lucille—Long Ago c. 1906
Etching
6 x 4½ in. (15.2 x 11.4 cm.)

Only known state: As illustrated.

Montgomery Museum of Fine Arts, Montgomery, Alabama, 1982

Lucille was Anne's sister.

16 Market Woman c. 1907
Etching and drypoint
7 x 5⅛ in. (17.7 x 13 cm.)

Only known state: She stands, seen from the rear, her face in shadow looking left, her left arm extends to left as though resting on a counter. Above it at upper left is the suggestion of another figure.

17 Gate at 4 Rue de Chevreuse c. 1907
Etching
4¹¹⁄₁₆ x 3 in. (12 x 7.6 cm.)

Only known state: A small print with two gateposts holding urns, steps between the posts; a small tree with few branches at either side.

Upon the artist's arrival in Paris she went to Mrs. Whitelaw Reid's Club for American Girls in the rue de Chevreuse. This print shows its entrance gate.

18 Towers of St. Sulpice, Paris c. 1907
Etching
6⅜ x 3½ in., screened to 6¼ x 3 in. (16 x 8.8 to 15.8 x 7.6 cm.)

Only known state: A narrow street down which a nun walks. Above tree branches are the two rounded towers.

Portland Art Association, Portland, Oregon, 1916; Syracuse Museum of Fine Arts, New York, New York, 1924

Some imps. in sepia.

19 On the Road to Fontainebleau c. 1907
Etching and drypoint
5 x 5¾ in. (12.7 x 14.6 cm.)
Arches

Only known state: In the middle of a broad road a woman is seen approaching, pushing a wheelbarrow. In the middle distance, a bank of tall trees.

Berlin Photographic Gallery, New York, New York, 1915; Portland Art Association, Portland, Oregon, 1916; Syracuse Museum of Fine Arts, New York, New York, 1924

Plate is screened on three sides on two of three imps.

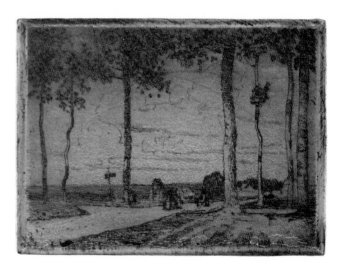

20 The Crossroads c. 1907
Etching
3½ x 4¾ in. (8.8 x 12 cm.)

Only known state: As illustrated.

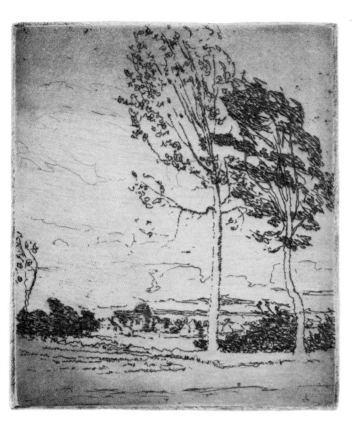

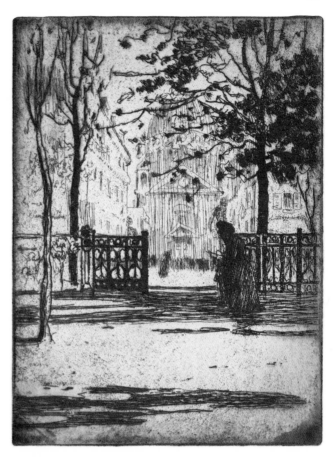

21 October in France c. 1907
Etching
4 ⅛ x 3 ½ in. (10.5 x 8.8 cm.)

Only known state: As illustrated.

Berlin Photographic Gallery, New York, New York, 1915; Portland Art Association, Portland, Oregon, 1916; Syracuse Museum of Fine Arts, Syracuse, New York, 1924; Montgomery Museum of Fine Arts, Montgomery, Alabama, 1977 (cat. 2); Montgomery Museum of Fine Arts, Montgomery, Alabama, 1982

Library of Congress

In 1929 four or five prints were available, some printed in black, others in sepia.

22 Chapelle du Val de Grâce (No. 1) c. 1907
Etching
7 ⅞ x 5¹⁵⁄₁₆ in. (20 x 15 cm.)
Van Gelder, Alfred

Only known state: As illustrated.

Portland Art Association, Portland, Oregon, 1916; Joseph Brummer Galleries, New York, New York, 1921; Syracuse Museum of Fine Arts, Syracuse, New York, 1924; Korner and Wood Company, Cleveland, Ohio, 1942; Montgomery Museum of Fine Arts, Montgomery, Alabama, 1982

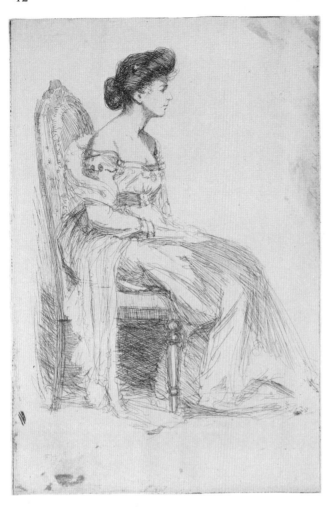

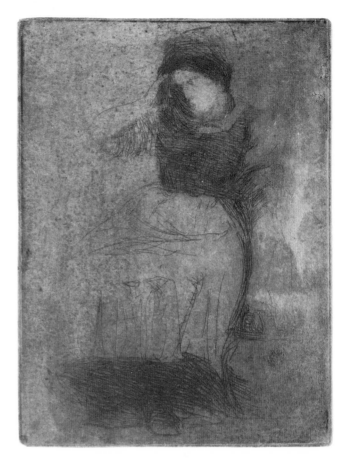

24 Dark Figure c. 1907
Etching and aquatint
4½ x 5⅞ in. (11.4 x 15.1 cm.)

Only known state: As illustrated.

One print only.

23 Seated Lady in Evening Dress c. 1907
Etching
8¾ x 6 in. (22.2 x 15.2 cm.)
Laid papers

First state: With the back of the chair on which she sits uncompleted, also the front leg.

Second state: As illustrated, with these additions. The lady is seen in near profile to right.

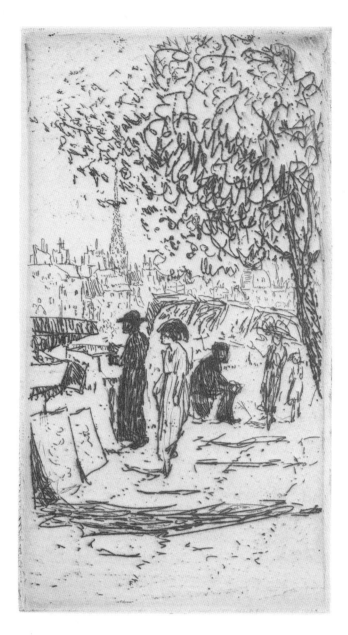

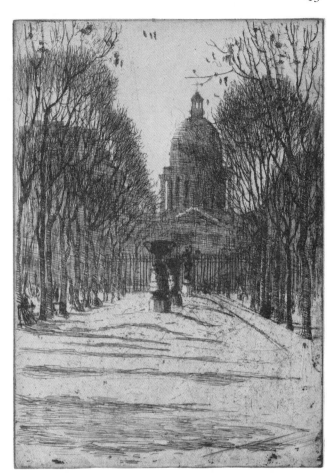

26 The Pantheon c. 1908
Etching
8⅛ x 5⅞ in. (20.8 x 15.1 cm.)

Only known state: As illustrated.

Portland Art Association, Portland, Oregon, 1916;
Joseph Brummer Galleries, New York, New York,
1921; Montgomery Museum of Fine Arts, Montgomery,
Alabama, 1982

25 Quai Voltaire c. 1908
(also called *Bookstalls Along the Seine*)
Etching
6½ x 3½ in. (16.5 x 8.8 cm.)
Porcaboeuf, Van Gelder

First state: With foreground quite clean.

Second state: As illustrated, with many small burred
dots at lower right. Some imps. screened in this state
with tone of ink not reaching to line at the top.

Portland Art Association, Portland, Oregon, 1916;
Syracuse Museum of Fine Arts, Syracuse, New York,
1924

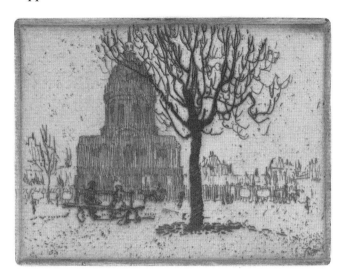

28 St. Sulpice, Paris c. 1908
Etching
7 ⅞ x 6 ¼ in. (20.1 x 15.8 cm.)
Porcaboeuf

Only known state: As illustrated.

Montgomery Museum of Fine Arts, Montgomery,
Alabama, 1977 (cat. 3); Montgomery Museum of Fine
Arts, Montgomery, Alabama, 1982

Some imps. in sepia.

29 The Madelaine, Paris c. 1908
Etching
6 ¼ x 8 in. (15.8 x 20.3 cm.)
Van Gelder, Alfred

Only known state: The columned facade is seen beyond
a fence. A tree, a lamppost, and a dark figure toward
left foreground.

27 Les Invalides, Paris c. 1908
Etching
4 ⅝ x 6 ⅛ in. (11.8 x 15.7 cm.)

Only known state: As illustrated.

Montgomery Museum of Fine Arts, Montgomery,
Alabama, 1982

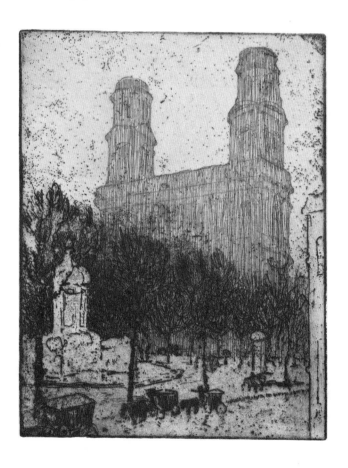

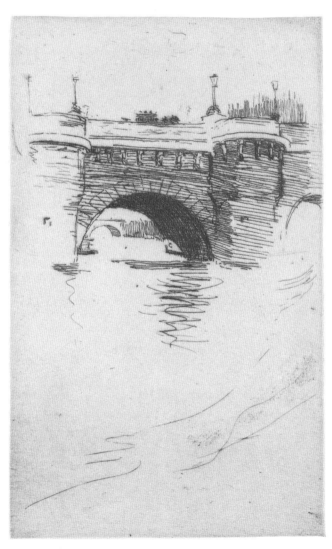

30 **Pont Neuf, Paris** c. 1908
Etching
4¼ x 2¾ in. (10.7 x 6.9 cm.)

Only known state: As illustrated.

Berlin Photographic Gallery, New York, New York,
1915; Syracuse Museum of Fine Arts, Syracuse, New
York, 1924; The Downtown Gallery, New York, New
York, 1929

Philadelphia

*Only three imps. One in sepia in 1929 when at The
Downtown Gallery.*

31 **Gates to a Paris Park** c. 1908
Etching
3½ x 2⁵⁄₁₆ in. (screened to 3³⁄₁₆ x 2¹⁄₃₂ in.) (8.8 x 5.7 to 8.2
to 5.1 cm.)

Only known state: A man stands between spectator and
the gates, toward left. Beyond the high gates are banks
of trees; between them, a vista with people.

32 **Luxembourg Fountain (No. 1)** c. 1908
Etching
3½ x 2⁵⁄₁₆ in. (screened to 3¼ x 2¹⁄₃₂ in.) (8.8 x 5.7 to
8.2 x 5.1 cm.)

Only known state: The fountain is toward right, with
two banks of trees beyond; between them, a high
column with statue above.

33 **Luxembourg Fountain (No. 2)** c. 1908
Etching
8⅛ x 5¾ in. (20.7 x 14.6 cm.)
C. H. Whitman

Only known state: The fountain toward upper left, trees
and high column with statue in distance. One tilted
child's sailboat in water at right.

*One imp. has two other child's sailboats added toward right
in pencil. Probably never developed since a note in artist's
writing says: "Only 2 or 3 proofs—plate destroyed."*

34 **Scene in a Paris Park** c. 1908
Etching
8³⁄₁₆ x 4¹⁵⁄₁₆ in. (20.9 x 12.5 cm.)
C. H. Whitman

Only known state: The only one seen has pencil or
conté corrections. Shading across foreground and trees
at either side. A nurse and two children are passing by.

*In artist's writing: "only 3 or 4 prints—there is a photo-
graphic reproduction of this."*

35 **Chapelle du Val de Grâce (No. 2)** c. 1908
Etching
7¹⁵⁄₁₆ x 5¹⁵⁄₁₆ in. (20.2 x 15 cm.)
Rives

Only known state: A woman and child walk before the
gates leading to the high domed chapel in the back-
ground. They are to the left of the entrance.

Metropolitan Museum of Art

36 **Gate to the Luxembourg Gardens** c. 1908
Etching
5⅞ x 6⅞ in. (15.1 x 17.3 cm.)

Only known state: The high gates in three sections,
two of which are open. At left, a tight little group of
people.

Berlin Photographic Gallery, New York, New York,
1915; Joseph Brummer Galleries, New York, New York,
1921; Montgomery Museum of Fine Arts, Montgomery,
Alabama, 1977 (cat. 4)

37 **The Letter—Miss Walker** c. 1908
Etching
4 x 3⅜ in. (10.1 x 8.5 cm.)

Only known state: The model, Miss Walker, sits in
profile at right writing a letter, her foot resting on a
stool. She holds the sheet of paper on her knee.

Berlin Photographic Gallery, New York, New York,
1915; Portland Art Association, Portland, Oregon,
1916; Syracuse Museum of Fine Arts, Syracuse, New
York, 1924; Korner and Wood Company, Cleveland,
Ohio, 1942; Montgomery Museum of Fine Arts,
Montgomery, Alabama, 1977 (cat. 5)

Springfield; Philadelphia

*In artist's handwriting alongside one print: "Miss
Walker."*

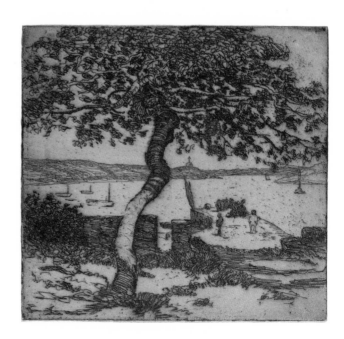

38 The Twisted Oak, Ile-aux-Moines c. 1909
(also called *The Little Oak*)
Etching
5⅞ x 6¼ in. (15.1 x 15.8 cm.)

Only known state: As illustrated.

Portland Art Association, Portland, Oregon, 1916;
Syracuse Museum of Fine Arts, Syracuse, New York,
1924; Montgomery Museum of Fine Arts, Montgomery,
Alabama, 1982

St. Louis

39 Fig Tree, Ile-aux-Moines c. 1909
Etching
6⅜ x 7 in. (16.2 x 17.7 cm.)

First state: A beach scene with a fenced-in group of
houses overshadowed by a tremendous fig tree close to
the strand.

Second state: With false biting throughout plate. Plate-
line bevelled.

Berlin Photographic Gallery, New York, New York,
1915; Portland Art Association, Portland, Oregon,
1916

Metropolitan Museum of Art

Some imps. in sepia.

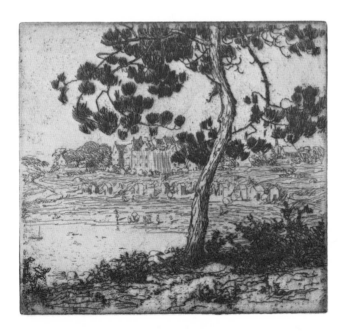

40 Pine Tree on the Brittany Coast c. 1909
(also called *The Beach, Ile-aux-Moines*)
Etching
5⅞ x 6⅜ in. (15.1 x 16.2 cm.)

Only known state: As illustrated.

Montgomery Museum of Fine Arts, Montgomery,
Alabama, 1982

Boston

Some imps. in sepia.

41 Sinago in Harbor, Brittany c. 1909
Etching
5⅞ x 6⅝ in. (15.1 x 16.8 cm.)

First state: Cleanly bitten with unbevelled plate-line.

Second state: As illustrated, p. 47. With false biting in
sky at upper left as well as in lower sections of plate.
The plate-line is bevelled.

Some imps. in sepia.

42 Garden by the Sea, Ile-aux-Moines c. 1909
Etching
6⅜ x 7⅛ in. (16.2 x 18 cm.)

Only known state: Beyond a path across the foreground
is a flower bed. Through some low pines is a view of
water, a boat, and houses.

Portland Art Association, Portland, Oregon, 1916

43 Deserted Garden, France c. 1909
Etching
6¼ x 7¹¹⁄₁₆ in. (15.8 x 17.9 cm.)

Only known state: To the left is an empty tub. Beyond
it are tall iris-leafed plants. To right of center is a fig tree
whose branches fill most of the upper half of the plate.

Portland Art Association, Portland, Oregon, 1916;
Joseph Brummer Galleries, New York, New York, 1921;
Syracuse Museum of Fine Arts, Syracuse, New York,
1924

Metropolitan Museum of Art

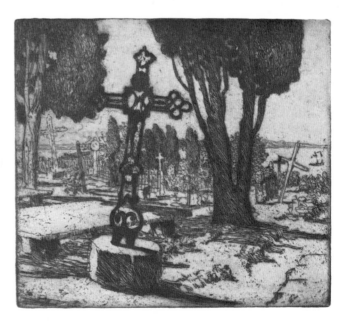

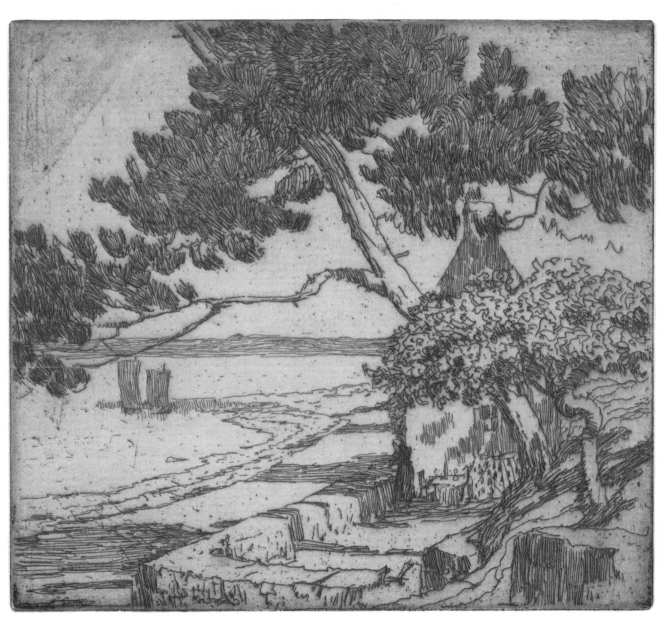

Sinago in Harbor, Brittany (cat. no. 41)

44 Brittany Churchyard c.1909
Etching
6 ¼ x 7 ⅛ in. (15.8 x 18 cm.)
Porcabouef

Only known state: As illustrated.

Berlin Photographic Gallery, New York, New York, 1915; Portland Art Association, Portland, Oregon, 1916; Montgomery Museum of Fine Arts, Montgomery, Alabama, 1982

Wadsworth Atheneum; Brooklyn; Springfield

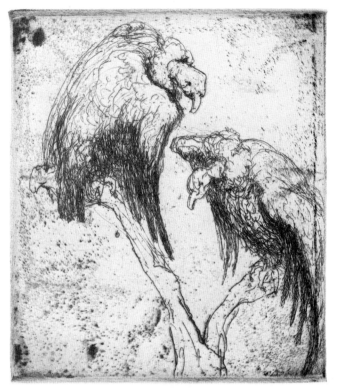

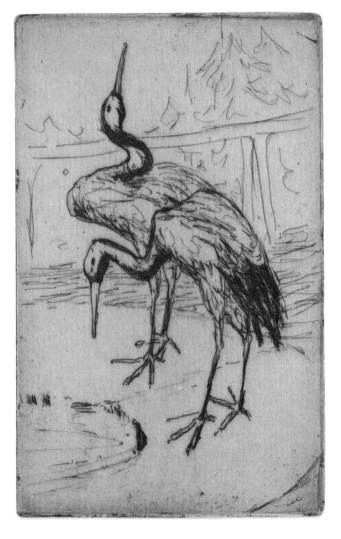

45 Cranes—Jardin des Plantes c. 1910
Etching
6�5⁄16 x 4 1⁄16 in. (15.1 x 10.3 cm.)

First state: Without trees and structure in background; less detail on plumage, etc.

Second state: As illustrated. With these additions.

46 Condors—Jardin des Plantes c. 1910
Etching
7 1⁄16 x 6 ¼ in. (17.9 x 15.8 cm.)
Handmade—Sweden

First state: Clean background. No bevel to plate.

Second state: As illustrated. Plate bevelled. Rough ground with rust marks at upper and lower left corners and down right side.

Berlin Photographic Gallery, New York, New York, 1915; Portland Art Association, Portland, Oregon, 1916; Joseph Brummer Galleries, New York, New York, 1921

47 Falcon c. 1910
Etching
7 7⁄16 x 5 15⁄16 in. (18.9 x 15.1 cm.)
Umbria, Italy

Only known state: The falcon is held on a gloved hand. He looks at viewer.

Two prints only.

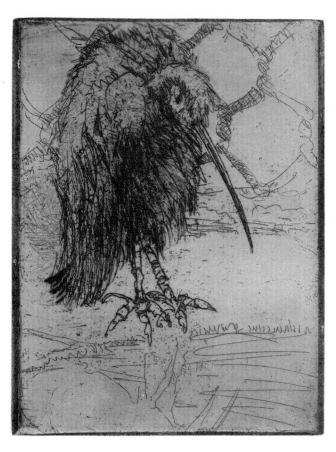

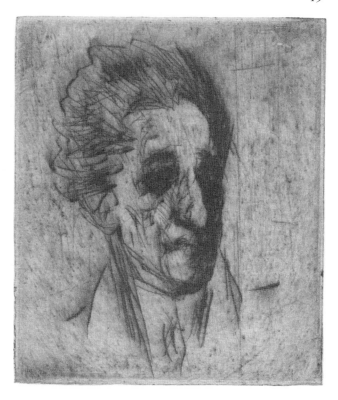

48 Melancholia—Jardin des Plantes c. 1910
Etching
6⅛ x 4¾ in. (15.7 x 12 cm.)

Only known state: As illustrated.

Montgomery Museum of Fine Arts, Montgomery, Alabama, 1982

49 Eagle c. 1910
Drypoint
6⅛ x 6⅛ in. (15.7 x 15.7 cm.)

Only known state: The eagle, perched on a rock, flaps its wings, and is open-mouthed, turned to right, seen in profile.

50 Robert Cole (No. 1) c. 1910
Etching and drypoint
2 x 1¾ in. (5 x 4.4 cm.)
Japan

Only known state: As illustrated. With very dark shading on face and hair, with scalloped edges; mouth turned down somewhat.

51 Robert Cole (No. 2) c. 1910
Etching and drypoint
2 x 1¾ in. (5 x 4.4 cm.)

Only known state: Head of a man looking to right in ¾ view. His long wavy hair is brushed back off his high forehead. In one imp. there are corrections in pencil, probably leading to another state. These corrections extend the outline of his hair above his ear.

Berlin Photographic Gallery, New York, New York, 1915

52 Egyptian Dancer, Paris (No. 1) c. 1910
Etching and drypoint
6⅞ x 5⅝ in. (17.3 x 14.2 cm.)

Only known state: Dressed in a beaded costume with beads flying and bare midriff, she bends back to the left.

Berlin Photographic Gallery, New York, New York, 1915; Portland Art Association, Portland, Oregon, 1916

Springfield; Wadsworth Atheneum

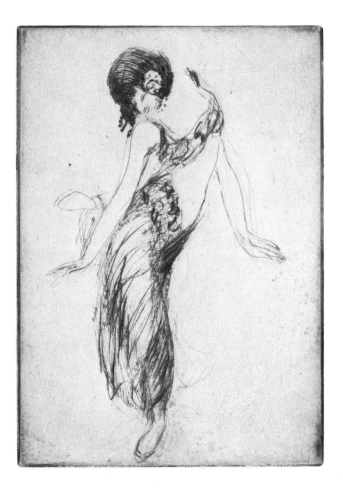

53 Egyptian Dancer, Paris (No. 2) c. 1910
Etching and drypoint
7½ x 5⁷⁄₁₆ in. (19 x 13.7 cm.)
Van Gelder, Alfred, Arches

First state: Some imps. screened about ⅛ in. within plate-line. Design completed and edition pulled.

Second state: As illustrated. Rebiting on shoulder strap of bra, on hip, in outlines of bloomers and shading within them.

Berlin Photographic Gallery, New York, New York, 1915; Portland Art Association, Portland, Oregon, 1916; Joseph Brummer Galleries, New York, New York, 1921; Montgomery Museum of Fine Arts, Montgomery, Alabama, 1982

Miss Madeline Vance, an American dancing in Grand Opera.

54 Egyptian Dancer, Kneeling c. 1910
Etching and drypoint
3⅜ x 4¾ in. (8.6 x 12 cm.)
Van Gelder Zonen

Only known state: The figure kneeling with feet tucked under her, salaams, her head touching her outstretched hands.

Berlin Photographic Gallery, New York, New York, 1915

55 At Montmartre c. 1910
(also called *New Year's Night—Café Versaille*) [sic]
Etching
5¹³⁄₁₆ x 7¹³⁄₁₆ (14.9 x 19.9 cm.)

Only known state: As illustrated, p. 51. At lower right on plate is written in reverse: "New Year's Night—Cafe Versaille."

Portland Art Association, Portland, Oregon, 1916; Joseph Brummer Galleries, New York, New York, 1921; Syracuse Museum of Fine Arts, Syracuse, New York, 1924; Korner and Wood Company, Cleveland, Ohio, 1942; Montgomery Museum of Fine Arts, Montgomery, Alabama, 1982

Brooklyn; Boston; Cleveland; Honolulu; National Museum of American Art; Philadelphia; Springfield; St. Louis; Wadsworth Atheneum; Worcester; Yale; Metropolitan Museum of Art

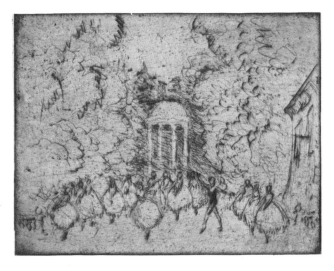

56 Les Sylphides c. 1910
(also called *Russian Dancers*)
Drypoint
6⁷⁄₁₆ x 8⁷⁄₁₆ in. (16.4 x 21.5 cm.)
Japan

Only known state: As illustrated.

Joseph Brummer Galleries, New York, New York, 1921; Montgomery Museum of Fine Arts, Montgomery, Alabama, 1977 (cat. 7)

Philadelphia; Wadsworth Atheneum

A scene from the Diaghilev Russian Ballet.

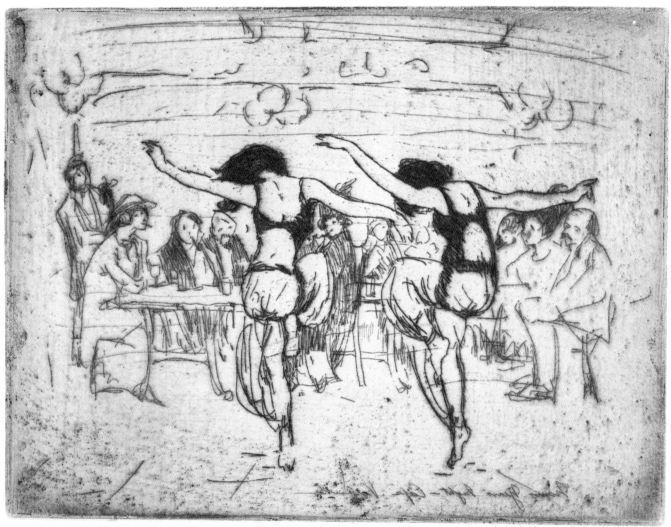

At Montmartre (cat. no. 55)

HORSESHOE BEND
LIBRARY
DADEVILLE, AL

57 At the Piano (No. 1) c. 1910
Etching
5⅞ x 7⅜ in. (15 x 18.7 cm.)
Japan

Only known state: A young woman with marcelled hair looks as though she were frightened. She sits with both arms extended to the piano at right. One long line across her forehead is a mistake.

58 At the Piano (No. 2) c. 1910
Etching
5⅞ x 7⅜ in. (15.1 x 18.7 cm.)
Japan

Only known state: The young woman looks calmly at the spectator. Her right hand is on her lap, her left is extended as though to turn a page of her music.

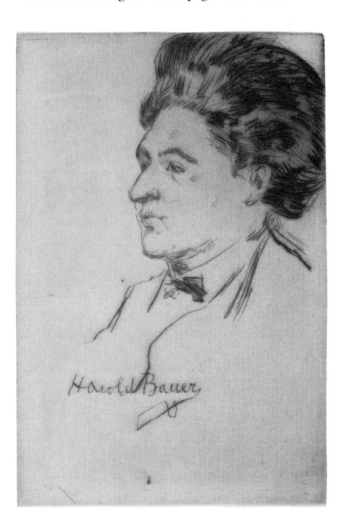

59 Harold Bauer—1910 c. 1910
(also called *Portrait of a Musician*)
Drypoint
6¹⁵⁄₁₆ x 4¾ in. (17.6 x 12.1 cm.)

Only known state: As illustrated.

Montgomery Museum of Fine Arts, Montgomery, Alabama, 1977 (cat. 29); Montgomery Museum of Fine Arts, Montgomery, Alabama, 1982

Harold Bauer (1873-1951) was a prominent concert pianist in Europe at the turn of the century. He appeared with the Boston Symphony in the U.S. Signature: "Harold Bauer" on plate. Some imps. printed in black ink, some in sepia; bevelled plate.

60 Portrait of a Young Girl c. 1910
Etching and drypoint
5⅞ x 4½ in. (15 x 11.4 cm.)

Only known state: She is seen in near profile to right, her hair parted and drawn back. A dark shadow is seen behind her head, and there is a suggestion of a ruffled blouse.

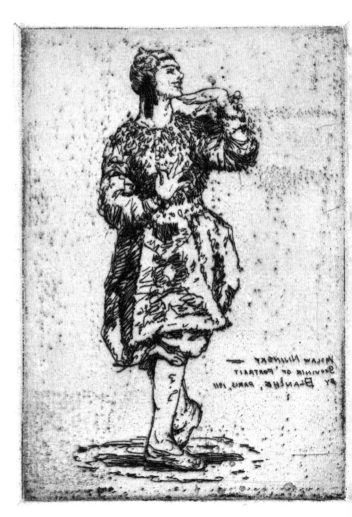

61 Nijinsky—1911 c. 1911
Etching
5¹¹⁄₁₆ x 4⅛ in. (14.4 x 10.5 cm.)

Only known state: As illustrated. Etched on plate at lower right: "Vaslav Nijinsky Souvenir of Portrait/by Blanche, Paris, 1911."

Berlin Photographic Gallery, New York, New York, 1915; Portland Art Association, Portland, Oregon, 1916; Montgomery Museum of Fine Arts, Montgomery, Alabama, 1977 (cat. 8); Montgomery Museum of Fine Arts, Montgomery, Alabama, 1982

Philadelphia

Some imps. wiped clean, others grained to hold ink. Bevelled plate.

62 Dancer Kneeling on One Knee c. 1911
Etching and drypoint
7¾ x 6¼ in. (19.6 x 15.8 cm.)
Umbria, Italy

Only known state: Dancer with nude torso kneels on her left knee and holds drapery up with right hand, while left hand rests on her head.

Portland Art Association, Portland, Oregon, 1916

Philadelphia

63 Spring c. 1911
Etching
8 x 7 in. (20.3 x 17.7 cm.)
Japan

Only known state: Dancer advances toward right with right leg raised and both arms extended outward.

Berlin Photographic Gallery, New York, New York, 1915

64 *Le Petit Coq* c. 1911
Etching
4¹¹⁄₁₆ x 3⁹⁄₁₆ in. (11.9 x 9.1 cm.)

Only known state: Little girl in her tutu stands facing the right with hands on her hips.

Berlin Photographic Gallery, New York, New York, 1915; Portland Art Association, Portland, Oregon, 1916

65 The Ballet c. 1911
Etching
8 x 6¼ in. (20.3 x 15.8 cm.)
Van Gelder Zonen

Only known state: Three dancers with raised right arms, one behind another.

Berlin Photographic Gallery, New York, New York, 1915; Portland Art Association, Portland, Oregon, 1916

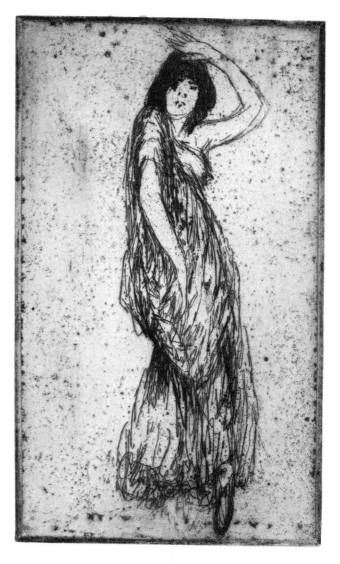

66 Spanish Dancer c. 1911
(also called *L'Espagnole*)
Etching
8⅜ x 5⅛ in. (21.4 x 13 cm.)
Van Gelder Zonen, Alfred, Porcaboeuf

First state: Dancer stands with one hand above her head. Her dark hair falling over her right eye is shorter at right, showing her shoulder. Three extra feet outlined faintly to left of her one foot darkly outlined, also in second state.

Second state: With her dark hair covering her left shoulder.

Third state: As illustrated. Three extra outlines of a foot covered by a lightly scratched scalloped ruffle in drypoint covering two of the three extra feet. Plate rebitten for enrichment of all lines.

Berlin Photographic Gallery, New York, New York, 1915; Portland Art Association, Portland, Oregon, 1916; Montgomery Museum of Fine Arts, Montgomery, Alabama, 1982

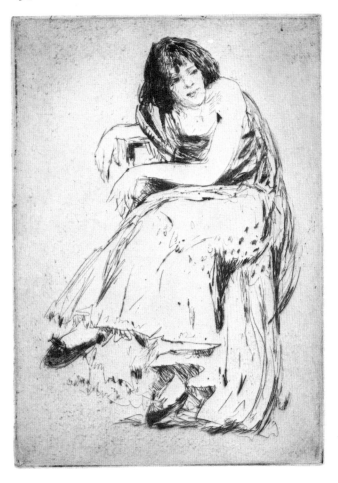

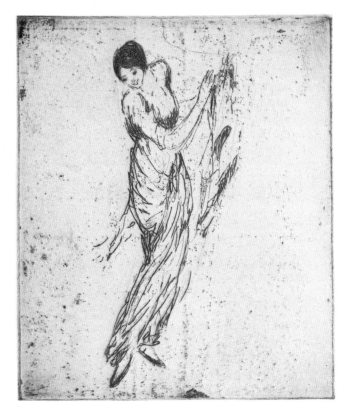

69 Dancer with Veil (No. 2) c. 1911
Etching
7¹¹/₁₆ x 6½ in. (19.4 x 16.5 cm.)
Handmade—Sweden

First state: With less shading on hair, gown and veil.
Shoes in outline only.

Second state: As illustrated. With these additions and
reinforced lines outlining shoes.

Berlin Photographic Gallery, New York, New York,
1915; Portland Art Association, Portland, Oregon,
1916

67 Spanish Dancer Seated—Zelina c. 1911
Etching and drypoint
10⅞ x 7⅞ in. (27.7 x 20.1 cm.)
Van Gelder Zonen, Alfred, Porcaboeuf

First state: With less shading, shoes light.

Second state: As illustrated. Shoes dark, more shading
throughout.

Berlin Photographic Gallery, New York, New York,
1915; Portland Art Association, Portland, Oregon,
1916; Montgomery Museum of Fine Arts,
Montgomery, Alabama, 1982

68 Dancer with Veil (No. 1) c. 1911
Etching
7¾ x 6⁵/₁₆ in. (screened to 7½ x 6³/₁₆)
(19.6 x 15.6 to 19 x 15.4 cm.)
Van Gelder

Only known state: The dancer in long filmy dress
holds a long filmy scarf with both arms extended.

Berlin Photographic Gallery, New York, New York,
1915; Portland Art Association, Portland, Oregon,
1916

Library of Congress

Ruby Cunningham posed.

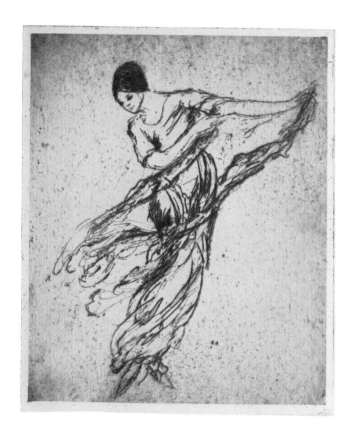

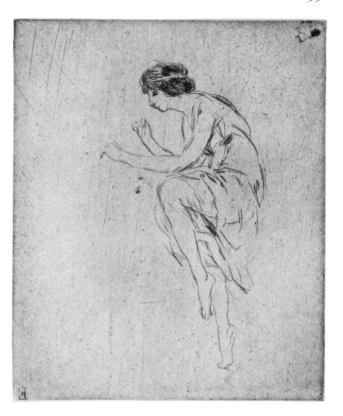

70 **Dancer with Veil (No. 3)** c. 1911
Etching
7 ¾ x 6 ½ in. (screened in third state to 7⁵⁄₁₆ x 6 ⅛)
(19.6 x 16.5 to 18.3 x 15.7 cm.)

First state: Hair flat on top, left foot outlined clearly.

Second state: Hair somewhat darker and left foot reduced in size but still pointed. Before rebiting. More detail on veil.

Third state: As illustrated. Hair darker, rounded on top. Left foot partly erased. Entire work rebitten.

Berlin Photographic Gallery, New York, New York, 1915; Portland Art Association, Portland, Oregon, 1916

71 *Moment Musical* (No. 1) c. 1911
Drypoint
8 ⅜ x 7 ⅛ in. (21.4 x 17.9 cm.)
Handmade—Sweden, Japan, F. J. Head

First state: Dancer, with hand holding her dark hair up, leans forward with her face equidistant from her two hands.

Second state: With receding chin and broken line of drapery.

Third state: As illustrated. Chin filled in. The line of drapery more defined. Edge of plate filed. Some imps. have figure tinted pink.

Berlin Photographic Gallery, New York, New York, 1915; Portland Art Association, Portland, Oregon, 1916; Joseph Brummer Galleries, New York, New York, 1921; Korner and Wood Company, Cleveland, Ohio, 1942

Yale; St. Louis; Metropolitan Museum of Art

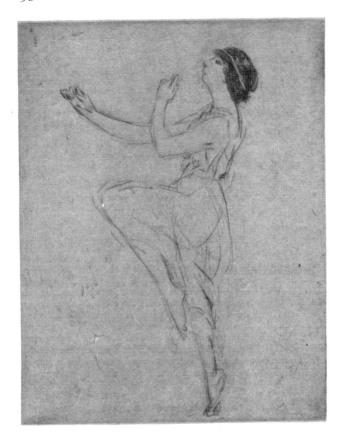

Berlin Photographic Gallery, New York, New York, 1915; Portland Art Association, Portland, Oregon, 1916; Joseph Brummer Galleries, New York, New York, 1921; Syracuse Museum of Fine Arts, Syracuse, New York, 1924

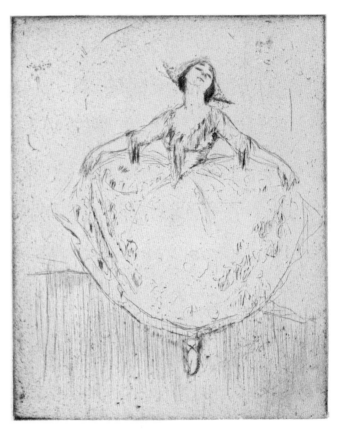

72 *Moment Musical* (No. 2) c. 1911
Etching and drypoint
7⅞₁₆ x 5⅞ in. (19 x 15 cm.)
Japan

First state: Dancer has her head thrown back and both arms raised.

Second state: As illustrated. More lines of drapery, especially over and below thigh.

Berlin Photographic Gallery, New York, New York, 1915; Portland Art Association, Portland, Oregon, 1916; Joseph Brummer Galleries, New York, New York, 1921; Syracuse Museum of Fine Arts, Syracuse, New York, 1924; Montgomery Museum of Fine Arts, Montgomery, Alabama, 1982

Boston; Wadsworth Atheneum; Metropolitan Museum of Art

73 *Moment Musical* (No. 3) c. 1911
Etching and drypoint
5⅞ x 4⅞ in. (15.1 x 12.5 cm.)
Handmade—Sweden

Only known state: Dancer moves toward the right, one hand above her head. In later imps. the plate is bevelled, which brings top line of this hand to the plate-line. On one imp., the artist wrote: "Un Moment Musical Schubert A. G." and another: (Un Moment Musical/Schubert 3)

74 The Moth c. 1911
Etching and drypoint
9¾ x 7¹³⁄₁₆ in. (24.7 x 20 cm.)
J. Green and Son, Handmade—Sweden

First state: Before two diagonal scratches in upper left background. Before filing of plate edges.

Second state: As illustrated. With these additions.

Joseph Brummer Galleries, New York, New York, 1921; Korner and Wood Company, Cleveland, Ohio, 1942

Philadelphia; Honolulu; Metropolitan Museum of Art

Ruby Cunningham posed.

75 Town of Château-Thierry c. 1911
Etching
4¹⁵⁄₁₆ x 5⅞ in. (12.5 x 15.1 cm.)

Only known state: The tall church tower rises above the cluster of other buildings. The bridge in foreground with a lamppost and a road sign toward left.

Joseph Brummer Galleries, New York, New York, 1921

76 Hôtel de Ville, Château-Thierry c. 1911
Etching
10⅜ x 8⅜ in. (26.5 x 21.3 cm.)

Only known state: The facade of the building is seen at the end of a row of houses on either side of the street leading to it. Trees beyond.

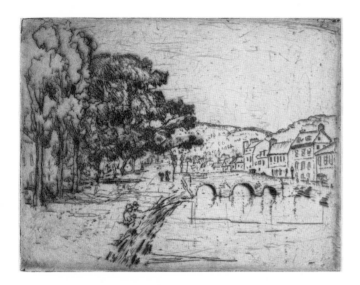

77 The Bridge at Château-Thierry c. 1911
Etching
6⅜ x 8⅜ in. (16.3 x 21.4 cm.)

First state: With three arches of bridge different widths.

Second state: As illustrated. With the arches broadened and made somewhat more even.

Joseph Brummer Galleries, New York, New York, 1921; Syracuse Museum of Fine Arts, Syracuse, New York, 1924; Montgomery Museum of Fine Arts, Montgomery, Alabama, 1982

The artist notes in the margin of one imp. of the second state: "I changed the bridge when it became so famous. This is not accurate." One imp. of first state has pencil corrections on arches of bridges.

78 Where the Marne Flows into Château-Thierry c. 1911
Etching
6⅜ x 8 ⅜ in. (16.3 x 21.3 cm.)

Only known state: Hilly landscape, river running by. Two spindly pine trees and a goat in the foreground.

79 Château-Thierry Station c. 1911
Etching
5¾ x 7¼ in. (14.6 x 18.4 cm.)
Handmade—Sweden

Only known state: The station master, a man, a woman and a child stand before a lamppost waiting for the train to come.

Syracuse Museum of Fine Arts, Syracuse, New York, 1924

80 The Storm—Grez-sur-Loing c. 1911
Etching
7 x 9⅜ in. (17.6 x 23.8 cm.)

Only known state: As illustrated, p. 58.

Montgomery Museum of Fine Arts, Montgomery, Alabama, 1982

Philadelphia

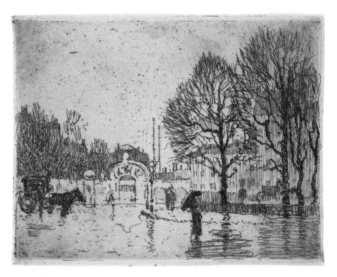

81 Paris in the Rain c. 1912
Etching
4¹¹/₁₆ x 6⅛ in. (12 x 15.6 cm.)

Only known state: As illustrated.

Korner and Wood Company, Cleveland, Ohio, 1942; Montgomery Museum of Fine Arts, Montgomery, Alabama, 1982

Brooklyn; Springfield; Honolulu; Metropolitan Museum of Art

This print won the Whitelaw Reid Prize in 1913, Paris.

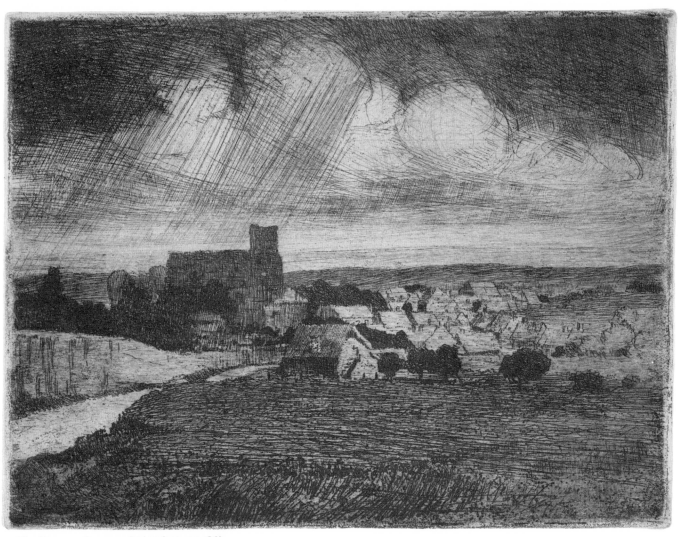

The Storm—Grez-sur-Loing (cat. no. 80)

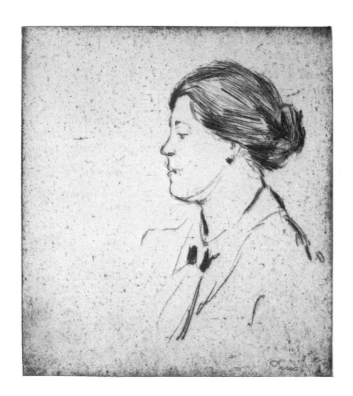

82 Profile of Nancy Spilman of Warrenton
c. 1912
Drypoint
6⅛ x 5½ in. (15.6 x 14 cm.)
Porcaboeuf

Only known state: As illustrated.

"Paris" written by artist at lower right within plate-line.

83 Nancy Spilman of Warrenton c. 1912
Etching and drypoint
7⅜ x 4⅝ in. (screened to 6¾ x 4)
(18.7 x 11.6 to 17.1 x 10.1 cm.)
Van Gelder

First state: Face larger, hair lighter, but touched up with graphite pencil; also used on blouse.

Second state: Three dark shadings on blouse. Hair shaded, also cheek and chin to make face appear somewhat smaller.

84 Profile Portrait of a Lady (No. 1) c. 1912
Drypoint
6¹⁄₁₆ x 4⁹⁄₁₆ in. (15.5 x 11.7 cm.)
Normandy Vellum

First state: Head and shoulders of a handsome woman with dark hair drawn into a bun at the back. She is seen in profile to left.

Second state: A few stray hairs added at the base of the bun and between that and her long earring, a few extra lines of shading on her hair.

85 Sunny Hillside, France c. 1912
(also called *Sunny Hillside, Ile-aux-Moines*)
Etching
6¼ x 7 in. (15.8 x 17.7 cm.)

Only known state: One looks down a sunny hill, broken by shrubbery and a large house toward right, to a bay with boats. A woman with a large umbrella is mounting the hill at lower center.

Berlin Photographic Gallery, New York, New York, 1915; Portland Art Association, Portland, Oregon, 1916; Joseph Brummer Galleries, New York, New York, 1921; Montgomery Museum of Fine Arts, Montgomery, Alabama, 1977 (cat. 13)

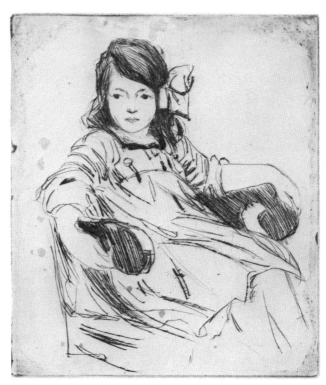

86 Bébé von Knapitsch c. 1912
Drypoint
7 x 6¼ in. (17.8 x 15.8 cm.)
Van Gelder, Porcabouef

First state: Detail of hands, face, hair, ribbon, etc. different. Mouth more pouting.

Second state: As illustrated. With these changes. Narrow bevel to plate. Some rust marks show in this state.

Portland Art Association, Portland, Oregon, 1916; Joseph Brummer Galleries, New York, New York, 1921; Syracuse Museum of Fine Arts, Syracuse, New York, 1924; Korner and Wood Company, Cleveland, Ohio, 1942; M. Knoedler and Company, New York, New York, 1944; Montgomery Museum of Fine Arts, Montgomery, Alabama, 1982

Brooklyn; Boston; Philadelphia; Library of Congress; Metropolitan Museum of Art

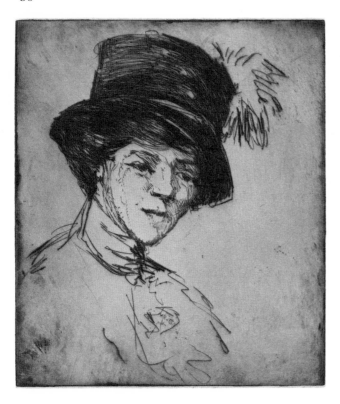

87 Lucille in Paris—1912 c. 1912
Etching and drypoint
7 x 6⅜ in. (17.7 x 16 cm.)
Van Gelder, Alfred

First state: With less shading on her face, before a straight line across her nose just above nostrils.

Second state: As illustrated. With that straight line and a few scallop-like shadings over her right cheek from the eye to the chin.

Lucille was Anne's sister.

88 The French Hat c. 1912
Etching and drypoint
6 x 5 in. (15.1 x 12.7 cm.)
Van Gelder Zonen

Only known state: An unfinished sketch of a young woman wearing a dark feathered hat at an acute angle on the side of her head. She is evidently seated, but her hands are not drawn.

Signed only with initials "A.G."

89 Portrait of an Elderly Lady: Profile View
c. 1912
Etching and drypoint
7⅞ x 5⅞ in. (19.9 x 15.1 cm.)
Laid papers

Only known state: She sits in a high-backed Queen Anne chair, facing left; on one imp. there are pencil marks added which might have been used in a possible later state. They lessen the curved line of her dress just above the waist.

90 Portrait of an Elderly Lady: Three-quarter View c. 1912
Etching and drypoint
2 x 1¾ in. (5 x 4.4 cm.)
Laid papers

Only known state: She is seen in half-length, seated in a high-backed Queen Anne chair.

91 Portrait of a Lady (No. 2) c. 1912
Drypoint
8¼ x 5⅞ in. (20.9 x 15 cm.)

Only known state: She is seen in profile to right wearing a large feathered hat, one feather falling onto her shoulder; there is a black bow on her chest and below it a large rose or two.

92 Portrait of a Lady in a Feathered Hat c. 1912
Etching and drypoint
7⅞ x 5⅞ in. (20 x 15.1 cm.)
C.H. Whitman

Only known state: She sits holding a magazine on her lap and looks at the observer. Her large, black hat has a number of feathers on it. A deep shadow is behind her.

93 Between the Acts c. 1912
Etching and drypoint
7 x 6⅜ in. (17.7 x 16.1 cm.)

Only known state: Dancer in tutu seated, her wide skirt about her, her legs extended toward lower right. Her dark hair decorated with flowers.

Berlin Photographic Gallery, New York, New York, 1915; Portland Art Association, Portland, Oregon, 1916

Yale; Worcester

Some imps. in sepia.

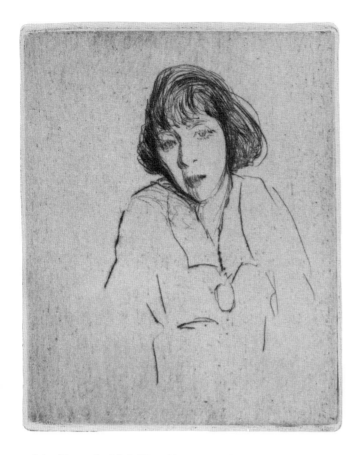

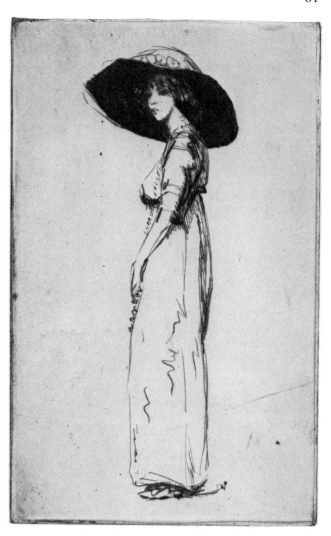

94 **French Girl (No. 1)** c. 1912
Drypoint
4 x 3 ¼ in. (10 x 8.2 cm.)
Handmade—Sweden

First state: Head and shoulders of a girl with soft bobbed hair and rather large features looking forward. Design complete except for the fuzzy lines extending the shading on her shoulder at left.

Second state: As illustrated. With those additional lines.

Montgomery Museum of Fine Arts, Montgomery, Alabama, 1982

95 **Mademoiselle** c. 1912
Etching and drypoint
8 ⅝ x 5 ½ in. (22 x 13.9 cm.)
Porcaboeuf, Van Gelder, Alfred

Only known state: As illustrated.

Montgomery Museum of Fine Arts, Montgomery, Alabama, 1982

Some imps. in sepia, with edges of plate bevelled.

96 **Une Parisienne (No. 1)** c. 1912
Drypoint
7 ⅞ x 6 in. (20 x 15.3 cm.)
Normandy Vellum

Only known state: A ¾ length view of a chic figure in a large kind of pouffe hat and a long coat.

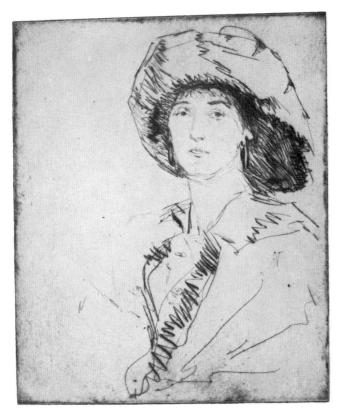

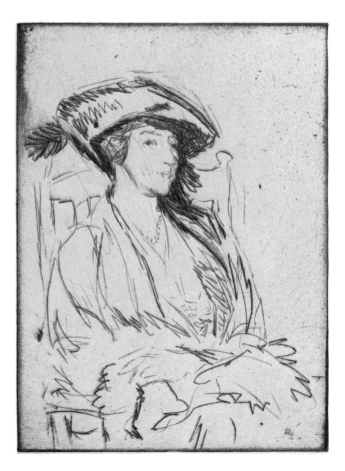

97 **Une Parisienne (No. 2)** c. 1912
Drypoint
7⅜ x 6⅛ in. (18.7 x 15.6 cm.)
Normandy Vellum

Only known state: As illustrated.

Montgomery Museum of Fine Arts, Montgomery,
Alabama, 1982

98 **Anne Peters—Paris, 1912** c. 1912
Drypoint
7⅞ x 6 in. (20.3 x 15.1 cm.)
Normandy Vellum, Japan

First state: Fully developed sketch with rich dark
shading under her hat and to the right of her face.

Second state: As illustrated. A small black terminal
added to the end of a line at left beyond her sleeves and
another on her hat toward left.

99 **Café Scene** c. 1912
Etching
6½ x 8⁷⁄₁₆ in. (16.5 x 21.5 cm.)

Only known state: As illustrated, p. 63.

Montgomery Museum of Fine Arts, Montgomery,
Alabama, 1982

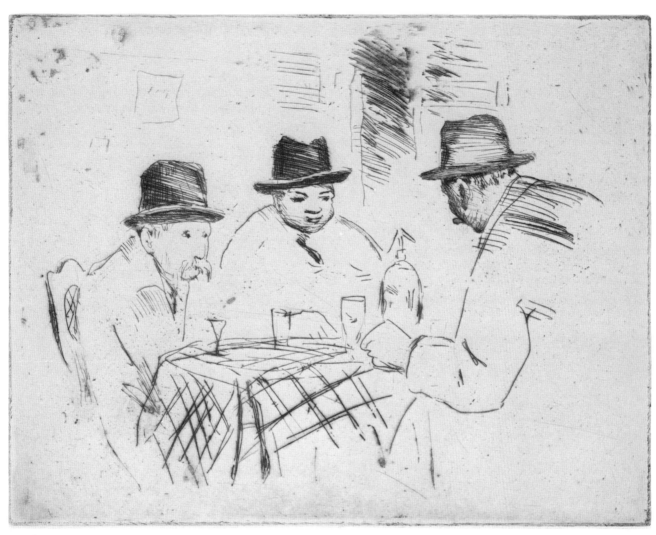

Café Scene (cat. no. 99)

100 Seated Lady with a Fan c. 1912
Etching and drypoint
9½ x 7¾ in. (24.2 x 19.7 cm.)
''S. Co. 1886 Exeter''

Only known state: She sits holding a fan in both hands. Her wide ruffled skirt extends to the plate-line at either side. She looks off to the left.

101 Still Life of Flowers c. 1913
Aquatint and softground
13¾ x 17½ in. (34.9 x 44.4 cm.)

Only known state: Arrangement of spring flowers in a vase.

National Museum of American Art

Watercolor used for colors.

102 Vase of Tulips c. 1913
Aquatint and softground
13⅝ x 17⅜ in. (34.5 x 39.7 cm.)

Only known state: An oval design of tulips in a vase.

Yale; Boston; Philadelphia; Cleveland; National Museum of American Art; Wadsworth Atheneum; Metropolitan Museum of Art

Red aquatint and green watercolor used for colors.

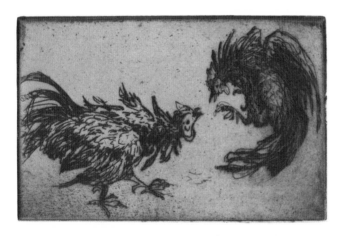

103 Cock Fight c. 1913
Etching
4 1/16 x 6 7/16 in. (10.4 x 16.4 cm.)
Arches, monogram ''MR''

Only known state: As illustrated.

Berlin Photographic Gallery, New York, New York, 1915; Portland Art Association, Portland, Oregon, 1916; Joseph Brummer Galleries, New York, New York, 1921; Syracuse Museum of Fine Arts, Syracuse, New York, 1924; Montgomery Museum of Fine Arts, Montgomery, Alabama, 1982

St. Louis; Worcester

104 Crocodiles c. 1913
Etching
5¼ x 7 5/16 in. (13.4 x 18.6 cm.)

Only known state: Three crocodiles around a pool. Two lie across foreground, a third at far side of rounded pool glares at two figures seen through trees.

105 Pigs at Perdido Bay c. 1913
Etching
4⅞ x 5¾ in. (12.5 x 14.6 cm.)

Only known state: Three pigs in a garden with bushes around them and water beyond, with two long decks reaching into it from left toward center.

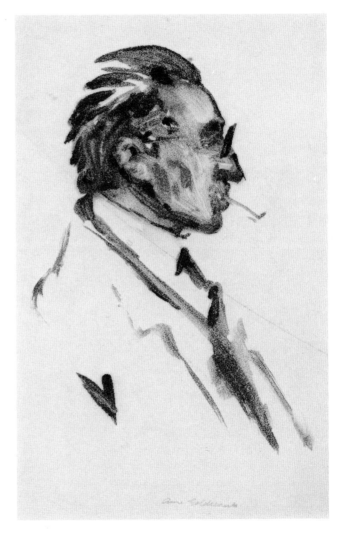

106 Profile Portrait of Roy Frank c. 1913
Color aquatint
6⅞ x 5 in. (17.3 x 12.7 cm.)

Only known state: As illustrated. His face is pink, the rest in tones of grey.

Montgomery Museum of Fine Arts, Montgomery, Alabama, 1982

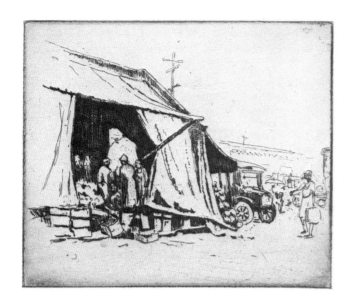

107 Southern Market c. 1913
Etching
4⁵⁄₁₆ x 5⅞ in. (11.2 x 15 cm.)
Arches

Only known state: As illustrated.

Montgomery Museum of Fine Arts, Montgomery,
Alabama, 1982

Some imps. in sepia.

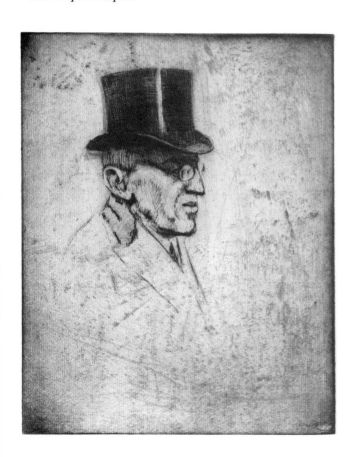

108 Woodrow Wilson c. 1913/14
Etching and aquatint
9¾ x 7¾ in. (24.8 x 19.7 cm.)
Arches

Only known state: As illustrated.

Korner and Wood Company, Cleveland, Ohio, 1942;
M. Knoedler and Company, New York, New York,
1944; Montgomery Museum of Fine Arts,
Montgomery, Alabama, 1982

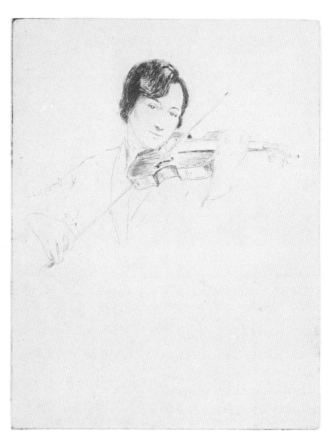

109 Miss Harris Playing the Violin c. 1914
Etching
8⅞ x 6⅞ in. (22.6 x 17.4 cm.)

Only known state: As illustrated. With different
inking—one print wiped absolutely clean, some lines
very faint; another imp. with ink left on plate
throughout and much more harmonious.

Korner and Wood Company, Cleveland, Ohio, 1942

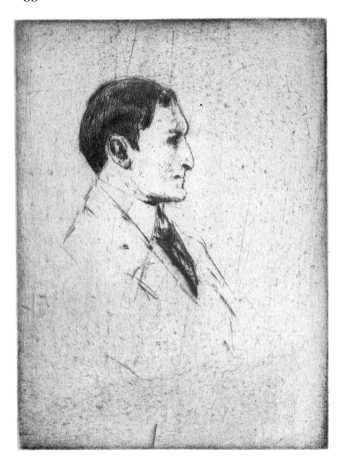

110 **Mr. McAdoo's Profile** c. 1914
Etching and drypoint
7⅞ x 5⅞ in. (20 x 15 cm.)

First state: Before definition of back of coat, shading on desk, etc.

Second state: As illustrated. With these additions.

The sitter is believed to be William Gibbs McAdoo (1863-1941), Secretary of the Treasury in the Cabinet of Woodrow Wilson. Mr. McAdoo married Eleanor Randolph Wilson, the President's daughter, in 1914 and was himself a strong contender for the Democratic nomination for President in 1920 and 1924. He served as a U.S. Senator from California from 1933-39.

111 **Mr. McAdoo Seated** c. 1914
Drypoint
8½ x 6⅞ in. (21.5 x 17.4 cm.)
Japan

Only known state: He is faced toward right, seen in ¾ view. His right hand rests on chair arm.

112 **Portrait of Man in Full Dress** c. 1914
Drypoint
7 x 6¼ in. (17.8 x 15.8 cm.)

Only known state: Head and shoulders of a man in ¾ view left. With flower in buttonhole, white tie and shirt contrasting with dark jacket. A large shadow at left.

113 **For a Soldier** c. 1915
Etching and drypoint
8⅜ x 6⅜ in. (21.3 x 16.3 cm.)
F.J. Head

Only known state: A young girl with dark hair parted on the side and drawn back with a bow, holds her knitting with both hands and looks down at it. Seen in ¾ view to left.

Yale; Honolulu

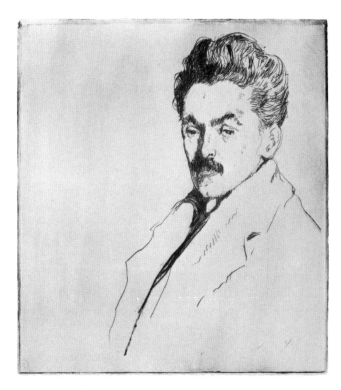

114 **Harry Wehle** c. 1915
Etching and drypoint
7¼ x 6½ in. (18.3 x 16.5 cm.)
Van Gelder with initials VGZ and crowned fleur de lys

First state: Before extension of lines of overcoat to within ¾ inch of lower margin.

Second state: As illustrated. With added lines.

Montgomery Museum of Fine Arts, Montgomery, Alabama, 1982

Harry Wehle (1887-1969) was curator of paintings at the Metropolitan Museum and a close friend of Anne's.

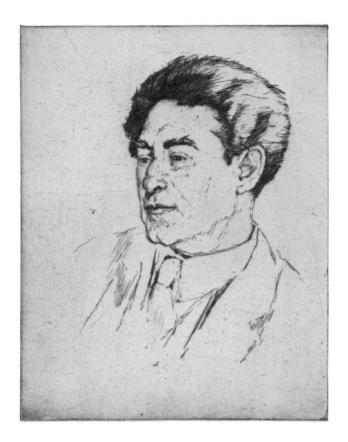

115 Harold Bauer (No. 2) c. 1915
Etching and drypoint
9¹³⁄₁₆ x 7⅞ in. (25 x 20 cm.)
Handmade—Sweden

First state: Mostly etching. Bow of tie only suggested.

Second state: Drypoint additions including a number of diagonal lines on throat. Extension of tie, etc.

Third state: Line of V of coat complete.

Fourth state: As illustrated. Pure etching again. V of coat removed together with shading on neck, etc. Eyebrows changed with diagonal accents.

Syracuse Museum of Fine Arts, Syracuse, New York, 1924; The Corcoran Gallery, Washington, D.C., 1940; Korner and Wood Company, Cleveland, Ohio, 1942; M. Knoedler and Company, New York, New York, 1944; Montgomery Museum of Fine Arts, Montgomery, Alabama, 1977 (cat. 21)

Philadelphia

Published in Fine Prints of the Year 1928, *page 73.*

116 Title Page for *Birds of Florida* c. 1915
Etching
3⅛ x 2³⁄₁₆ in. (7.9 x 5.4 cm.)

Only known state: A Covenhaven duck, with long streamers hanging from its wings, hangs by a string from a branch of a tree above the water.

117 Southern Pines c. 1915
(also called *Alabama Pines*)
Etching
5⅞ x 8⅞ in. (15 x 22.5 cm.)

First state: Across a field, a wide bank of pines; one large single one at right.

Second state: As illustrated, p. 68. A silhouette of what might be a house beyond the bank of pines at left.

Third state: The plate is cut off at both sides to 7 inches in width.

Berlin Photographic Gallery, New York, New York, 1915; Portland Art Association, Portland, Oregon, 1916; Syracuse Museum of Fine Arts, Syracuse, New York, 1924; Montgomery Museum of Fine Arts, Montgomery, Alabama, 1982

One imp. says: "Near Mt. Meigs."

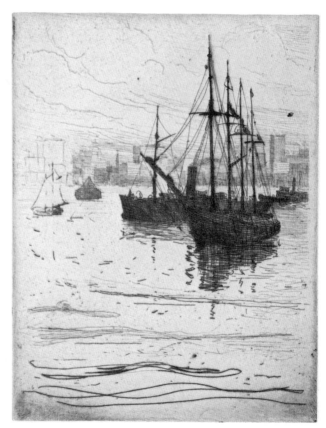

118 New York Harbor c. 1915
Etching
8⅜ x 6⅜ in. (21.2 x 16.5 cm.)
Arches

Only known state: As illustrated.

Berlin Photographic Gallery, New York, New York, 1915; Portland Art Association, Portland, Oregon, 1916; Joseph Brummer Galleries, New York, New York, 1921; Montgomery Museum of Fine Arts, Montgomery, Alabama, 1982

Cleveland; Metropolitan Museum of Art

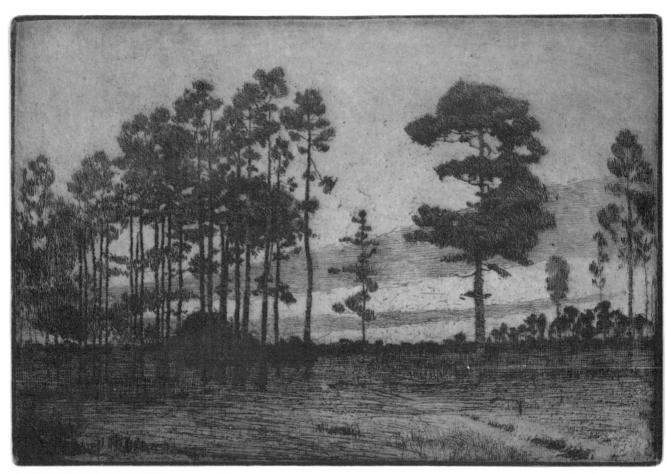

Southern Pines (cat. no. 117)

119 **Milbank Hall, Barnard College** c. 1915
Etching
5¹⁵⁄₁₆ x 6¹⁵⁄₁₆ in. (15.2 x 17.3 cm.)
Japan

Only known state: Facade with front lawn and two
wings at sides coming forward.

Syracuse Museum of Fine Arts, Syracuse, New York,
1924

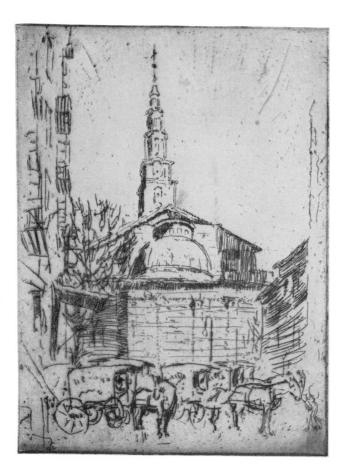

120 **Old St. Johns** c. 1915
Etching
7¾ x 5¾ in. (19.6 x 14.7 cm.)

Only known state: As illustrated.

The Downtown Gallery, New York, New York, 1929;
Montgomery Museum of Fine Arts, Montgomery,
Alabama, 1982

Metropolitan Museum of Art

121 **Little Church Around the Corner** c. 1915
Etching
3⅜ x 4⅜ in. (8.8 x 11.3 cm.)
Handmade—Sweden

Only known state: The church is seen beyond a fence
and a covered shrine holding a statue with cross on
terminal on its roof. A big tree at left.

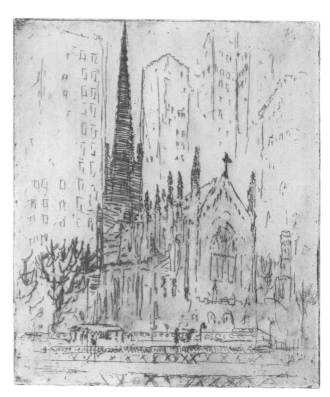

122 **Trinity from the Elevated Station** c. 1915
Etching
6¾ x 5⅞ in. (17.2 x 15.1 cm.)

First state: No branches of tree at right between back
of church and extra turret. Fewer x marks on
elevated.

Second state: As illustrated. With these additions.

*Usually printed in sepia ink for upper section and green
for elevated.*

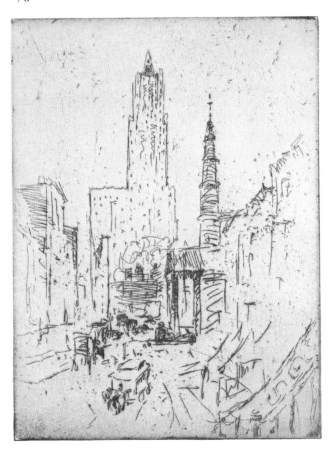

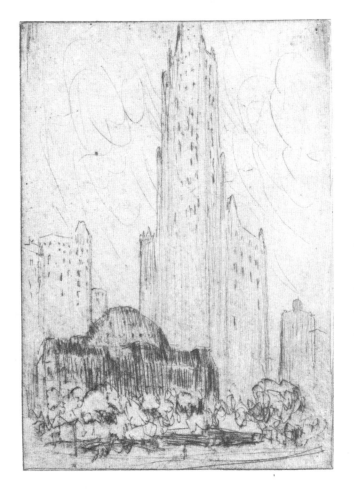

123 Old St. Johns and the Woolworth Building
c. 1915
Etching
7¹³⁄₁₆ x 5⅞ in. (19.9 x 15.1 cm.)
Handmade—Sweden

Only known state: As illustrated.

Montgomery Museum of Fine Arts, Montgomery, Alabama, 1982

124 Lower New York c. 1915
Etching and drypoint
6⅞ x 4⅞ in. (17.5 x 12.5 cm.)
Berkshire Text with "A" and eagle

First state: Before more windows in high tower toward left and before three people in foreground to right.

Second state: As illustrated. With these additions.

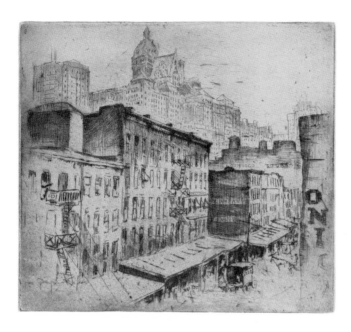

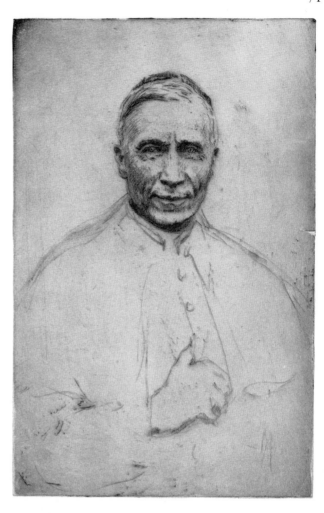

125 **New York Skyscrapers** c. 1915
Etching and drypoint
9⅞ x 8⅞ in. (25.2 x 22.6 cm.)
Arches

First state: Mostly etching before shading on the high
buildings and also the main block of buildings in front
of them.

Second state: As illustrated. With much drypoint
shading added.

Montgomery Museum of Fine Arts, Montgomery,
Alabama, 1982

126 **Sketch of Miss Gladys Baldwin** c. 1915
Drypoint
8¼ x 5⅞ in. (20.9 x 15.1 cm.)
Normandy Vellum

Only known state: Head and shoulders of a young girl
wearing a blouse with a ruffled jacket. Behind her hair,
parted in the middle, are dark ribbons extended on
either side. On her left eyebrow and her upper lip are
pencil lines which may have been added in another
state.

Berlin Photographic Gallery, New York, New York,
1915

127 **Cardinal Gibbons (No. 1)** c. 1915
Etching
9¾ x 6⅜ in. (24.8 x 16.3 cm.)

First state: Lighter etching. Only light shading on top
of cap.

Second state: Dark shading on cap, on eyes, under
chin, etc.

Third state: As illustrated. Shoulders raised; more
detail on robe, tie, buttons; more shadows on cheeks.

*James Cardinal Gibbons (1834-1921) was for 52 years the
ninth Archbishop of Baltimore and for 35 years Cardinal
and dean of the American Roman Catholic hierarchy. He
was an influential author and the first chancellor of the
Catholic University, Washington, D.C.*

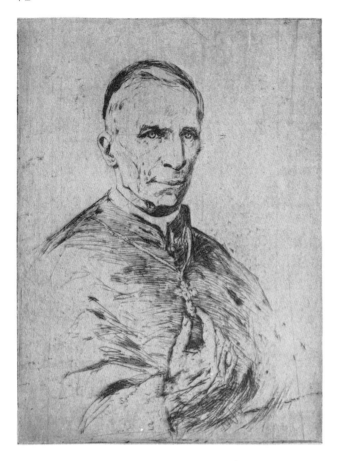

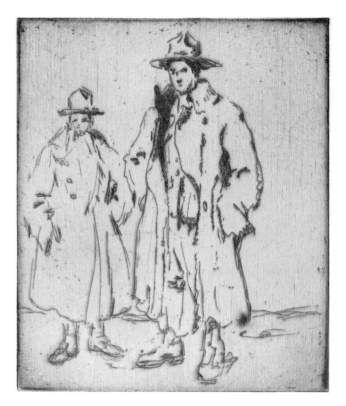

128 Cardinal Gibbons (No. 2) c. 1915
Etching
7⅞ x 5⅞ in. (18 x 15.1 cm.)
Japan

Only known state: As illustrated.

Montgomery Museum of Fine Arts, Montgomery,
Alabama, 1982

Numbered at lower left corner, one to at least 30.

129 Jules Kilmer Korner c. 1916
Etching
10⅛ x 8⁵⁄₁₆ in. (25.7 x 21.2 cm.)
F. J. Head

Only known state: Half-length of sailor in uniform
with white cap, collar and tie.

*Some imps. tinted with tan on face and neck, and shadow
of cap.*

130 U. S. Soldier c. 1915
Etching
7⅞ x 5¹⁵⁄₁₆ in. (19.9 x 15 cm.)
Arches, Japan

Only known state: He is seen in full length resting on
his right leg, left bent a little; he looks off toward left.

131 Two Soldiers at Yaphank c. 1916
Etching
6⅞ x 5¹⁵⁄₁₆ in. (17.3 x 15.1 cm.)

First state: Before plate was beveled with file, minus
perpendicular line on little soldier's coat above his
right leg.

Second state: As illustrated. With file marks of bevel
shaving and with perpendicular lines; also some
scratches on little soldier's chin.

132 Of the London Scottish c. 1916
Etching
7⅞ x 6¾ in. (20 x 17.2 cm.)
Japan

Only known state: A Scotsman in kilt is seen in full
length, facing forward but looking off toward left.

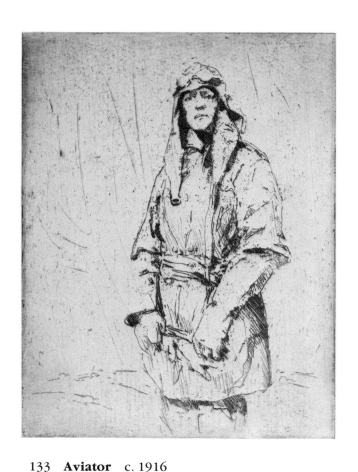

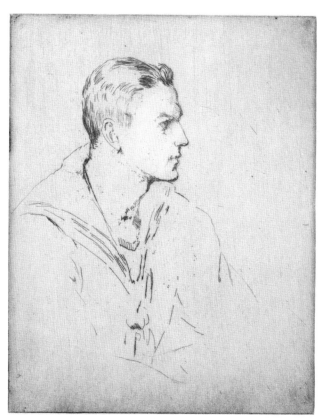

133 **Aviator** c. 1916
(also called *In the Leathers*)
Etching
7⅜ x 5¹⁵⁄₁₆ in. (18.7 x 15 cm.)
F. J. Head, Japan

Only known state: As illustrated. Most imps. have
pencil lines added to further define legs.

Joseph Brummer Galleries, New York, New York,
1921; Montgomery Museum of Fine Arts,
Montgomery, Alabama, 1982

134 **Profile Portrait of a Sailor** c. 1916
Etching
7⅜ x 6 in. (18.7 x 15 cm.)

Only known state: As illustrated.

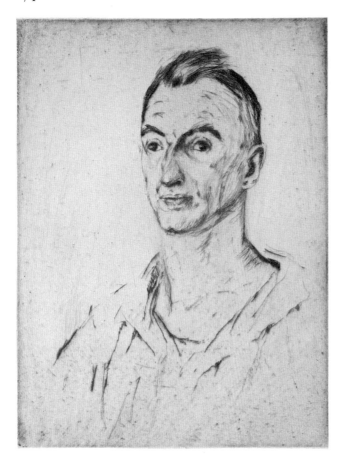

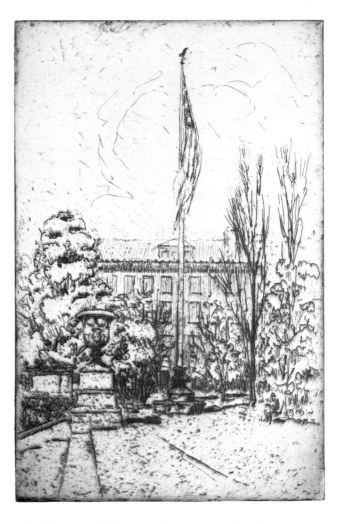

135 Fred Reynolds c. 1916
Etching and drypoint
7 ⅞ x 5 ⅛ in. (19.9 x 13 cm.)
Arches

First state: With line from chin defining neck, later
partly erased.

Second state: As illustrated. With this erasure and lines
added at lower left suggesting upper arms; stronger
lines at right side defining neck.

136 Columbia Library, New York City c. 1916
Etching
4¹⁵⁄₁₆ x 6⅜ in. (12.6 x 16.4 cm.)
Japan

Only known state: Fountain in center of plate, facade
beyond seen in ¾ view.

137 Washington Square, New York City
c. 1916
Etching and drypoint
3⁷⁄₁₆ x 4⁷⁄₁₆ in. (8.8 x 11.2 cm.)

Only known state: With large arch in middle ground.
Three men at center foreground. Trees at sides.

138 The U. S. Flag in a Garden c. 1916
Etching and drypoint
8⅞ x 5 ¾ in. (22.5 x 14.6 cm.)
F. J. Head

Only known state: As illustrated. The house beyond
the garden is shaded with drypoint.

139 The Capitol, Washington, D. C. c. 1916
Etching and drypoint
5¹³⁄₁₆ x 6¹³⁄₁₆ in. (14.2 x 16.7 cm.)
Japan

Only known state: Bushes, cab and path in fore-
ground. Columned facade and dome beyond. Dry-
point in sky at upper right.

140 Portrait of Katherine Dreier (No. 1) c. 1916
Drypoint
8⅞ x 6⅞ in. (22.6 x 17.3 cm.)
Japan

Only known state: The parrot perched on her left hand has his top feathers almost touching her hair.

Katherine Dreier (1877-1952) studied art with Anne's own teacher, Walter Shirlaw, from 1904-1905; however, she is best known as a patroness of the modernist movement in America. She was the founder of Societé Anonyme, Inc.: Museum of Modern Art in 1920 and promoted the work of such artists as Piet Mondrian and Wassily Kandinsky.

141 Portrait of Katherine Dreier (No. 2) c. 1916
Drypoint
8¹⁵⁄₁₆ x 6¹⁵⁄₁₆ in. (22.7 x 17.5 cm.)
Normandy Vellum

Only known state: The parrot perched on her left hand is well detailed. He seems to be turning his head around more to see, possibly, the artist.

142 Portrait of Katherine Dreier (No. 3) c. 1916
Drypoint
9⅞ x 7¹⁵⁄₁₆ in. (25 x 19.9 cm.)
Normandy Vellum

Only known state: Here the parrot is perched on her right hand and his feathers are ruffled as though he were angry. The plaited standing collar of Miss Dreier's dress stands more away from her neck.

Boston; Metropolitan Museum of Art

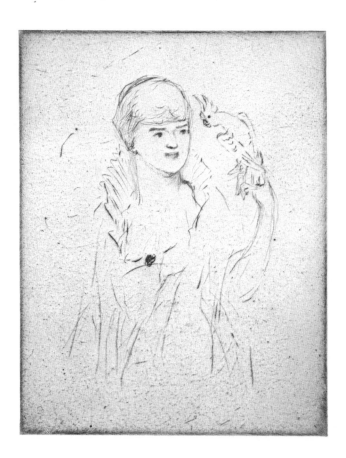

143 Portrait of Katherine Dreier (No. 4) c. 1916
Drypoint
8⅞ x 6⅞ in. (22.4 x 17.5 cm.)

First state: An erased start of her head and that of the parrot can be seen upside down in lower part of plate.

Second state: Now no longer visible. A sharp line added on the bridge of her nose, later removed. Dark corners to her mouth later softened. Her arm still not fully described.

Third state: As illustrated. The long line of her neck from the ear down much better described with one strong line. Her hair across the front has more detailing. Her arm below the wrist more defined.

144 Child with a Lute c. 1917
(also called *The Little Musician*)
Etching
2½ x 2⅜ in. (6.3 x 6.2 cm.)

Only known state: Small child wearing a loose robe sits on the floor and strums a lute which rises above her blond head.

145 Aeolian Hall c. 1917
(also called *The Recital*)
Etching
4¹⁵⁄₁₆ x 5¹⁵⁄₁₆ in. (12.5 x 15 cm.)

Only known state: As illustrated. Early imps. have sharp edges to plate, later filed so that file marks show on all four sides.

The Downtown Gallery, New York, New York, 1922; Syracuse Museum of Fine Arts, Syracuse, New York, 1924

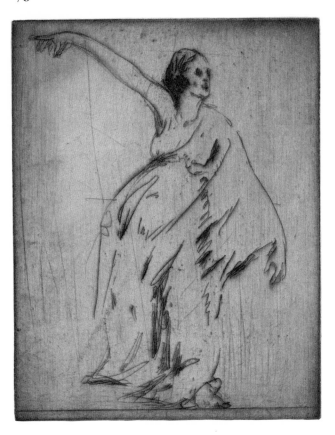

146 Isadora Duncan Dancing to La Marseillaise
c. 1916
(also called *La Marseillaise—The Night of the Russian Revolution*)
Etching
7 ¾ x 6 ⅛ in. (19.7 x 15.6 cm.)

Only known state: As illustrated.

Portland Art Association, Portland, Oregon, 1916;
Montgomery Museum of Fine Arts, Montgomery,
Alabama, 1982

The artist wrote in margin: "one print only" and also: "Night of the Russian Revolution." As the Russian Revolution occurred in 1917, this information was probably added at a later date.

147 Victoria Reclining on a Sofa c. 1917
Etching
7 ⅜ x 15¹⁵⁄₁₆ in. (18.7 x 40.3 cm.)
Thin China and Van Gelder

Only known state: Young girl, with dark curls laying forward over her shoulders, wearing black ballet slippers with crossed ribbons; leans her head on her left hand, her index finger raised.

148 Victoria in a Lace Hat c. 1917
Etching
7 ⅞ x 6 ¾ in. (20 x 17.2 cm.)
Thin China and Van Gelder with fleur de lys

Only known state: A ¾ length view of a girl, with a long dark curl over each shoulder, holds on to her big lace hat by a narrow ribbon held in her right hand.

Philadelphia

149 Victoria Seated c. 1917
Etching
6 ⅞ x 5 ⅞ in. (17.3 x 15.1 cm.)
Thin China

Only known state: Young girl wearing a very big lace hat holds it on by a long ribbon which she holds in her left hand. Her long dark curls hang over her shoulders, her wide skirt billows around her.

Late imps. have acid marks at upper right corner.

150 Victoria Standing c. 1917
Etching
7 ⅞ x 6 ⅞ in. (20 x 17.5 cm.)

Only known state: Seen in profile to right with a very large hat hanging down her back.

Yale; Philadelphia; Worcester

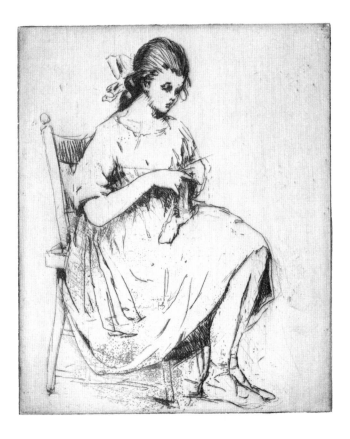

151 **A Young Girl of 1917** c. 1917
Etching
5¹⁵⁄₁₆ x 4¾ in. (15 x 12 cm.)
F. J. Head

Only known state: As illustrated.

Springfield

Some imps. with watercolor added. Green chair, tan stockings, blue bow, brown stocking on which she is knitting (one with pink slippers).

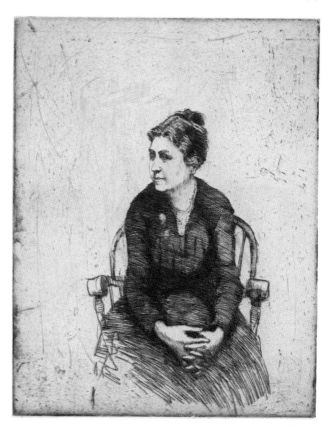

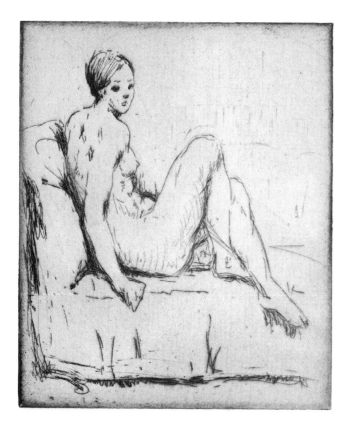

152 **Nude Seated on a Couch** c. 1917
Etching
5⅞ x 4⅞ in. (15 x 12.5 cm.)

Only known state: As illustrated.

Montgomery Museum of Fine Arts, Montgomery, Alabama, 1982

153 **Portrait of Viola Roseboro: Three-quarter View** c. 1917
Etching
9⅞ x 7⅞ in. (25.1 x 20.1 cm.)
F. J. Head

Only known state: As illustrated.

Montgomery Museum of Fine Arts, Montgomery, Alabama, 1982

154 **Portrait of Viola Roseboro Seen in Profile**
c. 1917
Etching and drypoint
9⅞ x 9 in. (25 x 22.9 cm.)
F. J. Head

Only known state: She sits in a low arm chair with her arms resting on those of the chair. Her relaxed hands hang; the right one featured at left. She looks to the left.

Joseph Brummer Galleries, New York, New York, 1921; Syracuse Museum of Fine Arts, Syracuse, New York, 1924

Metropolitan Museum of Art

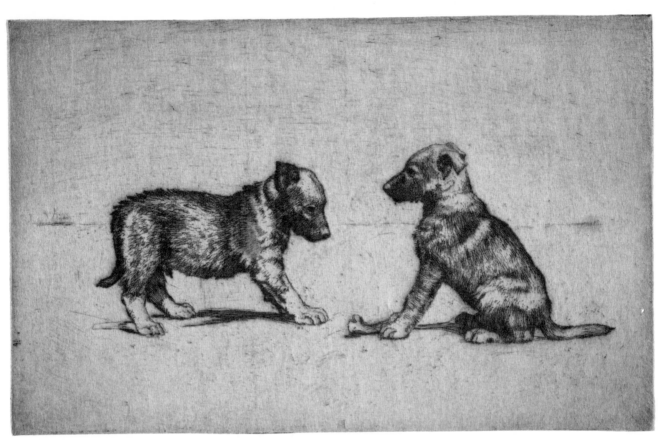

Two Puppies (cat. no. 157)

155 Portrait of Mrs. Lippman c. 1917/18
Drypoint
8⅜ x 6½ in. (21.2 x 16.4 cm.)
Japan

Only known state: She looks directly at observer.
Wears earrings and long beads, a characterful woman.

156 French Poodle c. 1918
Etching
4¹⁵⁄₁₆ x 6⅞ in. (12.6 x 17.5 cm.)

Only known state: The poodle, with long hair
covering his eyes, turns his head somewhat left, but
faces toward right.

An unfinished state.

157 Two Puppies c. 1918
Etching
4¹⁵⁄₁₆ x 7¹⁵⁄₁₆ in. (12.6 x 20.2 cm.)
Japan

Only known state: As illustrated, p. 78.

Montgomery Museum of Fine Arts, Montgomery,
Alabama, 1982

One proof only.

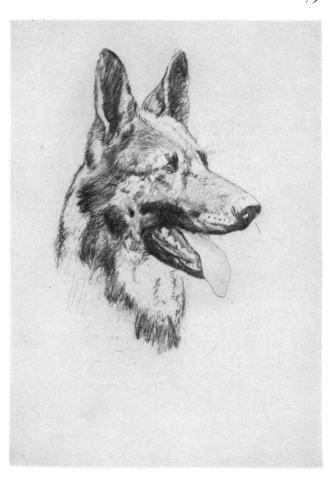

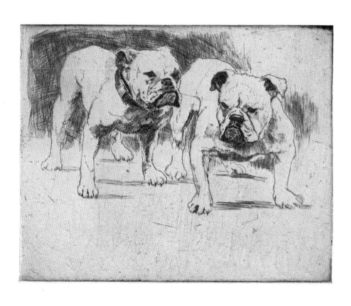

158 Two Bull Dogs c. 1918
Etching
7⅞ x 9⅞ in. (20 x 25 cm.)

Only known state: As illustrated.

Montgomery Museum of Fine Arts, Montgomery,
Alabama, 1982

*Artist made notation: "D. R. and me together." D. R. is
David Rosen, her teacher in Paris and her good friend.*

159 The Alert c. 1918
Etching and drypoint
7¹³⁄₁₆ x 5⅞ in. (19.9 x 15 cm.)
Handmade—Sweden; Berkshire Text

First state: Pure etching with white tongue and much
less shading.

Second state: As illustrated. With shaded tongue and
much darker ruff, etc., signed: "Robert Armistead."

Artist notes: "David and I Together Reverment of Major."

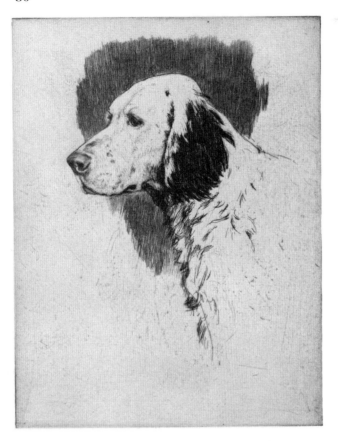

160 Head of Setter c. 1918
Etching
8⅞ x 6⅞ in. (22.5 x 17.5 cm.)
Handmade—Sweden

Only known state: As illustrated.

*Signed in pencil: ''Robert Armistead'' in artist's
handwriting.*

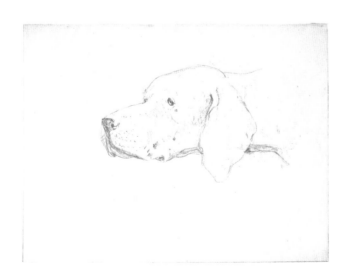

161 Head of White Pointer c. 1918
Etching
9¹⁵⁄₁₆ x 11⅞ in. (25.2 x 30 cm.)
Berkshire

First state: Before whiskers are added. Far eye lighter,
top of head has different outline.

Second state: As illustrated. With these changes.

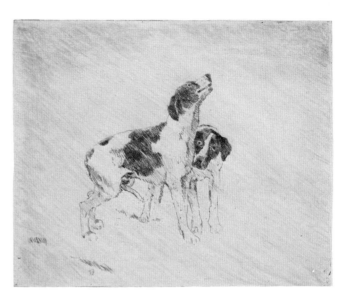

162 Pointers in a Storm c. 1918
Etching and drypoint
8¹⁵⁄₁₆ x 10¹⁵⁄₁₆ in. (22.7 x 27.8 cm.)

Only known state: As illustrated.

*This print was reproduced in facsimile on Japan with a
plate-line indented. Marked in artist's handwriting:
''Copy.''*

163 Two Pointers by the Shore c. 1918
Etching and drypoint
6¹⁵⁄₁₆ x 8⅞ in. (17.7 x 22.6 cm.)
Japan, Normandy Vellum

First state: Left hand dog has four feet on ground. No
shoreline visible.

Second state: Dog has left foreleg raised, shoreline
added.

164 Two Pointers in the Field c. 1918
Etching
6⅞ x 8⅞ in. (17.5 x 22.5 cm.)

Only known state: Nearer dog points to left with left
foreleg raised. Other one is farther away.

Edges of plate filed.

165 Two Pointers on a Hilltop c. 1918
Etching
5⅞ x 8⅞ in. (15 x 22.4 cm.)

Only known state: Nearer dog advances forward right, followed by other one which is more spotted.

Edges of plate filed.

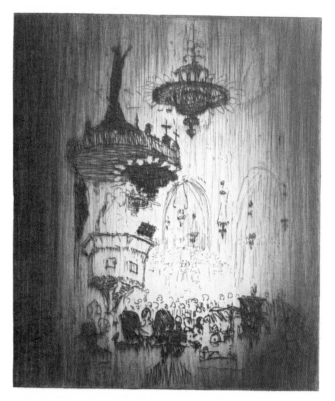

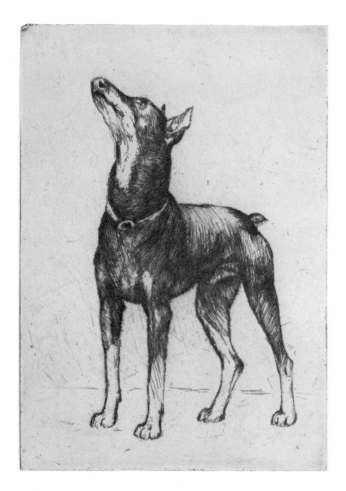

166 Captain c. 1918
Etching and drypoint
5¹⁵⁄₁₆ x 4¼ in. (15.2 x 10.7 cm.)

First state: Etching only; much lighter.

Second state: As illustrated. Deeply shaded with drypoint.

167 Church of St. Mary the Virgin, 46th St., N.Y.
c. 1918
Etching
9⅞ x 7⅞ in. (25.2 x 20.1 cm.)

Only known state: Gothic facade with crucifixion and two supporting figures above central entrance.

Metropolitan Museum of Art

168 Interior, St. Mary the Virgin c. 1918
Etching and drypoint
6⅞ x 5⅞ in. (17.7 x 15.1 cm.)
F. J. Head

First state: Pulpit, chandelier and foreground people etched. Before dark shadow at left.

Second state: As illustrated. With that shadow and shading in foreground at top.

Montgomery Museum of Fine Arts, Montgomery, Alabama, 1982

169 Detail of Facade, St. Mary The Virgin, 46th St., N.Y. c. 1918
(also called *The Calvary*)
Etching
8⅞ x 7⅞ in. (22.7 x 20.3 cm.)
F. J. Head

First state: Crucifixion with two female saints. Face on saint at left with clearer features.

Second state: With more shading on face of left-hand saint.

Joseph Brummer Galleries, New York, New York, 1921

170 **Shrine Figure: The Virgin (No. 1)** c. 1918
Etching
10⅝₁₆ x 8⅝₁₆ in. (26.4 x 21.2 cm.)
F. J. Head

Only known state: Head smaller—shadow of figure on wall with diagonal lines all parallel from upper left to lower right.

171 **Shrine Figure: The Virgin (No. 2)** c. 1918
Etching
7¹⁵⁄₁₆ x 6⅞ in. (20.1 x 17.5 cm.)
F. J. Head

Only known state: With head somewhat larger—shadow of figure on wall with many overlapping lines.

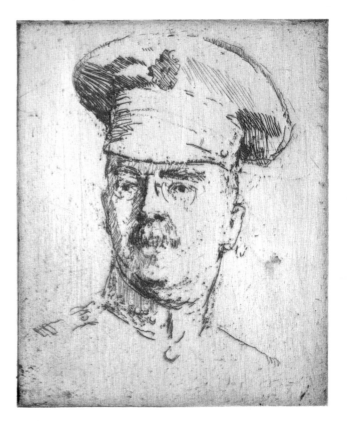

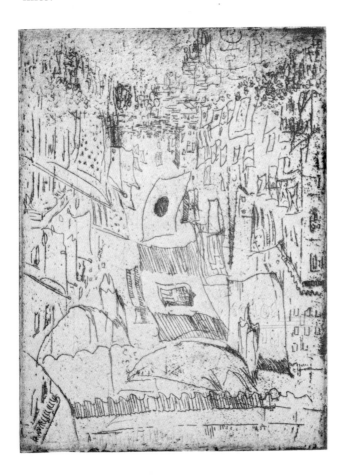

172 **Avenue of the Allies—5th Avenue, 1918**
c. 1918
Etching
7⅞ x 5⅞ in. (19.9 x 15.1 cm.)
Japan

Only known state: As illustrated.

Montgomery Museum of Fine Arts, Montgomery, Alabama, 1982

National Museum of American Art; Philadelphia

173 **Captain Edward Lowry (No. 1)** 1918
Etching
6 x 4⅞ in. (15 x 12.5 cm.)

Only known state: As illustrated. Head only, looking slightly to left.

Done in January, 1918.

174 **Captain Edward Lowry (No. 2)** c. 1918
Etching
10⅞ x 8⅞ in. (27.8 x 22.7 cm.)
Arches

First state: In overcoat, insignia on cap smaller; no braid, ear lighter, etc.

Second state: Shadows on face darker. Shadow on collar at left extended; insignia larger, etc.

Joseph Brummer Galleries, New York, New York, 1921; Syracuse Museum of Fine Arts, Syracuse, New York, 1924; Korner and Wood Company, Cleveland, Ohio, 1942

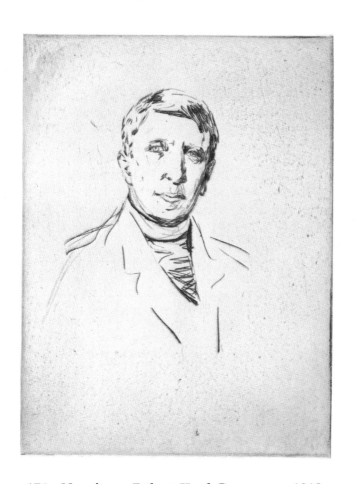

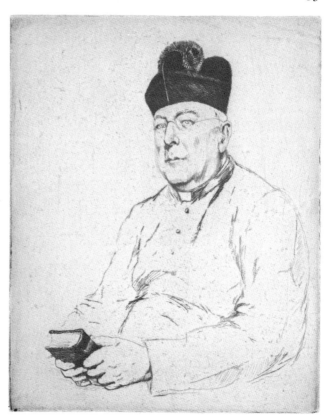

175 **Monsignor Robert Hugh Benson** c. 1918
Drypoint
8⅜ x 6⅜ in. (21.4 x 16.4 cm.)
Umbria Italy, Van Gelder, and monogram ''P. C.''

Only known state: As illustrated.

Library of Congress

Edition of 50—numbered at lower left corner.

176 **Dr. Joseph Berry** c. 1918
(also called *Portrait of an Ecclesiastic*)
Etching
10⅞ x 8⅞ in. (27.6 x 22.4 cm.)
Arches

Only known state: As illustrated.

Joseph Brummer Galleries, New York, New York,
1921; Syracuse Museum of Fine Arts, Syracuse, New
York, 1924; Exposition de la Gravure Moderne
Americaine, Bibliothèque Nationale, Paris, 1928;
Korner and Wood Company, Cleveland, Ohio, 1942;
M. Knoedler and Company, New York, New York,
1944

Philadelphia; Museum of Modern Art; Metropolitan
Museum of Art

*Dr. Joseph Berry was the pastor of St. Mary the Virgin, a
frequent subject in Anne's graphic work.*

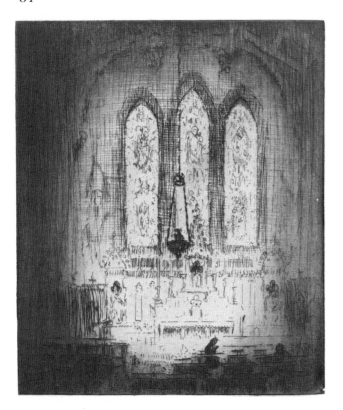

177 Lady Chapel: St. Mary The Virgin c. 1918
Etching and drypoint
6⅞ x 5⅞ in. (17.7 x 15 cm.)
J. Green and Son, F. J. Head

First state: Before more drypoint shading at left.

Second state: As illustrated. With this shading, sometimes with much ink left on plate.

Montgomery Museum of Fine Arts, Montgomery, Alabama, 1982

178 Self-portrait c. 1918
Etching
9⅞ x 7⅞ in. (24.9 x 20 cm.)

First state: Before slightly diagonal shading added under her chin on her collar at right, and before three accenting lines on her shoulder at left.

Second state: As illustrated, frontispiece. With these additions.

Exposition de la Gravure Moderne Americaine, Bibliothèque Nationale, Paris, 1928; M. Knoedler and Company, New York, New York, 1944; Montgomery Museum of Fine Arts, Montgomery, Alabama, 1982

Brooklyn; Yale; National Museum of American Art; Newark; Philadelphia; Cleveland; Museum of Modern Art; Metropolitan Museum of Art

179 Gladys Baldwin (Mrs. Stringfellow Barr) (No. 1) c. 1919
Drypoint
7⅞ x 6 in. (20.1 x 15.1 cm.)
Japan and monogram crowned fleur de lys

First state: Detail at top of right sleeve resembles 6/7; termination of scrolled detail at bow center resembles an S.

Second state: Three small parallel lines added over 6/7; work over S with 2 series of 3 diagonal lines added. Plate edges beveled in this state.

Joseph Brummer Galleries, New York, New York, 1921

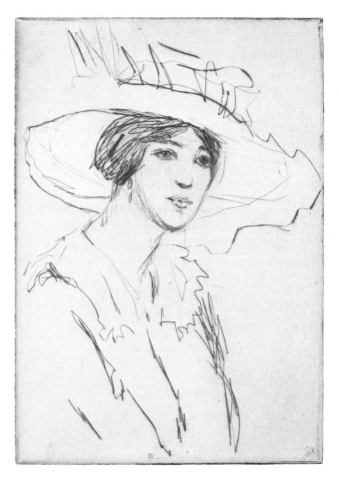

180 Gladys Baldwin (Mrs. Stringfellow Barr) (No. 2) c. 1919
Drypoint
6⁷⁄₁₆ x 4⁹⁄₁₆ in. (16.4 x 11.6 cm.)
Laid papers

Only known state: As illustrated.

Montgomery Museum of Fine Arts, Montgomery, Alabama, 1982

One print from this plate.

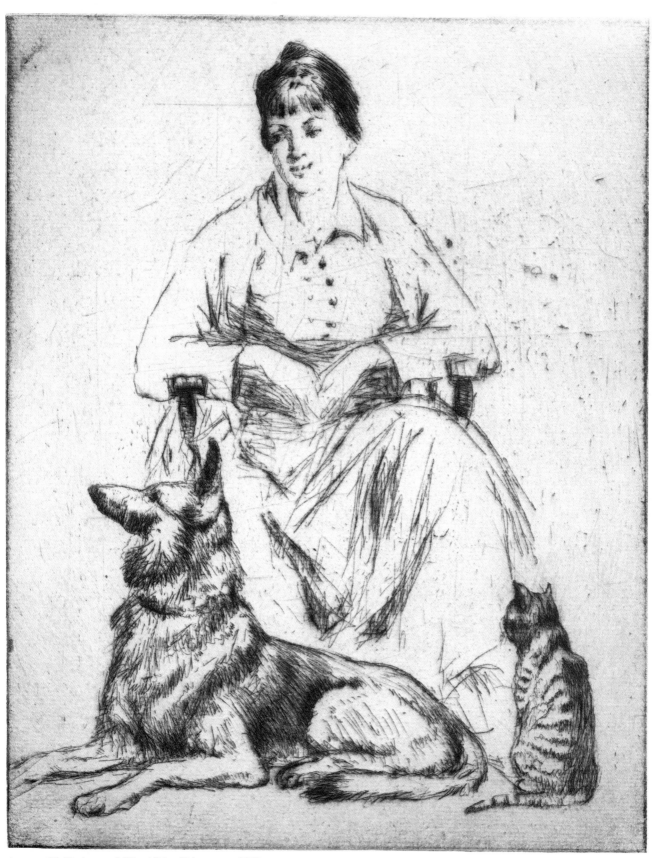

Anne with Major and Mimi (No. 3) (cat. no. 183)

181 Anne with Major and Mimi (No. 1) c. 1916
Etching
9¾ x 7¾ in. (24.6 x 19.6 cm.)

Only known state: With cat turned toward right and looking toward Major.

One print from this plate.

182 Anne with Major and Mimi (No. 2) c. 1919
Etching
9⅞ x 7⅞ in. (25.1 x 20 cm.)
Normandy Vellum

Only known state: Mimi turned more toward center; Major has right ear thrown back.

One print from this plate.

183 Anne with Major and Mimi (No. 3) c. 1919
(also called *Trio*)
Etching
9⅞ x 7⅞ in. (25.2 x 20 cm.)
Arches

First state: Working proof with pencil lines outlining both animals.

Second state: As illustrated, p. 85. Completed with corrected outlines; Major has both ears erect.

U.S. National Museum, 1929

Metropolitan Museum of Art

184 Saturday c. 1920
(also called *Saturday in Alabama*)
Etching
6⅞ x 8⅞ or 7 x 8¾ in. (17.5 x 22.4 or 17.7 x 22.2 cm.)

Only known state: As illustrated, p. 136.

Joseph Brummer Galleries, New York, New York, 1921; Syracuse Museum of Fine Arts, Syracuse, New York, 1924; Chicago International Exhibition of Etchings, Chicago, Illinois, 1924; Korner and Wood Company, Cleveland, Ohio, 1942; Montgomery Museum of Fine Arts, Montgomery, Alabama, 1982

Cleveland; National Museum of American Art; Philadelphia; Museum of Modern Art; Metropolitan Museum of Art

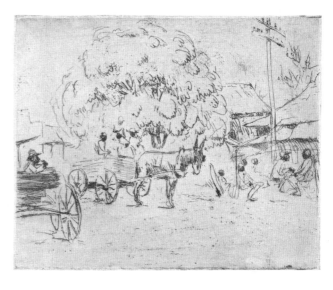

185 Boguehomme c. 1920
Etching
6¼ x 7¼ in. (15.8 x 18.4 cm.)
Porcaboeuf, Arches

Only known state: As illustrated.

The Downtown Gallery, New York, New York, 1929; Montgomery Museum of Fine Arts, Montgomery, Alabama, 1977 (cat. 4); Montgomery Museum of Fine Arts, Montgomery, Alabama, 1982

Worcester; National Museum of American Art; Boston; Philadelphia; Metropolitan Museum of Art

Later imps. have beveled edges to plate; earlier ones do not.

186 Negro Women at a Fountain c. 1920
Etching
5⅞ x 6¹⁵⁄₁₆ or 6 x 6¾ in. (15 x 17.5 or 15.2 x 17.1 cm.)
F. J. Head, Arches

Only known state: As illustrated.

Joseph Brummer Galleries, New York, New York,
1921; Montgomery Museum of Fine Arts,
Montgomery, Alabama, 1982

Wadsworth Atheneum; National Museum of
American Art; Philadelphia; Boston; Metropolitan
Museum of Art

*Later imps. have beveled edges to plate; early ones do not.
Both black and sepia ink used.*

187 Cotton Wagons in Court Square c. 1920
Etching
5⅞ x 6⅞ in. (15 x 17.3 cm.)
"Clearwater"

First state: Without background buildings and
fountain. No shading on bales—only one man below.

Second state: As illustrated, p. 12. With these additions;
also the man standing next to back wheel of the wagon
is talking to another man.

Joseph Brummer Galleries, New York, New York,
1921; Syracuse Museum of Fine Arts, Syracuse, New
York, 1924; M. Knoedler and Company, New York,
New York, 1944; Montgomery Museum of Fine Arts,
Montgomery, Alabama, 1977 (cat. 32); Montgomery
Museum of Fine Arts, Montgomery, Alabama, 1982

188 Carnival c. 1921
Etching and drypoint
6⅜ x 8¼ in. (16.3 x 20.9 cm.)
Arches, Van Gelder

First state: Sharp edges to plate, clown's hand faint.

Second state: As illustrated, p. 88. Edges of plate filed.
Clown's head and hand accented, also lines added.
Sharp lines on her cheek and arm and partner's neck.

Joseph Brummer Galleries, New York, New York,
1921; Montgomery Museum of Fine Arts,
Montgomery, Alabama, 1982

Philadelphia; Springfield; Metropolitan Museum
of Art

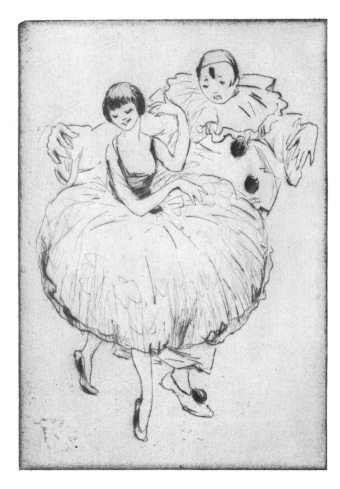

189 Pierrot and Columbine c. 1921
Etching and drypoint
6¹³⁄₁₆ x 4⅞ in. (17.5 x 12.5 cm.)
J. Green and Son

First state: Before accent and deep etching on her
hair, his right hand, and both costumes.

Second state: As illustrated. With these additions.

190 Christmas Story c. 1921
Drypoint
6¹⁵⁄₁₆ x 5⅜ in. (17.6 x 13.7 cm.)
Japan

Only known state: A young girl with her hair piled
high with curls, is seated on the floor in profile to
right. A younger child beyond has an arm around her
shoulders. They both look down at a large book. A
large Christmas wreath hangs in a window above
them.

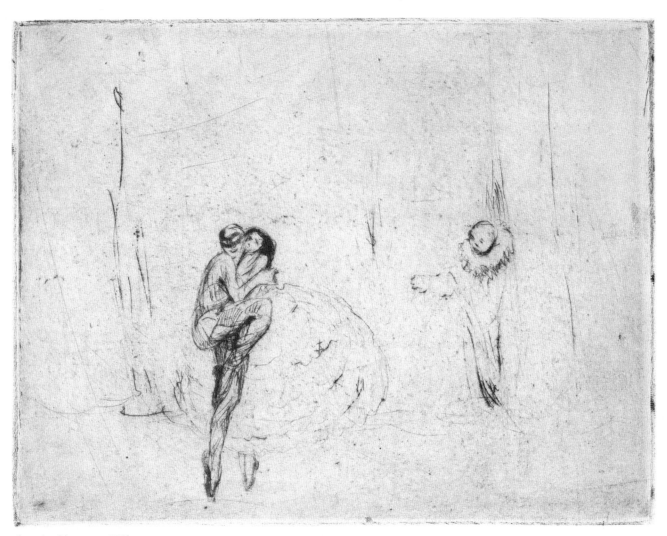

Carnival (cat. no. 188)

191 Fairy Tales (No. 1) c. 1921
(also called *Sisters*)
Etching and drypoint
6 x 8 in. (15.1 x 20.2 cm.)
Japan

Only known state: An older girl with her hair in a high bun sits on the floor reading a book to her younger sister, who sits on a stool next to her.

Honolulu

192 Fairy Tales (No. 2) c. 1921
(also called *Sisters*)
Etching and drypoint
5⅞6 x 4¹⁵⁄16 in. (13.9 x 12.7 cm.)
Japan

First state: An older girl sits on the floor and reads a book to a child in a chair next to her.

Second state: Drypoint accenting child's shoulders added. Profile of girl changed.

Third state: Profile of girl changed again. Much more work on her dress.

Korner and Wood Company, Cleveland, Ohio, 1942

193 Mike, from the Bowery c. 1921
Etching
7¹⁵⁄16 x 5¹⁵⁄16 in. (20.2 x 15 cm.)

Only known state: As illustrated.

Montgomery Museum of Fine Arts, Montgomery, Alabama, 1982

194 The Kiss c. 1921
Etching and drypoint
7⅞ x 9¾ in. (20 x 25 cm.)
Handmade—Sweden

First state: A young woman lounges in a big overstuffed armchair with her long legs bent and both feet on the floor. She is kissed by a nude young child who stands at right and leans over to kiss her.

Second state: Plate reworked at left to wipe out outline of legs.

Third state: Right leg extended almost to left margin.

Fourth state: Drapery of long skirt over extended leg reworked, including folds above left shoe.

Springfield

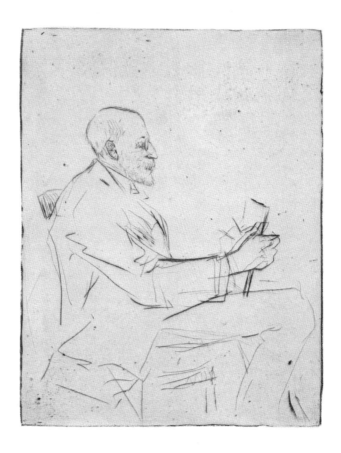

195 Mr. Yeats Drawing the Portrait of a Young Lady c. 1922
Etching
9¹³⁄₁₆ x 7¾ in. (25 x 19.8 cm.)
Handmade—Sweden, Arches

Only known state: As illustrated.

M. Knoedler and Company, New York, New York, 1944; Montgomery Museum of Fine Arts, Montgomery, Alabama, 1982

Brooklyn; Philadelphia; Baltimore; Museum of Modern Art; Metropolitan Museum of Art

196 Bookplate of Herman and Paul Jaehne (No. 1) c. 1922
Etching
4⅞ x 3⅞ in. (12.4 x 9.7 cm.)

First state: Design complete showing an elaborate bay window with silhouetted figure in lower left-hand window. Above: "Ex Libris;" below: "Herman & Paul/Jaehne."

Second state: With her initials "A. G." at lower left above the "er" in Herman.

197 Bookplate of Herman and Paul Jaehne (No. 2) c. 1922
Etching
5⅝ x 4⅝ in. (14.2 x 11.8 cm.)

First state: Design completed of elaborate bay window of their home, with silhouette of a man in profile right holding a book in lower left section of a six-sectioned window.

Second state: With initials "A. G." added toward lower left. Above the drawing of the bay window is: "Ex Libris," below it: "Herman and Paul Jaehne."

198 The Jaehne House c. 1922
Etching
9¾ x 7⅞ in. (24.9 x 20 cm.)
Arches

First state: The edge of the step at left is dark. The upper diagonal railing has no socket.

Second state: With socket added and a dark line outlining the bottoms of the edge of the step.

Third state: The edge of step and line of bottom step removed. A suggestion of bricks at right and left of bay added. Detail and shading of lower window added.

Fourth state: As illustrated. With shadow of bay added at right. Window of door at right has different panes and other changes.

Syracuse Museum of Fine Arts, Syracuse, New York, 1924; Montgomery Museum of Fine Arts, Montgomery, Alabama, 1982

Yale; Newark; Boston; Philadelphia; Honolulu; Cleveland; Worcester

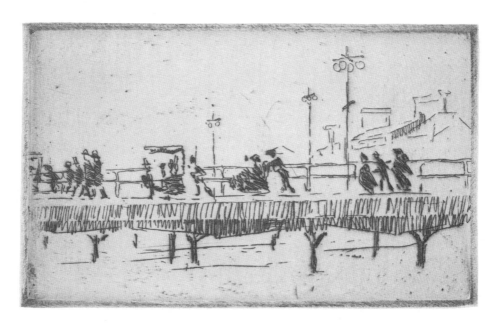

199 Boardwalk c. 1922
Etching
2^{15}/$_{16}$ x 4^{15}/$_{16}$ in. (7.5 x 12.5 cm.)
Van Gelder Zonen

Only known state: As illustrated.

Montgomery Museum of Fine Arts, Montgomery, Alabama, 1982

Boston

Some imps. printed in sepia.

200 Bookplate for Alabama State Department of Archives and History 1922
Etching
3 1/$_{8}$ x 2^{7}/$_{16}$ in. (8 x 6.1 cm.)
China paper

Only known state: Against a spreading tree rests the map of Alabama. This design is signed: "Anne Goldthwaite 1922." Below is the title as above, with an added line: "Founded 1901 by Thomas M. Owen." Above on a ribbon: "Here We Rest."

201 Bookplate of Alabama State Department of Archives and History 1922
Etching
4 ⅛ x 3 ⅝ in. (10.4 x 9 cm.)
China paper

Only known state: Scroll with map of the state resting against a tree. Above this, a banderolle with legend: "Here We Rest." Below the title: ALABAMA/State Department of/Archives and History/founded 1901 by Thomas M. Owen. Under the tree somewhat to left is: "Anne Goldthwaite 1922."

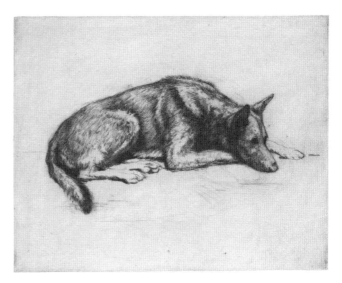

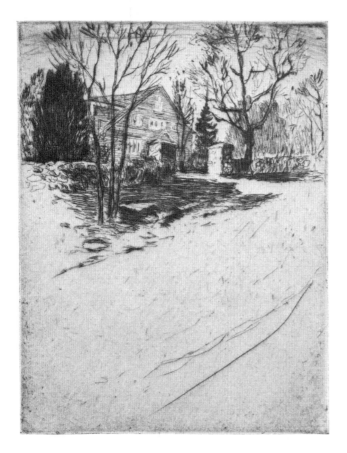

202 The Ledges, Christmas 1922 c. 1922
Etching and drypoint
4 ⅜ x 3 ⁷⁄₁₆ in. (11.2 x 8.4 cm.)

First state: Before leaves at top of tree at left and before long drypoint line outlining road at lower right.

Second state: As illustrated. With these additions.

Third state: With "The Ledges, Christmas 1922" across plate close to bottom—on folded paper for correspondence in this state.

In artist's writing: "The Ledges Bookplate for John Dorr."

203 Major c. 1922
Etching
7¹³⁄₁₆ x 9⅞ in. (19.8x 25 cm.)

Only known state: As illustrated.

Syracuse Museum of Fine Arts, Syracuse, New York, 1924; Montgomery Museum of Fine Arts, Montgomery, Alabama, 1982

Boston; Metropolitan Museum of Art

Early imps. with sharp plate-line, later ones beveled.

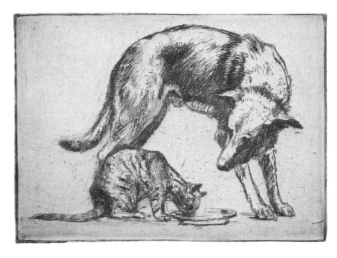

204 Major and Minnie c. 1922
Etching
5 x 7 in. (12.7 x 17.7 cm.)

First state: Before plate was beveled; with thicker end to dog's tail.

Second state: As illustrated. Tail thinner, plate beveled.

Syracuse Museum of Fine Arts, Syracuse, New York, 1924

Yale; Newark; Worcester

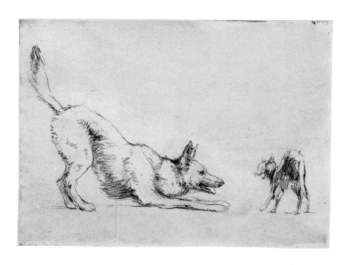

205 Major and the Janitor's Cat c. 1922
(also called *The Stray Cat*)
Etching and drypoint
6⅞ x 9⅞ in. (17.6 x 25.2 cm.)
Umbria Italy, Japan

First state: With light eye; ear with little hair.

Second state: Fuzz of hair over ear; tip of tail darker.

Third state: As illustrated. Black drypoint behind ear.

Syracuse Museum of Fine Arts, Syracuse, New York, 1924

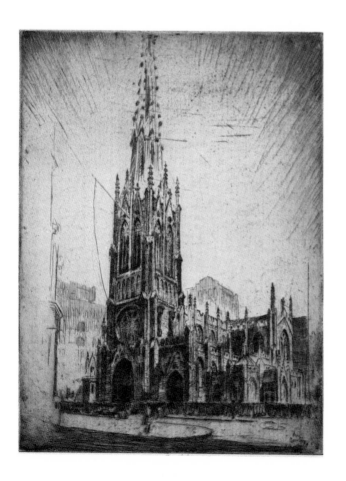

206 Grace Church, Broadway c. 1923
Etching and drypoint
11⅞ x 8⅞ in. (30.2 x 22.5 cm.)
Arches

Only known state: As illustrated.

Syracuse Museum of Fine Arts, Syracuse, New York, 1924; Montgomery Museum of Fine Arts, Montgomery, Alabama, 1982

Artist notes: "Done for Hilma Holmes."

207 St. Thomas—5th Avenue, N.Y.C. c. 1923
Etching
11¾ x 8⅝ in. (29.9 x 21.9 cm.)

First state: Design completed before false biting patch at upper left in sky. Before beveling of plate.

Second state: As illustrated, p. 94. With these changes.

Syracuse Museum of Fine Arts, Syracuse, New York, 1924

Some imps. in sepia.

208 Madison Square c. 1923
Drypoint
10⅞ x 8¾ in. (27.8 x 22.2 cm.)
Berkshire text with "A" and eagle

Only known state: Autos and trees in foreground; very high tower beyond in center.

209 The Plaza c. 1923
Drypoint
9⅞ x 7¾ in. (25.2 x 20 cm.)
Berkshire text with "A" and eagle

First state: Before shading on building at extreme left and on cart at extreme right and on lower section of fountain at right.

Second state: With these additions.

210 Court Street Methodist Church, Montgomery, Alabama c. 1923
Etching
11⅞ x 8¹³⁄₁₆ in. (30.2 x 22.5 cm.)
Van Gelder Zonen

First state: Before shading on curb and finishing of left steeple, and before two walking figures at left.

Second state: With these additions.

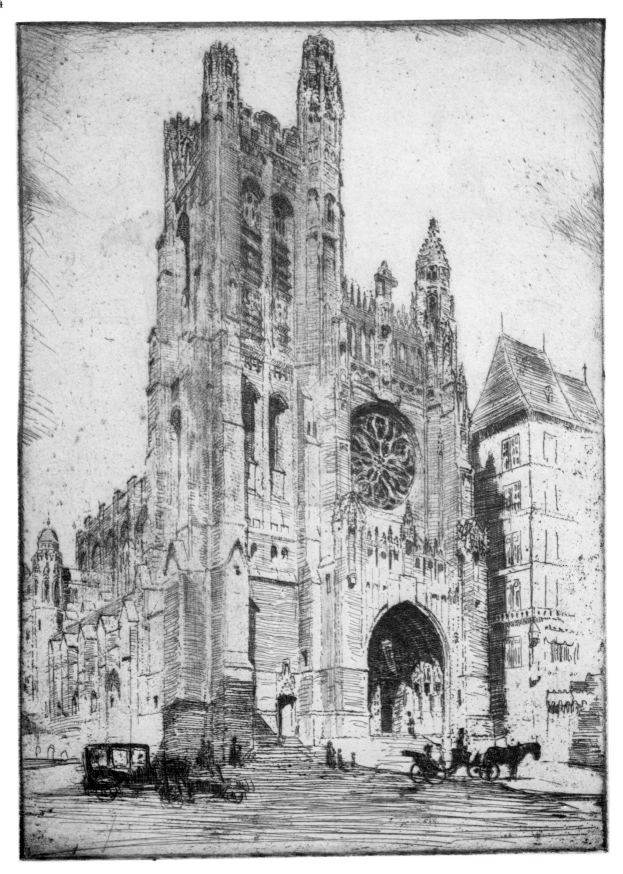

St. Thomas—5th Avenue, N.Y.C. (cat. no. 207)

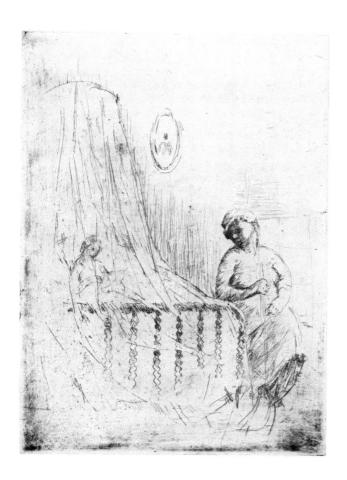

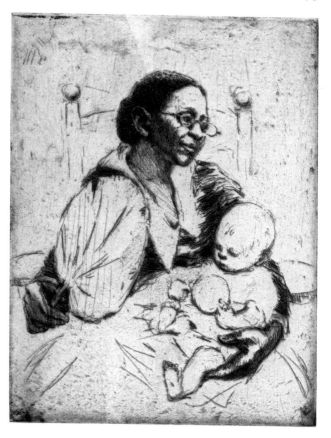

211 **The Mosquito Net** c. 1923
Etching and drypoint
7 ¾ x 6 in. (19.6 x 15.2 cm.)

First state: Design complete except for eye of woman in bed under the net.

Second state: As illustrated. With that addition.

The Downtown Gallery, New York, New York, 1929; Montgomery Museum of Fine Arts, Montgomery, Alabama, 1982

Philadelphia; Metropolitan Museum of Art

212 **His Mammy** c. 1923
Etching and drypoint
8¹³/₁₆ x 6⅞ in. (22.6 x 17.7 cm.)

First state: Mammy, wearing glasses and holding a palm leaf fan in her right hand, holds a blond little baby on her lap. Design complete except for some lines of shading on mammy's left shoulder.

Second state: As illustrated. With this addition.

Montgomery Museum of Fine Arts, Montgomery, Alabama, 1982

213 **Live Oak with Grey Moss** c. 1923
(also called *Bearded Oak*)
Etching
3¹⁵/₁₆ x 4⅞ in. (10 x 12.5 cm.)
Arches

First state: A large tree full of hanging moss before cabin in background. Before cabin in background was drawn and before the blades of long grass around the base of the tree.

Second state: With these additions.

Probably near New Orleans.

214 Vieux Carré, New Orleans, Royal Street
c. 1923
Etching
4¹⁵⁄₁₆ x 3¹⁵⁄₁₆ or 5 x 4 in. (12.5 x 10 or 12.7 x 10.1 cm.)

First state: In a courtyard beyond a high arch is a stairway with a woman looking down from the second story. At left is a faint suggestion of a palm.

Second state: With this palm more fully described though still lightly etched.

Boston; Metropolitan Museum of Art

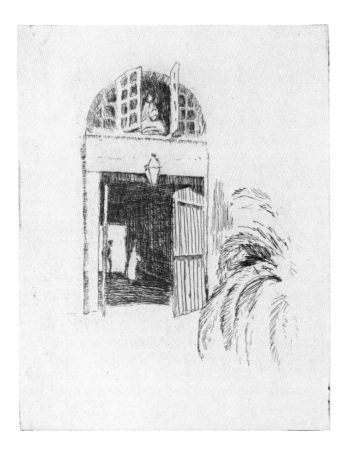

215 Vieux Carré, New Orleans (No. 2) c. 1923
Etching
4¹⁵⁄₁₆ x 3¹⁵⁄₁₆ in. (12.5 x 10 cm.)
Van Gelder, Arches

First state: A large palm at right beyond an open gate. In dark interior, two figures; above in open arched window are two people—one seated, the other standing. The palm here has no darker leaf in center and no lines of shading on wall above it.

Second state: As illustrated. With the additions noted above.

Korner and Wood Company, Cleveland, Ohio, 1942; Montgomery Museum of Fine Arts, Montgomery, Alabama, 1982

Yale; Boston; Worcester; Wadsworth Atheneum; Metropolitan Museum of Art

216 Patio, New Orleans c. 1923
Etching
4³⁄₁₆ x 2¹⁵⁄₁₆ in. (10.7 x 7.5 cm.)

Only known state: Through a high rounded archway one looks into a courtyard with a winding stairway and a large palm at left.

Korner and Wood Company, Cleveland, Ohio, 1942

217 New Orleans c. 1923
Etching
6⅞ x 7⅞ in. (17.5 x 20.3 cm.)
Crown and sceptre atop a book

Only known state: Three figures on a wrought iron balcony— one, a woman seated at center leaning on railing. At extreme left, two others.

The Downtown Gallery, New York, New York, 1929

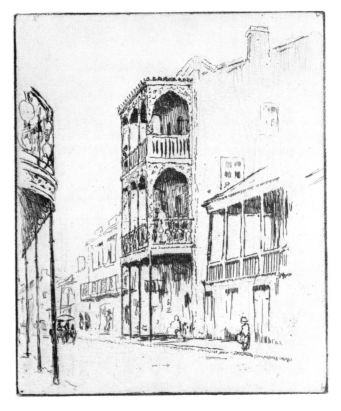

218 New Orleans Street with Balconies c. 1923
Etching
5⅞ x 4⅞ in. (15 x 12.6 cm.)

Only known state: As illustrated.

Montgomery Museum of Fine Arts, Montgomery, Alabama, 1982

219 Old Balconies, New Orleans c. 1923
Etching
6¾ x 8¾ in. (17.4 x 22.4 cm.)

Only known state: Frontal view of two houses with wrought iron balconies. At right, two nuns converse standing.

Beveled edges to plate.

220 Leading the Field c. 1924
Etching
5¹⁵⁄₁₆ x 7⅞ in. (15 x 20 cm.)

Only known state: The leading horse and jockey move toward right with three others neck and neck following.

Syracuse Museum of Fine Arts, Syracuse, New York, 1924

Some imps. hand colored.

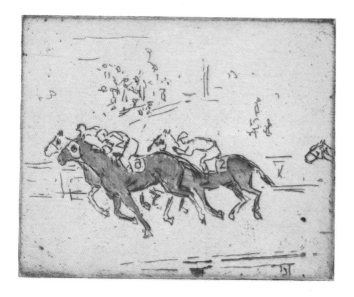

221 The Finish c. 1924
Etching and roulette
3¹⁵⁄₁₆ x 4¹⁵⁄₁₆ in. (10 x 12.5 cm.)
Arches

Only known state: As illustrated.

The Downtown Gallery, New York, New York, 1929; Olympic Exhibition, Los Angeles, California

Los Angeles; Wadsworth Atheneum

Some imps. printed in colored inks. Others toned grey, with roulette.

222 Golf—The Drive c. 1924
Etching
6¹⁵⁄₁₆ x 8¹⁵⁄₁₆ in. (17.6 x 22.7 cm.)

Only known state: A young man rests on his left foot and swings his club high over his head.

223 Woman Golfer c. 1924
Etching
6¹⁵⁄₁₆ x 8¹⁵⁄₁₆ in. (17.6 x 22.7 cm.)
Van Gelder Zonen

Only known state: She stands on her left foot as she swings the club over her left shoulder.

224 Golf—the Approach c. 1924
Etching
7⅞ x 9⅞ in. (20 x 25.3 cm.)
Van Gelder Zonen, F. J. Head

First state: Man holding his bag of clubs approaches the green from the right. One other man is at left on the green. A large elm tree is between them beyond the green.

Second state: A second man is now on the green, putting, seen from the rear. Drypoint lines added in sky at left and in center and around the shores of a pond.

225 The Great Game c. 1924
Etching
3⅞ x 4¾ in. (9.9 x 12.1 cm.)
China paper

Only known state: A ball game showing a player at bat. Three men in left foreground and the crowded stands in two tiers veering around to right.

226 Skating in Central Park, 1922 c. 1924
Etching
5¹⁵⁄₁₆ x 6⅞ in. (15.1 x 17.5 cm.)
Van Gelder

Only known state: As illustrated, p. 98.

Syracuse Museum of Fine Arts, Syracuse, New York, 1924; The Downtown Gallery, New York, New York, 1929; Montgomery Museum of Fine Arts, Montgomery, Alabama, 1982

Metropolitan Museum of Art

Shown at the Olympic Exhibit in Los Angeles.

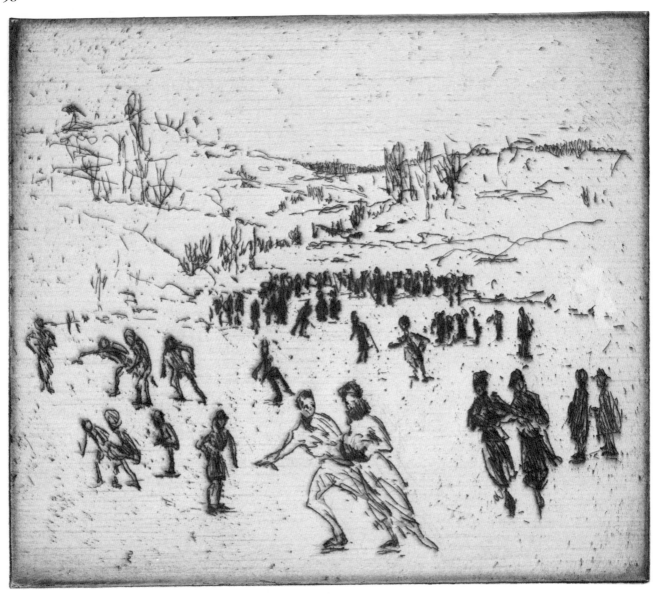

Skating in Central Park (cat. no. 226)

228 Polo (No. 1) c. 1924
Etching
6 x 6¾ in. (15.2 x 17.3 cm.)

Only known state: As illustrated.

Syracuse Museum of Fine Arts, Syracuse, New York,
1924; Korner and Wood Company, Cleveland, Ohio,
1942; M. Knoedler and Company, New York, New
York, 1944

Boston; Philadelphia; Cleveland; Yale; Honolulu;
Metropolitan Museum of Art

*Later imps. have rust marks at lower left on horse's back at
right. Some imps. colored; later ones have beveled edge to
plate-line. Published in* Fine Prints of the Year, 1926, *p.
13.*

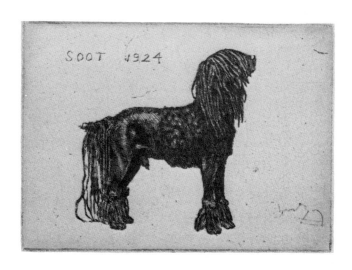

227 Soot—A Portrait c. 1924
Etching
4⅞ x 6⅞ in. (12.4 x 17.2 cm.)

First state: Without title in background.

Second state: As illustrated. With title: "Soot 1924" at
upper left.

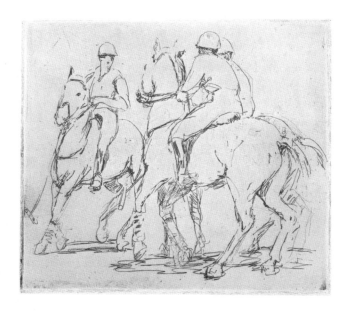

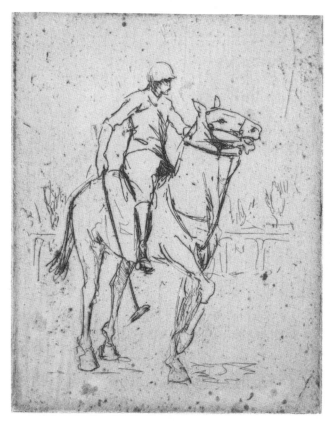

229 Polo (No. 2) c. 1924
Etching
4⅞ x 3¹⁵⁄₁₆ in. (12.3 x 10 cm.)
Alfred

Only known state: As illustrated.

The Downtown Gallery, New York, New York, 1929;
Korner and Wood Company, Cleveland, Ohio, 1942

Worcester

Some imps. printed in colored inks, tan and blue.

230 Christmas Card of Cherubim c. 1925
Etching
4 ¼ x 3 in. (10.5 x 7.4 cm.)

Only known state: Wording "Peace on Earth/Good Will to Men" etched below.

In the series sketched at the Metropolitan Museum. Most imps. hand colored in blue, pink, yellow.

231 The Lady and the Unicorn c. 1925
Etching
8 ⅜ x 6 ⅝ in. (21.4 x 16.7 cm.)

Only known state: Detail from Unicorn Tapestry at the Cloisters.

The Downtown Gallery, New York, New York, 1929

In series sketched at Metropolitan Museum.

232 Madonna and Child with Cherubim
c. 1925
Etching and drypoint
4¹⁵⁄₁₆ x 2¹⁵⁄₁₆ in. (12.5 x 7.5 cm.)

First state: Etching only.

Second state: With most lines reinforced with drypoint; line of Madonna's chin changed and pouch under child's eyes removed.

Museum of Modern Art

In series sketched at Metropolitan Museum. Most imps. hand colored in rose and blue.

233 Angel Holding a Candle c. 1925
Etching
4 ¾ x 3 ⅞ in. (12 x 9.7 cm.)

Only known state: Angel kneels, turned toward right, looking left.

Metropolitan Museum of Art

In series sketched at Metropolitan Museum.

234 Ave Maria c. 1925
Etching
8 ¼ x 6 ⅜ in. (21 x 16.2 cm.)
Arches, Van Gelder Zonen

Only known state: Taken from a shrine with title "Ave Maria" below.

Metropolitan Museum of Art

Most imps. hand colored with rose dress and blue outer robe. In series sketched at Metropolitan Museum.

235 The Flight Into Egypt c. 1925
Etching
6¹⁄₁₆ x 6¹⁄₁₆ in. (15.4 x 15.4 cm.)

First state: Mostly outline; before heavy etching on donkey and top of Madonna's robe over her head.

Second state: With these additions and with most lines reinforced.

Museum of Modern Art

Most imps. hand colored with light tints of pink, blue and brown for donkey. In series sketched at Metropolitan Museum.

236 The Flight Into Egypt (with Joseph) c. 1925
Etching and aquatint
6¹⁵⁄₁₆ x 7¹⁵⁄₁₆ in. (17.5 x 20.3 cm.)
"B.F.K."

Only known state: Mary holding the Child rides on the donkey toward right. Joseph at left; dog at right.

Metropolitan Museum of Art

In series sketched at Metropolitan Museum.

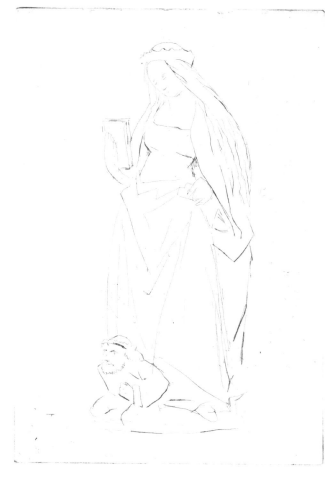

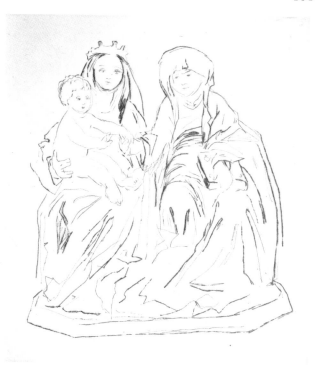

237 St. Catherine c. 1925
Etching and drypoint
9⅞ x 6¹⁵⁄₁₆ in. (25.1 x 17.5 cm.)

First state: Pure etching.

Second state: As illustrated. Reinforced with
drypoint. Line of page of book lengthened and a small
perpendicular line added at back of book.

Springfield; Metropolitan Museum of Art

*Most imps. of both states hand colored with varying
effects; book red. In series sketched at Metropolitan
Museum.*

238 Virgin and Child with St. Anne c. 1925
Drypoint
8⅝ x 7¹⁵⁄₁₆ in. (22 x 20.1 cm.)

Only known state: As illustrated.

Boston; Metropolitan Museum of Art

*Most imps. are hand colored in varying light tints. In series
sketched at Metropolitan Museum.*

239 Annunciation c. 1925
Drypoint
9¹³⁄₁₆ x 7⅞ in. (25.2 x 20.1 cm.)

Only known state: Angel alights to the left in a vaulted
space before Mary, who is seated and dips her head to
the left. She holds an open book on her lap. A
canopied bed and gothic window form the
background.

The Downtown Gallery, New York, New York, 1929;
Milan Gallery, San Antonio, Texas

Yale; Boston; Metropolitan Museum of Art

*Mostly hand colored in rose, blue and yellow. In series
sketched at Metropolitan Museum.*

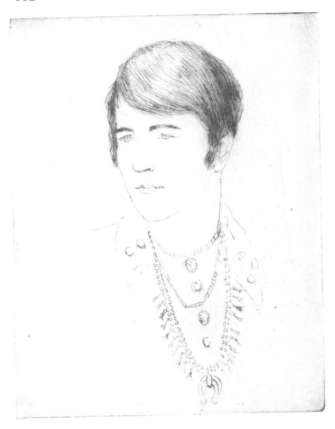

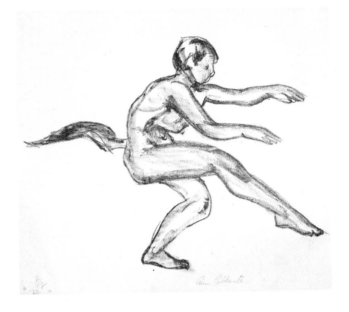

241 Pan c. 1928
Lithograph
page 8 ¾ x 10 ¼ in. (22.2 x 26 cm.)

Only known state: As illustrated.

There is one proof and a series of eight numbered prints.

240 Portrait of a Woman with Necklace
c. 1926/27
(also called *Jane Jordan*)
Drypoint
9 ⅞ x 8 in. (25.2 x 20.2 cm.)

First state: With lower lip undefined; two strong lines at left jaw, later reduced.

Second state: With these changes; eyes lighter— shaded— also mouth.

Third state: As illustrated. Very few subtle lines added to eyelids, lower lip, chin, etc. Long scratch in background on right.

Jane Jordan posed for this.

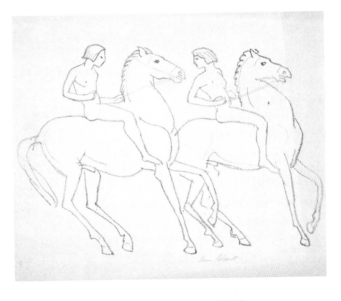

242 Two Greek Horsemen c. 1928
Lithograph
page 10 ⅛ x 12 ⅞ in. (25.7 x 33 cm.)
Canson

Only known state: As illustrated.

Edition numbered 1 to 8. Done at the Art Students' League when studying the medium of lithography.

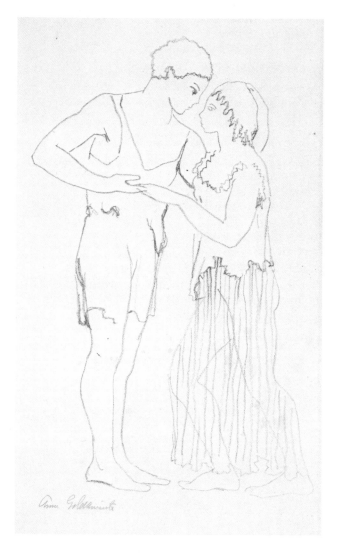

243 Greek Youth and Maiden c. 1928
(also called *Two Lovers*)
Lithograph
page 13 x 10 ¼ in. (33 x 26 cm.)
Gravure—France

Only known state: As illustrated.

*Edition numbered 1 to 10. Done at the Art Students'
League when studying the medium.*

244 Brunette c. 1928
Lithograph
page 13 x 10 ¼ in. (33 x 26 cm.)
Gravure—France

Only known state: Girl with grey eyes and dark, curly
bobbed hair—head and shoulders. Dress with round
neckline, bow with long end at front; smocking on
blouse detailed to right.

*Numbered in edition of 15. One proof screened, cutting off
long ends to knot. Sitter is Mrs. William McCall née Jean
Jordan.*

245 Cow and Calf c. 1928
Drypoint
5⅞ x 8⅜ in. (14.9 x 21.2 cm.)

Only known state: Cow turns her head to observe her
calf as he nurses. Cow turned to right, calf to left.

The Downtown Gallery, New York, New York, 1929

Philadelphia; Museum of Modern Art; Cleveland;
Chapel Hill

246 Calf c. 1928
Etching
8¹⁵⁄₁₆ x 6¹⁵⁄₁₆ in. (22.7 x 17.7 cm.)
Van Gelder

First state: Before back ear was added, with portrait sketch of a man or woman showing (upside down) in lower part of plate, later erased.

Second state: As illustrated. With back ear added and a few other minor additions.

The Downtown Gallery, New York, New York, 1929; Korner and Wood Company, Cleveland, Ohio, 1942; M. Knoedler and Company, New York, New York, 1944; Montgomery Museum of Fine Arts, Montgomery, Alabama, 1982

Brooklyn; Boston; Philadelphia; Cleveland; Worcester; Metropolitan Museum of Art

247 Deer Grazing c. 1928
Etching
6⅞ x 9⅞ in. (17.5 x 25 cm.)

Only known state: A single deer with head lowered to nibble grass advances toward left.

Museum of Modern Art

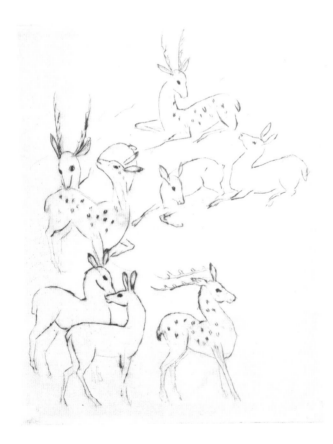

248 Herd of Deer c. 1928
Etching and drypoint
9¹⁵⁄₁₆ x 7⅞ in. (25 x 20.2 cm.)

First state: Light etching only.

Second state: As illustrated. Redrawn entirely in drypoint with much burr that was quickly reduced.

The Downtown Gallery, New York, New York 1929

Museum of Modern Art

Some imps. hand colored. Reproduced in Fine Prints of the Year, 1929, *p. 71.*

249 Stag and Doe (No. 1) c. 1928
Etching
7⅞ x 9⅞ in. (20 x 25 cm.)
Van Gelder Zonen

First state: Before suggestion of bushes in the background and before much work on both the heads and bodies of both deer.

Second state: With these additions.

Boston

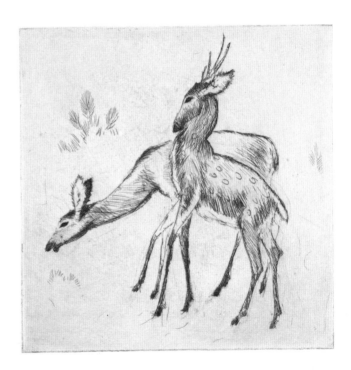

250 Stag and Doe (No. 2) c. 1928
Etching
6⅛ x 6⅛ in. (15.6 x 15.5 cm.)

First state: Before background detail.

Second state: As illustrated. With those details and much more work on both animals—darkening them.

Museum of Modern Art; Yale; Worcester

In artist's handwriting: "Two Deers—November, 1931." Edition of 50.

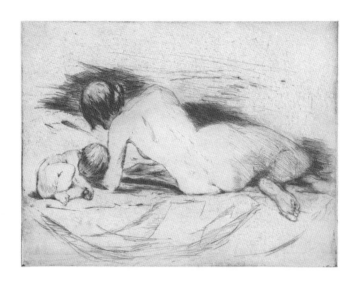

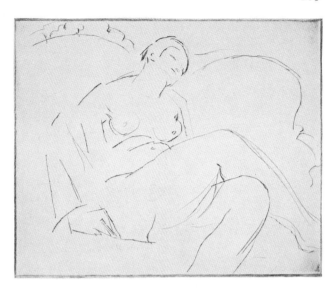

251 Asleep c. 1928
Etching and drypoint
8¾ x 11¾ in. (22.4 x 29.7 cm.)
Handmade—Sweden

First state: A nude mother seen from the rear reclines, leaning on her left elbow and looks down at her baby hunched up, asleep, his head leaning against her left arm.

Second state: As illustrated. A number of long sweeping lines enclose the figures in a large oval.

Montgomery Museum of Fine Arts, Montgomery, Alabama, 1982

Worcester

252 Cockleshell (No. 1) c. 1928
Etching and drypoint
1¾ x 2 in. (4.4 x 5 cm.)

Only known state: A baby sits on the ground looking down, leaning against a bank.

This may be the first state, later erased for Cockleshell (No. 2).

253 Cockleshell (No. 2) c. 1928
Etching and drypoint
1¾ x 2 in. (4.4 x 5 cm.)

First state: With design complete except for a few more lines of shading at upper left corner. The baby sits on the sand, leaning forward.

Second state: With additional shading at upper left corner.

254 Nude on a Sofa (No. 1) c. 1928
Drypoint
8⁷⁄₁₆ x 10⁷⁄₁₆ in. (21.4 x 26.5 cm.)
Van Gelder

First state: Design completed. Nude reclines with her head leaning against back of sofa, her right leg crossed over her left, her eyes almost closed.

Second state: As illustrated. With reinforced lines of face, head and many other lines.

The Downtown Gallery, New York, New York, 1929

Philadelphia; Museum of Modern Art

255 Nude on a Sofa (No. 2) c. 1928
Drypoint
7⅞ x 9⅞ in. (20.2 x 25 cm.)
Van Gelder Zonen

Only known state: She holds a wine glass in her left hand. She looks up with her head thrown back, leaning against the back of the sofa. (Some of the lines may be reinforced.)

The Downtown Gallery, New York, New York, 1929

Brooklyn; Museum of Modern Art

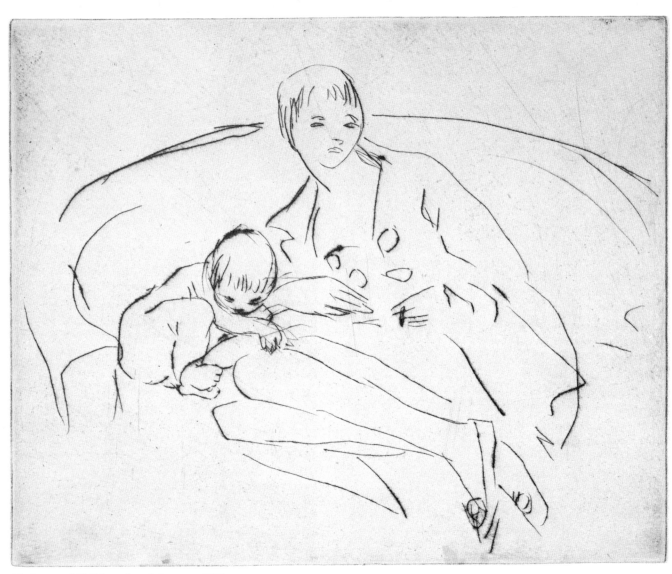

Mother and Child on Couch (cat. no. 258)

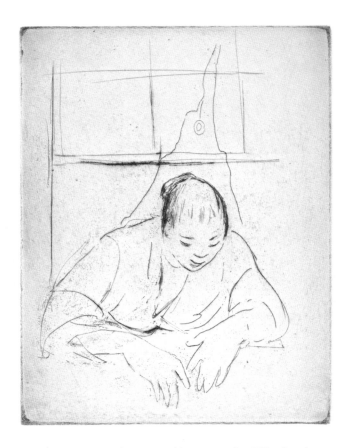

256 East Tenth Street (Anne at the Window)
c. 1928
(also called *An Eastside Window*)
Etching
9⅞ x 7⅞ in. (25 x 20 cm.)

First state: Figure leaning out of window completed, but before the windowpanes were added.

Second state: As illustrated.

M. Knoedler and Company, New York, New York, 1944

Yale; Boston; Philadelphia; Baltimore; Museum of Modern Art; Cleveland; Wadsworth Atheneum; Metropolitan Museum of Art

In Fine Prints of the Year, 1931, *p. 74.*

257 Cock and Hen c. 1928
Etching
4¹¹⁄₁₆ x 5⅞ in. (12 x 15.1 cm.)

Only known state: The large, long-tailed cock struts toward right; the hen farther right, partly behind him pecks on the ground for food. A round dish at lower left.

Some imps. hand colored—blue and brown, red and yellow.

258 Mother and Child on Couch c. 1928
Drypoint
8⅜ x 10⅜ in. (21.4 x 26.5 cm.)

Only known state: As illustrated, p. 106.

The Downtown Gallery, New York, New York, 1929; Montgomery Museum of Fine Arts, Montgomery, Alabama, 1982

Philadelphia

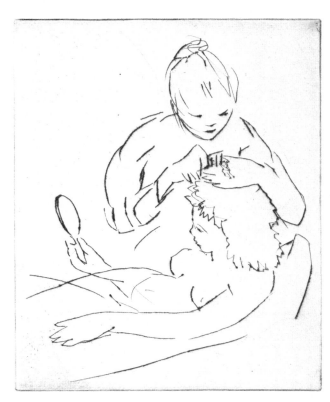

259 *Coiffeuse* c. 1929
Drypoint
6⅞ x 5⅞ in. (17.5 x 15 cm.)

First state: With design completed; all but one line on either side of the face of the hairdresser added very lightly.

Second state: As illustrated. With these two added lines.

The Downtown Gallery, New York, New York, 1930; Montgomery Museum of Fine Arts, Montgomery, Alabama, 1982

Philadelphia; Museum of Modern Art

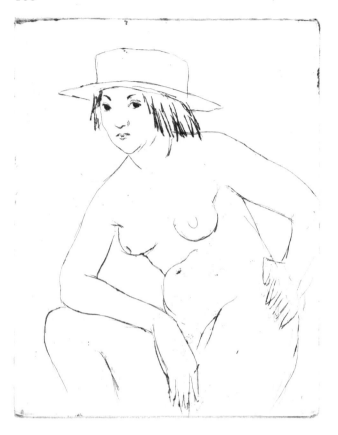

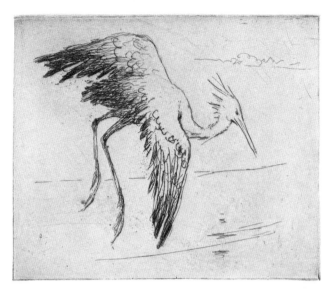

260 Nude with Hat c. 1929
Drypoint
9⅞ x 7⅞ in. (25 x 20 cm.)

First state: Design complete except for hand on hip at right.

Second state: As illustrated. Hand redrawn and many lines reinforced.

The Downtown Gallery, New York, New York, 1930; Korner and Wood Company, Cleveland, Ohio, 1942; M. Knoedler and Company, New York, New York, 1944; Montgomery Museum of Fine Arts, Montgomery, Alabama, 1982

Philadelphia; Boston; Metropolitan Museum of Art

261 Heron Rising over the Alabama c. 1929
Etching
4¹⁵⁄₁₆ x 5¹⁵⁄₁₆ in. (12.5 x 15 cm.)

Only known state: As illustrated.

Montgomery Museum of Fine Arts, Montgomery, Alabama, 1982

Yale; Museum of Modern Art; Philadelphia

Edition of 50.

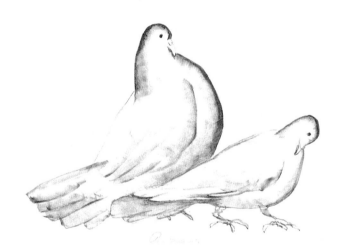

262 **Pigeons (Cock and Hen)** c. 1929
Lithograph
page 11 ¼ x 15 ¾ in. (28.5 x 40 cm.)
Rives

Only known state: As illustrated.

The Downtown Gallery, New York, New York, 1929;
Korner and Wood Company, Cleveland, Ohio, 1942;
M. Knoedler and Company, New York, New York,
1944; Montgomery Museum of Fine Arts,
Montgomery, Alabama, 1982

Brooklyn; Yale; Boston; Springfield; Museum of
Modern Art; Philadelphia; Wadsworth Atheneum;
Worcester; Metropolitan Museum of Art

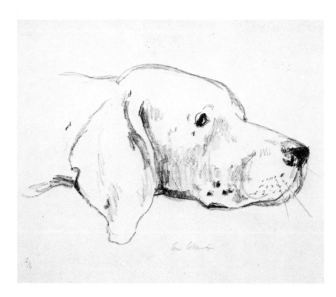

263 **Pointer** c. 1929
Lithograph
page 10 1/16 x 13 in. (25.7 x 33 cm.)
Canson Gravure—France

First state: Called "1st proof;" nose lighter.

Second state: Called "2nd proof;" detail of ear and
neck quite different.

Third state: As illustrated. Like first state but with
darker nose. In an edition numbered 1 to 6.

264 **Small Lobster** c. 1929
Drypoint
3 x 3 15/16 in. (7.5 x 10 cm.)

First state: Pattern on top of shell less defined; legs at
right unfinished.

Second state: With these additions.

Springfield

Imps. hand colored.

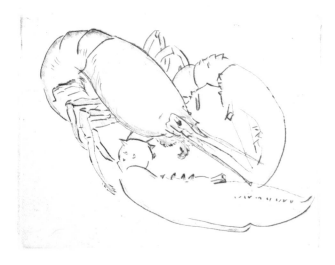

265 **Large Lobster** c. 1929
Drypoint
5 15/16 x 7 15/16 in. (14.8 x 20 cm.)

Only known state: As illustrated.

The Downtown Gallery, New York, New York, 1929;
Korner and Wood Company, Cleveland, Ohio, 1942

Usually hand colored, red and orange.

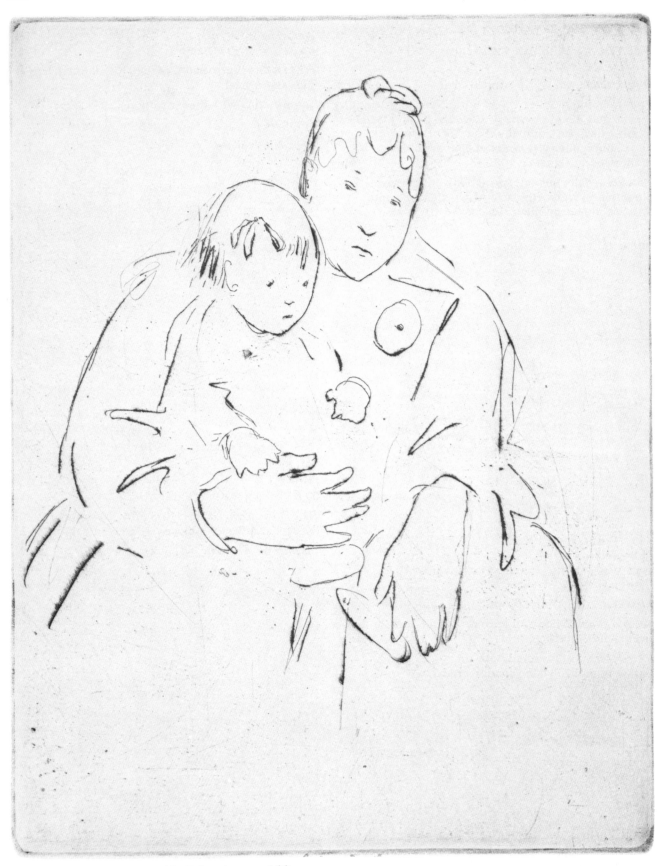

La Grandmere of Rue Leopold—Robert (cat. no. 266)

266 La Grandmère of Rue Leopold-Robert
c. 1929
Etching
10 x 8 in. (25 x 20 cm.)

First state: Design about complete except for two heavy lines marking her skirt at left and one at right and outline of baby's foot or shoes below her left hand.

Second state: As illustrated, p. 110. With these additions.

Montgomery Museum of Fine Arts, Montgomery, Alabama, 1982;

Wadsworth Atheneum; Metropolitan Museum of Art

267 Mother and Child c. 1929
Etching and drypoint
8⅞ x 5⅞ in. (22.5 x 15 cm.)

First state: Mother holds baby on right arm as he reaches up both arms and tilts his head. Design sketched in drypoint and then lightly etched, her left hand more deeply etched.

Second state: All lightly etched lines deepened in drypoint.

Brooklyn; Boston; Worcester

268 Cranes Under a Palm Tree c. 1929
Etching and drypoint
7⅞ x 9⅞ in. (20 x 25 cm.)
Rives

Only known state: Two cranes stand in the water under the branches of a large palm tree. The one looks to right, the other to left.

Done in Florida.

269 Covenhaven Duck from *Birds of Florida*
c. 1929
Etching
3⅛ x 2⅛ in. (7.9 x 5.4 cm.)

Only known state: Title above, picture of Covenhaven duck hanging in a tree and below: ''Covenhaven Duck;'' evidently the title page of a series of *Birds of Florida*.

Made on the Indian River in 1929 as a Christmas card for a friend.

270 Dog Baying at the Moon (No. 1) c. 1930
White-line lithograph
6 x 5 in. (15 x 12.5 cm.)

Only known state: Seated dog in profile wth head and neck thrust up. The muzzle of the dog silhouetted against a full moon.

Korner and Wood Company, Cleveland, Ohio, 1942

From the Night series. Trial taken from outline of black-line etching; unsuccessful with interrupted outline of moon, back of dog, etc.

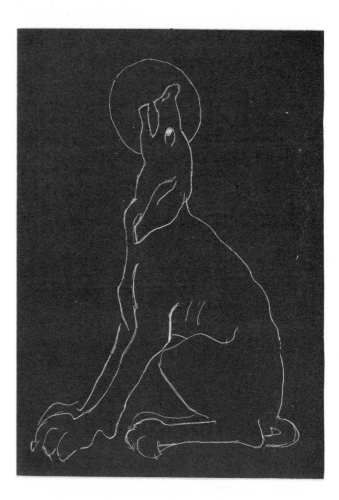

271 Dog Baying at the Moon (No. 2) c. 1930
White-line lithograph
6 x 4¼ in. (15.1 x 10.9 cm.)

Only known state: As illustrated.

The Downtown Gallery, New York, New York, 1930; Pennsylvania Academy and Philadelphia Watercolor Club 31st Annual Show, 1933; Montgomery Museum of Fine Arts, Montgomery, Alabama, 1982

Brooklyn; Yale; Boston; Springfield; Cleveland; Wadsworth Atheneum; Metropolitan Museum of Art

From the Night series; white eye differentiates this print from the unsuccessful trial proof for it.

272 Dog Baying at the Moon c. 1930
Etching
6 x 5 in. (15.1 x 12.7 cm.)

Only known state: Seated dog in profile with head and neck thrust up. The muzzle of the dog silhouetted against a full moon.

From the Night series. With some outlines as faint as lines in trial lithograph in which outlines of moon and of dog's back are broken.

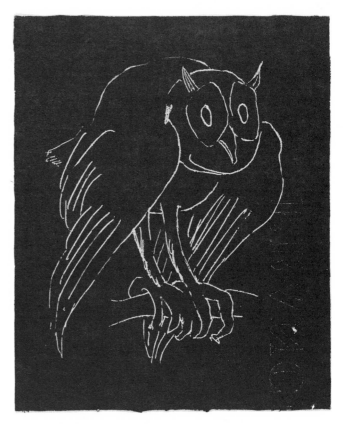

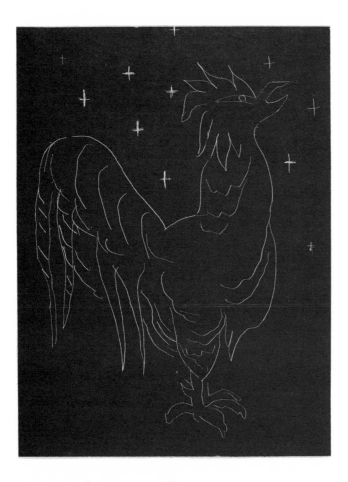

273 Cock Crow c. 1930
White-line lithograph
6⁵⁄₁₆ x 4¾ in. (16 x 12 cm.)

Only known state: As illustrated.

Korner and Wood Company, Cleveland, Ohio, 1942; Montgomery Museum of Fine Arts, Montgomery, Alabama, 1982

Brooklyn; Yale; Boston; Springfield; Wadsworth Atheneum; Metropolitan Museum of Art

From the Night series. There is a trial proof of different dimensions (5⅞ x 4⅞ in.), which is not clearly outlined and has fewer crosses in background. The definitive state has 11 crosses, the trial has about 3 +.

274 The Owl c. 1930
White-line etching
5¹⁵⁄₁₆ x 4¹⁵⁄₁₆ in. (15 x 12.4 cm.)

Only known state: As illustrated.

From the Night series. Trial with rough outlines broader than in other print.

275 The Owl c. 1930
White-line lithograph
5½ x 4⁷⁄₁₆ in. (14.1 x 11.4 cm.)

Only known state: The owl is perched on a branch seen in ¾ view. The white lines are smooth.

Brooklyn; Boston; Yale; Springfield; Wadsworth Atheneum; Worcester; Metropolitan Museum of Art

From the Night series.

276 The Bat c. 1930
White-line etching
4¹⁵⁄₁₆ x 5¹⁵⁄₁₆ in. (screened to 4¹¹⁄₁₆ x 5¹¹⁄₁₆) (12.5 x 14.9 to 12 x 14.6 cm.)

Only known state: As illustrated, p. 113.

Brooklyn; Springfield; St. Louis

From the Night series. Some imps. printed with black lines; rough zinc plate shows black specks at right, which in white-line prints show as tiny white specks.

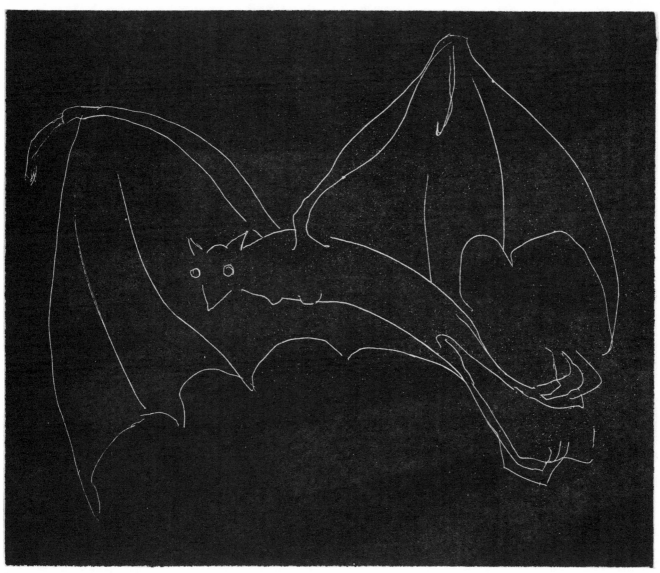

The Bat (cat. no. 276)

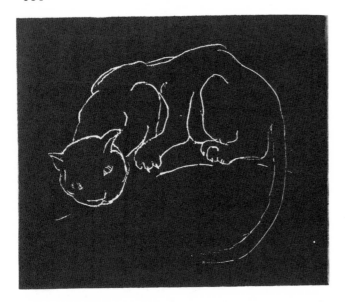

277 The Cat c. 1930
White-line lithograph
4½ x 5¹⁵⁄₁₆ in. (11.4 x 15 cm.)
Rives, "B.F.K."

Only known state: As illustrated.

Montgomery Museum of Fine Arts, Montgomery,
Alabama, 1982

Brooklyn; Yale; Springfield; Wadsworth Atheneum;
Worcester; Metropolitan Museum of Art

*From the Night series. Same pose as in etching of same, but
here the whites of the eyes are much more emphasized. The
outline is finer and smoother.*

278 The Cat c. 1930
White-line etching
4¹⁵⁄₁₆ x 5⅞ in. (12.4 x 15 cm.)
Rives, "B.F.K."

Only known state: Cat crouches on a limb with tail
hanging down the right margin of the print.

Metropolitan Museum of Art

*From the Night series. Done in zinc, rough line with no
white to eyes.*

279 Hugh Walpole c. 1930
Drypoint
10⅜ x 8⅜ in. (26.4 x 21.2 cm.)
Arches

First state: Arm at right indicated only by two outer
strokes. Fingers of left hand separated. One strand of
hair stands up on top of head.

Second state: Eyes and glasses reworked; also far side
of face and shadow on near side.

Third state: As illustrated. Arm at right more fully
defined, tie has darker shading. Fingers of left hand
together, etc.

U.S. National Museum, Washington, D.C., Feb. 1929

Metropolitan Museum of Art

Done for Doubleday-Doran book publishers.

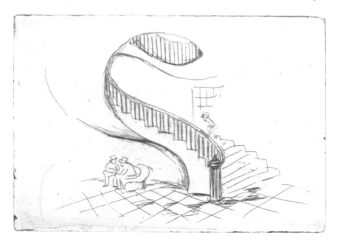

280 Somerset Maugham c. 1930
Etching
10¼ x 8¼ in. (26.2 x 20.9 cm.)

Only known state: As illustrated.

Done from a photograph for Doubleday-Doran book publishers.

281 Olive c. 1931
Etching and drypoint
7⅞ x 9⅞ in. (20 x 25 cm.)

First state: Very light drypoint sketch of the composition.

Second state: As illustrated, p. 116. Etched lines replacing drypoint.

The Downtown Gallery, New York, New York, 1930; Montgomery Museum of Fine Arts, Montgomery, Alabama, 1982

Boston; Museum of Modern Art; Metropolitan Museum of Art

Illustrated in Fine Prints of the Year, 1932.

282 Montgomery Capitol, Halls of Legislature (No. 1) c. 1931
Etching
5⅞ x 8⅞ in. (15 x 22.5 cm.)

Only known state: As illustrated.

Montgomery Museum of Fine Arts, Montgomery, Alabama, 1982

283 Montgomery Capitol, Halls of Legislature (No. 2) c. 1931
Etching
5⅞ x 6⅜ in. (14.9 x 16.2 cm.)
"B.F.K."

Only known state: The smaller version—the man on stairway better drawn. The stairway made of only one line; practically no shading under stairway.

284 Violin (No. 1) c. 1931
Etching and drypoint
11⅞ x 8⅞ in. (30.2 x 22.5 cm.)

Only known state: Etched line reinforced over drypoint guidelines. The violinist stands ¾ to right, his bow crossing the strings. His hair stands up with many long, curly lines.

From the Musicians series.

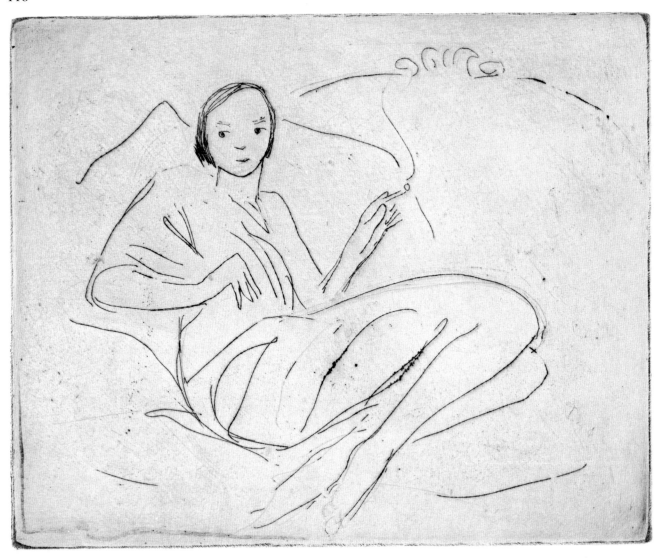

Olive (cat. no. 281)

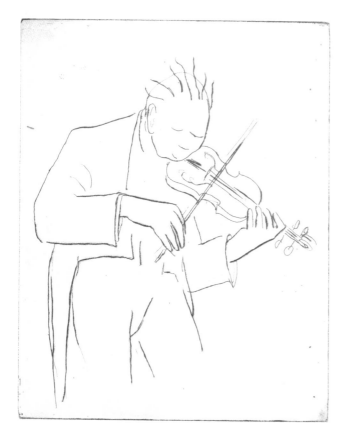

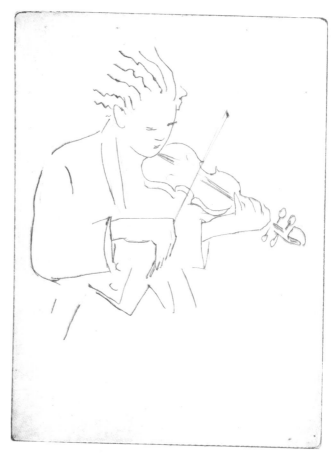

285 Violin (No. 2) c. 1931
Etching and drypoint
9⅞ x 7⅞ in. (25 x 20 cm.)

First state: Simple biting over drypoint guidelines.

Second state: As illustrated. Lines reinforced and some added. Four lines of strings near face instead of three. Line of coat extends from neck to within ⅛″ of head.

From the Musicians series.

286 Violin (No. 3) c. 1931
Etching and drypoint
11⅞ x 8⅞ in. (30 x 22.5 cm.)
Rives, Van Gelder, China paper

First state: Single biting over light drypoint.

Second state: Lines reinforced and a little deeper accenting of certain portions. Additional line at right cuff touching upper button.

Third state: As illustrated. Bridge of violin and F holes added.

The Downtown Gallery, New York, New York, 1933

Metropolitan Museum of Art

From the Musicians series.

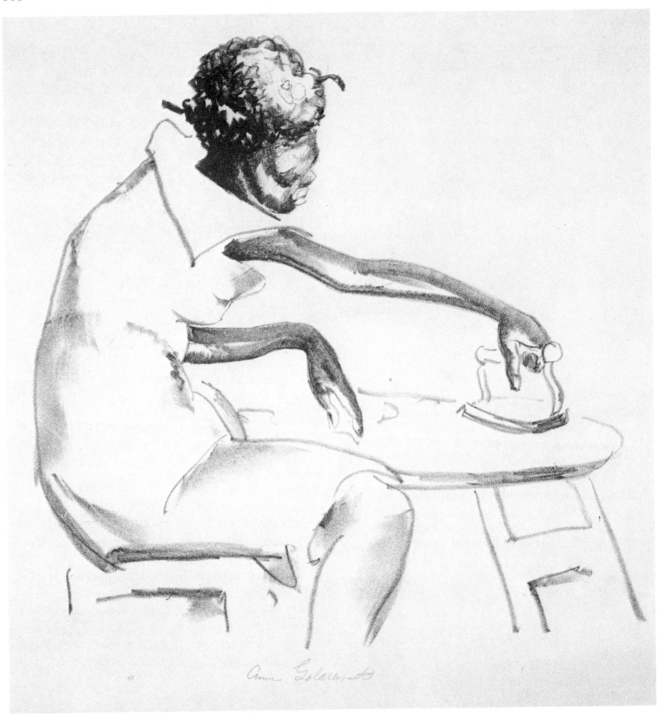

Ironing (cat. no. 290)

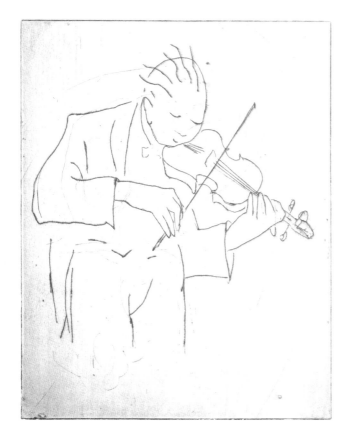

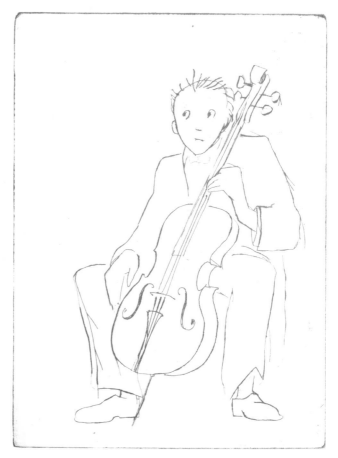

287 Viola c. 1931
Etching and drypoint
15⅞ x 10⅝ or 14 x 10⅞ in. (40.3 x 27 or 35.5 x 27.6 cm.)
China paper, Rives

First state: He stands facing somewhat to right, playing his viola. His hair stands up, indicated by five long lines.

Second state: As illustrated. Etched lines over drypoint lines.

Boston

From the Musicians series. Done on used plate of mother holding a baby; not as noticeable in first state.

288 Cello (No. 1) c. 1931
Etching and drypoint
8⅞ x 7⅞ in. (22.5 x 20 cm.)

First state: Single biting over light drypoint.

Second state: Bitten deeper with some additional lines on upper, outer fret of cello, bottom of trousers, etc. Two inner diagonal lines accentuate parts of bottom of trousers at right.

Montgomery Museum of Fine Arts, Montgomery, Alabama, 1982

Library of Congress; Brooklyn; Metropolitan Museum of Art

From the Musicians series.

289 Cello (No. 2) c. 1931
Etching and drypoint
11⅞ x 8⅞ in. (30.3 x 22.6 cm.)
Van Gelder

First state: Simple biting before reinforcing of lines; F holes of cello in clear outline.

Second state: As illustrated. Lines reinforced. F holes show dark; two diagonal lines break off of inner trouser line of right leg, etc.

From the Musicians series.

290 Ironing c. 1931
(also called *Young Laundress*)
Lithograph
page 11⅜ x 15¾ in. (31.5 x 40 cm.)
Rives, Navarre

Only known state: As illustrated, p. 118.

American Printmakers, 1932; The Downtown Gallery, New York, New York, 1932; Korner and Wood Company, Cleveland, Ohio, 1942; Montgomery Museum of Fine Arts, Montgomery, Alabama, 1982

Brooklyn; Yale; Boston; Springfield; Cleveland; Wadsworth Atheneum; Worcester; Metropolitan Museum of Art

Edition of possibly 50.

120

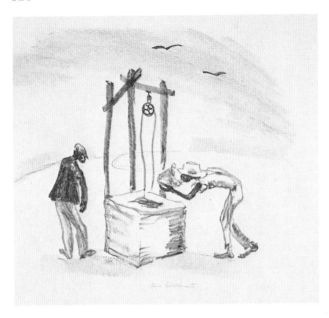

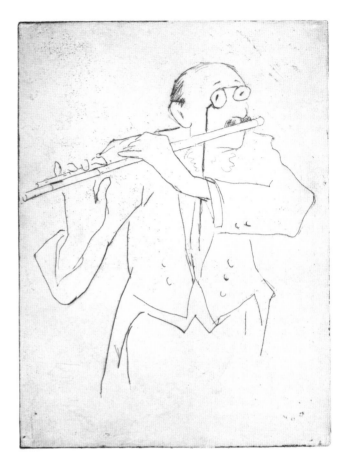

291 Two Black Crows c. 1931
Lithograph
page 12½ x 18⅞ in. (31.7 x 48 cm.)
Rives, Navarre

Only known state: As illustrated.

Korner and Wood Company, Cleveland, Ohio, 1942;
Montgomery Museum of Fine Arts, Montgomery,
Alabama, 1982

Yale; National Museum of American Art; Boston;
Springfield; Philadelphia; Cleveland; Wadsworth
Atheneum; Worcester; Metropolitan Museum of Art

Illustrated in Fine Prints of the Year, 1932. *Edition of
possibly 50.*

292 The Flute: Mr. William Gaul c. 1931
Etching
11⅞ x 8⅞ in. (30.2 x 22.7 cm.)
Japan, China paper, Rives, Van Gelder

Only known state: As illustrated.

M. Knoedler and Company, New York, New York,
1944; Montgomery Museum of Fine Arts,
Montgomery, Alabama, 1982

Seattle; Brooklyn; Metropolitan Museum of Art

293 Small German Band c. 1932
Etching
4 x 4¹⁵⁄₁₆ in. (10 x 12.5 cm.)
Van Gelder Zonen, Rives

First state: Design completed.

Second state: As illustrated. Outlines of all four figures reinforced with many little lines of shading.

The Downtown Gallery, New York, New York, 1933

294 Large German Band c. 1932
Etching
7 x 8 in. (17.5 x 20.2 cm.)

First state: Design completed.

Second state: As illustrated. Top line of tuba reinforced and the arm of tuba player at elbow.

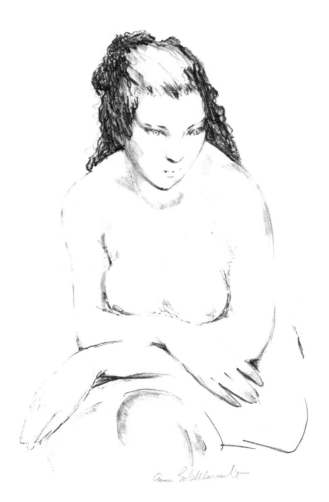

295 Selma (No. 1) c. 1933
Lithograph
page 15 ¾ x 11³⁄₁₆ in. (40 x 28.5 cm.)

First state: Pose mostly realized, but very little shading except on sides of hair. (Artist writes: "Proof before correction.")

Second state: Top of hair still light, eyes light, outline of left arm weak, no deep shadows.

Third state: Hair lacking some curls; shadow between breasts darker than later.

Fourth state: As illustrated. That shadow lightened.

Montgomery Museum of Fine Arts, Montgomery, Alabama, 1982

Yale; Boston; Springfield; Philadelphia; Seattle; Museum of Modern Art; Cleveland; Worcester; Wadsworth Atheneum; Metropolitan Museum of Art

Edition of possibly 50.

296 **Selma (No. 2)** c. 1933
Lithograph
page 15 ¾ x 11 ¾₁₆ in. (40 x 28.2 cm.)
Rives

First state: Before any stump shading, face somewhat wider, eyes lighter.

Second state: With stump shading (as on knee), darker accents on eyes, hair and under wrists. The lines defining separation of breasts and fingers on left hand are added in pencil and therefore vary.

Edition of 50.

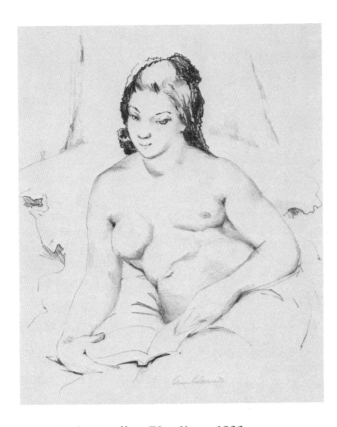

297 **Nude Reading (No. 1)** c. 1933
Lithograph
page 10 ¾ x 9 ¼ in. (40 x 28.5 cm.)
"B.F.K."

First state: In artist's writing: "2nd proof/before correction." Thin lines extend down from center of book and two dashes below them; later erased.

Second state: As illustrated. With two dashes and weak lines below book erased, extended fingers of left hand simplified.

M. Knoedler and Company, New York, New York, 1944; Montgomery Museum of Fine Arts, Montgomery, Alabama, 1982

Brooklyn; Yale; National Museum of American Art; Boston; Springfield; Philadelphia; Baltimore; Museum of Modern Art; Cleveland; Wadsworth Atheneum; Worcester; Metropolitan Museum of Art

Edition of possibly 50.

298 **Nude Reading (No. 2)** c. 1933
Lithograph
page 15 ¾ x 11 ¼ in. (40 x 28.5 cm.)

First state: Before correction on fingers of left hand. Lines below back of book extend lower.

Second state: Extended fingers of left hand simplified. Lines below back of book shortened.

Korner and Wood Company, Cleveland, Ohio, 1942

Edition of 50.

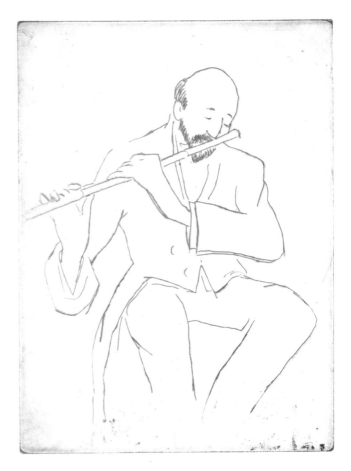

299 **George Barrère, Flutist** c. 1933/34
(also called *Flute*)
Drypoint
12 x 9 or 11⅞ x 8⅞ in. (30.1 x 22.7 or 29.9 x 22.6 cm.)
Rives, China paper

Only known state: As illustrated.

The Downtown Gallery, New York, New York, 1936; The Corcoran Gallery, Washington, D.C., 1939/40; Korner and Wood Company, Cleveland, Ohio, 1942; M. Knoedler and Company, New York, New York, 1944

Philadelphia

Illustrated in Fine Prints of the Year, 1934. *George Barrère was a member of the New York Symphony.*

300 **Two Rascals** c. 1934
Etching
7⅞ x 9⅞ in. (20 x 25 cm.)

Only known state: Two riders; the one toward left on a long horse, the other beyond.

301 **Class Prejudice** c. 1934
Etching
8¹⁵⁄₁₆ x 9¹⁵⁄₁₆ in. (22.7 x 25 cm.)
"B.F.K.", Navarre

Only known state: Heads of a mule and a horse facing each other, both looking alarmed.

Yale

302 **Horse, Jockey and Trainer** c. 1934
Lithograph
page 11¹⁵⁄₁₆ x 15¹³⁄₁₆ in. (30 x 40.5 cm.)
"B.F.K."

Only known state: A trainer leads a horse and jockey onto the field walking toward left; suggestion of crowd in grandstand in background.

303 **Lovers on a Bench** c. 1934
Lithograph
page 16 x 11¾ in. (40.6 x 29.8 cm.)
"C.C.W."

Only known state: The girl wears a coat with a fur collar. She rests her forehead against that of the boy. Her right hand is on his knee.

304 **Her Daughter** c. 1934
Lithograph
page 15¹⁵⁄₁₆ x 11⅜ in. (40.5 x 29 cm.)

Only known state: As illustrated, p. 124.

Montgomery Museum of Fine Arts, Montgomery, Alabama, 1982

The American Printmaker's Annual, 1935; The Corcoran Gallery, Washington, D.C. 1939/40; Korner and Wood Company, Cleveland, Ohio, 1942; M. Knoedler and Company, New York, New York, 1944

National Museum of American Art; Boston; Philadelphia; Museum of Modern Art; Cleveland; Worcester; Metropolitan Museum of Art

Edition of possibly 25.

124

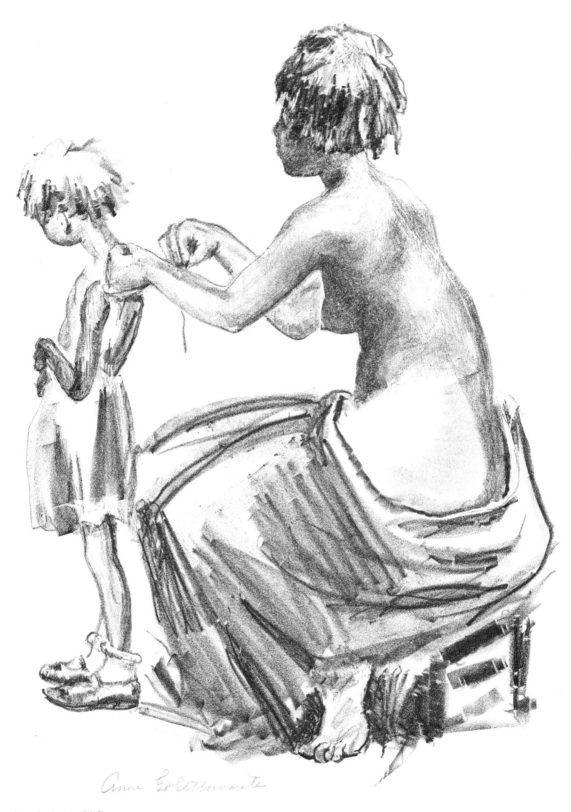

Her Daughter (cat. no. 304)

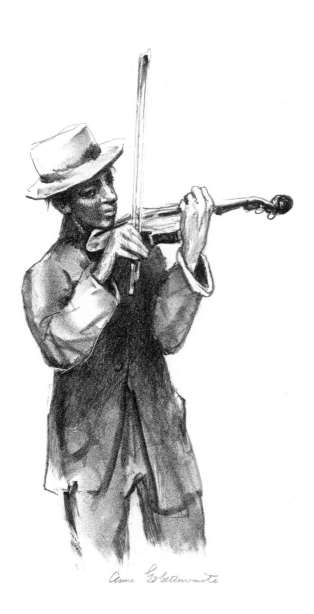

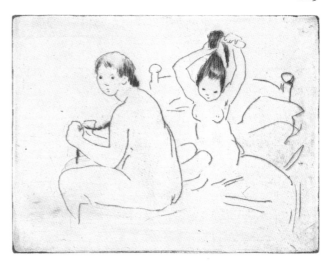

306 Up in the Morning c. 1934
Etching
6 x 8 or 5 x 7⅞ in. (15.2 x 20.3 or 14.9 x 20 cm.)
Van Gelder and Rives

Only known state: As illustrated.

The Downtown Gallery, New York, New York, 1934;
The American Printmaker's Annual, 1934;
Montgomery Museum of Fine Arts, Montgomery,
Alabama, 1982

307 Sheep c. 1934
Etching
6 x 4½ in. (15.2 x 11.4 cm.)

Only known state: Two sheep lying down; the black
snout of the left one shows, the right-hand one has his
back turned.

The American Printmaker's Annual, 1934; The
Downtown Gallery, New York, New York, 1934

Baltimore

308 Ward Heelers c. 1934
Etching
6 x 8 in. (15.1 x 20.2 cm.)
Rives

Only known state: Head and shoulders of two men
wearing hats. The right-hand one holds a cigarette and
is fat.

The Corcoran Gallery, Washington, D.C., 1939/40

Yale

305 Street Fiddler c. 1934
(also called *The Violin*)
Lithograph
page 15¹⁵⁄₁₆ x 11⅜ in. (40.5 x 29 cm.)
"B.F.K."

Only known state: As illustrated.

Yale; National Museum of American Art; Boston;
Worcester; Metropolitan Museum of Art

*On back of one print: "The Violin," by Anne
Goldthwaite/112 East 10 St., N.Y./price 5.00/edition 25/
dealer—The Downtown Gallery/Oct. 35.*

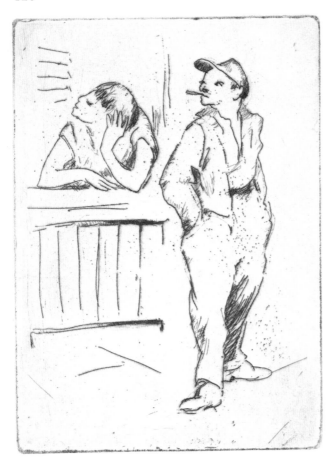

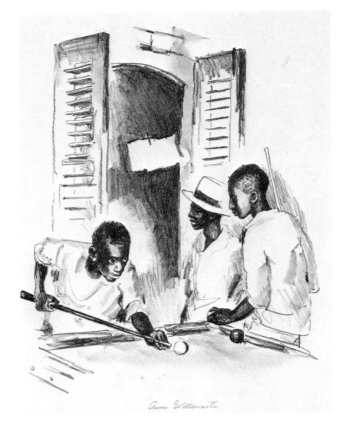

309 **"So Long"** c. 1934
Etching
6 x 4¼ in. (15.1 x 10.7 cm.)
Rives

Only known state: As illustrated.

The American Printmaker's Annual, 1934; The Downtown Gallery, New York, New York, 1934; Montgomery Museum of Fine Arts, Montgomery, Alabama, 1982

Brooklyn; Springfield; Philadelphia

310 **Pool Room** c. 1935
Lithograph
page 15⅞ x 11½ in. (40.5 x 29.5 cm.)
Rives

Only known state: As illustrated.

The American Printmaker's Annual, 1934; Korner and Wood Company, Cleveland, Ohio, 1942; Montgomery Museum of Fine Arts, Montgomery, Alabama, 1982

Yale; National Museum of American Art; Boston; Philadelphia; Seattle; Baltimore; Museum of Modern Art; Cleveland; Metropolitan Museum of Art

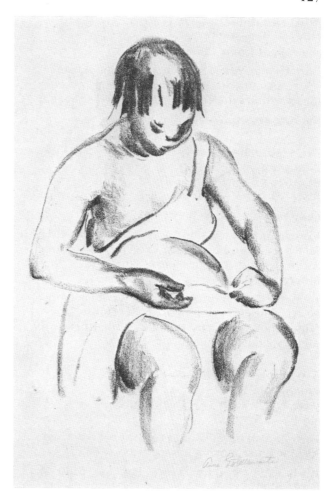

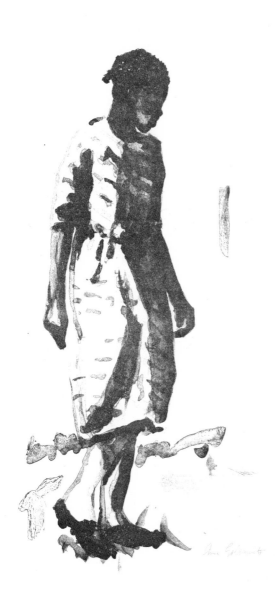

311 Young Negress c. 1936
Lithotint
page 13 x 10⅛ in. (33 x 26 cm.)

Only known state: As illustrated.

M. Knoedler and Company, New York, New York,
1944; Montgomery Museum of Fine Arts,
Montgomery, Alabama, 1982

Boston; Philadelphia; Metropolitan Museum of Art

Published in The Negro in Art, *by Alain Locke, 1940.*

312 Mending (No. 1) c. 1936
Lithograph
page 14½ x 10½ in. (36.8 x 26.6 cm.)

Only known state: Face entirely dark, in shadow.
Much the same composition as *Mending (No. 2).*

Metropolitan Museum of Art

313 Mending (No. 2) c. 1936
(also called *The Seamstress*)
Lithograph
page 12⅜ x 9½ in. (31.4 x 24.1 cm.)
Navarre

First state: Shadow over left eye so dark that line of
eyelid does not show. Shading on left hand does not
suggest lines separating fingers.

Second state: Shadow over eye lightened to show lid.
Fingers suggested slightly.

Third state: As illustrated. Shading across highlight
on front of head. Further shading on upper lines of
skirt and on lower right arm.

The Downtown Gallery, New York, New York, 1936;
Korner and Wood Company, Cleveland, Ohio, 1942;
M. Knoedler and Company, New York, New York,
1944; Montgomery Museum of Fine Arts,
Montgomery, Alabama, 1982

Metropolitan Museum of Art

314 Mending (No. 3) c. 1936
Lithograph
page 19 x 12½ in. (48.3 x 31.7 cm.)

Only known state: Highlight over front of hair scratched out with fine white lines. Finger is mostly toned with scratched highlights. Right breast shows.

National Museum of American Art

315 Waterhole c. 1936
Lithograph
page 9½ x 11 in. (24.1 x 27.9 cm.)
Rives, Navarre

Only known state: As illustrated, p. 129.

Korner and Wood Company, Cleveland, Ohio, 1942; M. Knoedler and Company, New York, New York, 1944; Montgomery Museum of Fine Arts, Montgomery, Alabama, 1982

Brooklyn; Yale; Boston; Springfield; Philadelphia; Seattle, Museum of Modern Art; St. Louis; National Museum of American Art; Wadsworth Atheneum; Metropolitan Museum of Art

316 Horse and Rider c. 1936
Lithograph
page 11½ x 16 in. (29.2 x 40 cm.)
"B.F.K.", Navarre

Only known state: Young black sport rides a high-kicking horse moving toward right.

Korner and Wood Company, Cleveland, Ohio, 1942

National Museum of American Art; Boston; Museum of Modern Art; Wadsworth Atheneum; Metropolitan Museum of Art

Edition of possibly 50. Illustrated in Fine Prints of the Year, 1936.

317 Corner Pocket c. 1931 or 1936
(also called *Pool Room*)
Etching
7¾ x 9⅞ in. (19.8 x 25.2 cm.)
Rives

Only known state: A black pool player aims, bending over and holding his cue to land the ball in the corner pocket (at lower left beyond plate-line).

Boston; Philadelphia; Worcester; Metropolitan Museum of Art

318 Mare and Foal c. 1938
Lithograph
page 11⅜ x 16 in. (28.7 x 40.5 cm.)
Rives

Only known state: A light-colored horse with a somewhat darker head looks at spectator. Before her, also turned to left, is her foal, somewhat darker.

Korner and Wood Company, Cleveland, Ohio, 1942; M. Knoedler and Company, New York, New York, 1944

Yale; Boston; Springfield; Philadelphia; Worcester; Museum of Modern Art

Edition of 50.

319 Fishermen's Wives c. 1938
Lithograph
page 16 x 11⁵⁄₁₆ in. (40.6 x 28.9 cm.)
"B.F.K."

Only known state: Three peasant women seated in a row. Each grasps her chin with her right hand while her left rests in her lap.

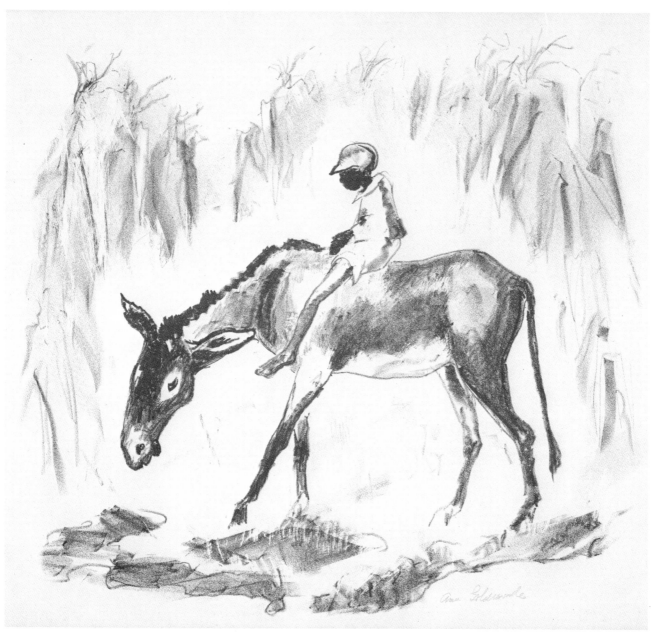

Waterhole (cat. no. 315)

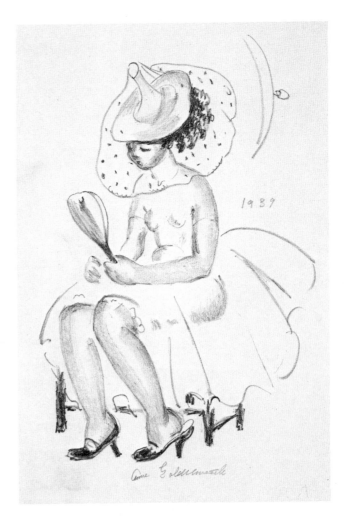

320 **1939** c. 1939
Lithograph
page 17⅞ x 12½ in. (45 x 31.7 cm.)

Only known state: As illustrated.

Springfield; Metropolitan Museum of Art

321 **The Visitor** c. 1942
(also called *The Stranger*)
Etching
10⅞ x 8⁷⁄₁₆ in. (27.6 x 21.3 cm.)
Rives

First state: Before heavy shading between hands and hat, etc. Lowest of three diagonal twig branches at upper right much shorter.

Second state: As illustrated, p. 131. With these additions and much more shading throughout.

Korner and Wood Company, Cleveland, Ohio, 1942; M. Knoedler and Company, New York, New York, 1944; Montgomery Museum of Fine Arts, Montgomery, Alabama, 1982

Philadelphia

Numbered at right in lower margin 1-10. Her last etching.

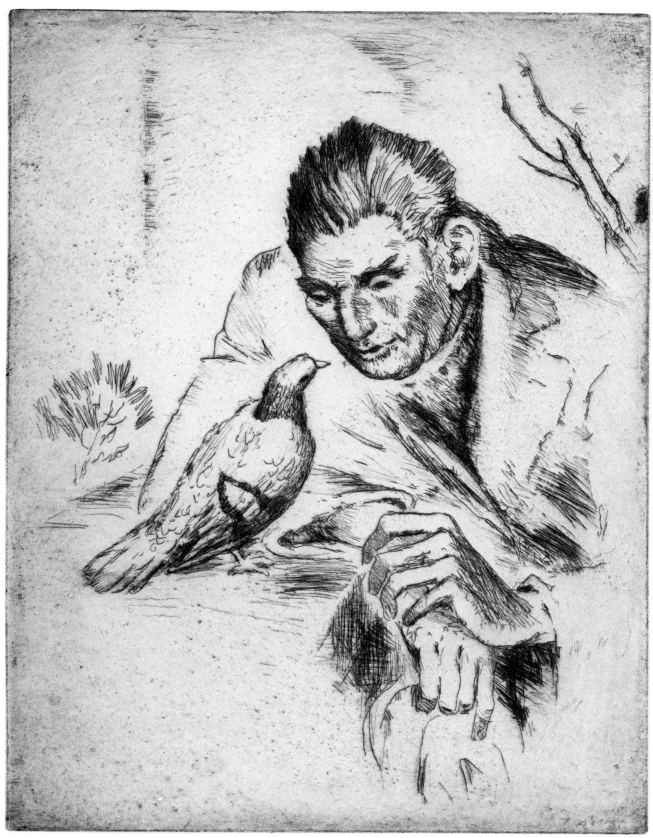

The Visitor (cat. no. 321)

List of Print Exhibitions

This listing is limited to those exhibitions of Anne Goldthwaite's work which contained prints.

1915 *Exhibition of Paintings, Watercolors and Etchings*

Berlin Photographic Company
305 Madison Avenue, New York, New York
October 23 - November 13

1916 *Etchings*
Portland Art Association
Museum of Art, Fifth and Taylor Streets, Portland, Oregon
February 19 - March 25

1920 *Forty-Two Etchings*
Goodspeed's
Park Street, Boston, Massachusetts
December 28 - January 8

1921 *Exhibition of Paintings and Etchings*
Joseph Brummer
43 East 57th Street, New York, New York
October 24 - November 23

1923 *New Etchings*
Goodspeed's
Park Street, Boston, Massachusetts
April 2 - April 14

1923 St. Mark's in the Bouwerie
Tenth Street west of Second Avenue, New York, New York
February 2 - 16

1924 Paintings and Etchings
Syracuse Museum of Fine Arts
Syracuse, New York
March

1924 Group Exhibition
Chicago International Exhibition of Etchings, Chicago, Illinois

1926 *Exhibition of Etchings*
 The Milch Galleries
 January 11-23

1928 *Exposition de Gravure Moderne Americaine*
 Bibliothéque Nationale
 Paris, France
 July 1-?

1929 *Recent Work*
 The Downtown Gallery
 113 West 13th Street, New York, New York
 January 2 - 21

1929 The Art Committee of the Women's City Club
 22 Park Avenue, New York, New York

1930 The Downtown Gallery
 113 West 13th Street, New York, New York
 November 20 - December 5

1931 *Etchings by Anne Goldthwaite*
 Montgomery Museum of Fine Arts
 High and Lawrence Streets, Montgomery, Alabama

1932 *Fifth Annual Review of Recent Work by Regular Exhibitors*
 The Print Corner
 Main Street, Hingham Center, Massachusetts
 July 1 - September 10

1932 The Downtown Gallery
 113 West 13th Street, New York, New York
 October 19 - November 2

1934 *American Printmakers Eighth Annual Exhibition*
 December

1934 The Downtown Gallery
 113 West 13th Street, New York, New York
 December 6

1935 *American Printmakers Ninth Annual Exhibition*
 December 1 - 28

1936 The Downtown Gallery
 113 West 13th Street, New York, New York
 November 16

1937 *Etchings by Anne Goldthwaite*
 Montgomery Museum of Fine Arts
 High and Lawrence Streets, Montgomery, Alabama

1939 Group Exhibition
 The Corcoran Gallery
 Washington, D.C.
 December, 1939 - January, 1940

1942 Korner and Wood Company
 Cleveland, Ohio
 June

1944 *Full Dress Memorial for Anne Goldthwaite*
M. Knoedler and Company
14 East 57th Street, New York, New York
October 23 - November 4

1945 *Memorial Exhibition*
M. Knoedler and Company
14 East 57th Street, New York, New York

1946 *Etchings and Lithographs by Anne Goldthwaite*
Montgomery Museum of Fine Arts
High and Lawrence Streets, Montgomery, Alabama

1954 *Etchings by Anne Goldthwaite*
Montgomery Museum of Fine Arts
High and Lawrence Streets, Montgomery, Alabama

1977 *Anne Goldthwaite 1869-1944*
Montgomery Museum of Fine Arts
440 South McDonough Street, Montgomery, Alabama
March 22 - May 1

1982 *Anne Goldthwaite Print Retrospective*
Montgomery Museum of Fine Arts
440 South McDonough Street, Montgomery, Alabama
June 30 - September 8

Selected Bibliography

"A Modern Painter with a Strong Sense of Style." *The New York Times Magazine,* October 24, 1915, pp. 21-22.

Anne Goldthwaite, 1869-1944. Montgomery, Alabama: Montgomery Museum of Fine Arts, 1977.

Catalogue of an Exhibition of Paintings, Watercolors and Etchings by Anne Goldthwaite. New York: Berlin Photographic Company, 1915.

Defries, A. D. "Anne Goldthwaite as a Portrait Painter." *The International Studio,* LIX, No. 233 (July, 1916): 3-5.

Exhibition of Paintings and Etchings by Anne Goldthwaite. New York: Joseph Brummer Galleries, 1921.

Fitzpatrick, J. Kelly. "Anne Goldthwaite Etchings are to be Exhibited at the Museum." *The Montgomery Advertiser,* Montgomery, Alabama, March 13, 1931, p. 16.

Forty-Two Etchings by Anne Goldthwaite. Boston: Goodspeed's Gallery, 1920.

Memorial Exhibition: Anne Goldthwaite. New York: M. Knoedler and Company, 1944.

"New York Woman's Etchings Charm Art World." *The New York Times,* March 22, 1914, p. 22.

Oil and Watercolor Paintings by Anne Goldthwaite, 1870-1944. New York: Kennedy Galleries, 1967.

Paintings and Watercolors by Anne Goldthwaite. New York: Macbeth Gallery, 1938.

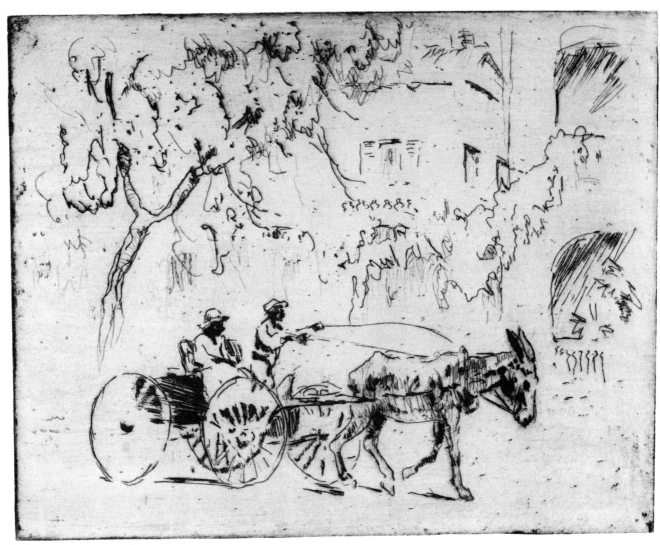

Saturday (cat. no. 184)

Alphabetical Listing of Prints by Title

138

Designed by Julie Toffaletti, Toffaletti Design,
Montgomery, Alabama.

Two thousand copies produced by Brown Printing
Company, Montgomery, Alabama in June, 1982.

Text type is Garamond set by Compos-it, Inc., Montgomery,
Alabama. Titling is Vivaldi set by Compos-it, Inc.

Text and cover stock are Curtis Colophon.